EDITED BY KATY DEEPWELL

New feminist art criticism

Critical strategies

MANCHESTER UNIVERSITY PRESS

MANCHESTER AND NEW YORK

distributed exclusively in the USA and Canada by St. Martins' Press

Published by Manchester University Press
Oxford Road, Manchester M13, 9NR, UK
and Room 400, 175 Fifth Avenue,
New York, NY 10010, USA

Distributed exclusively in the USA and Canada
by St Martin's Press, Inc.,
175 Fifth Avenue, New York, NY 10010, USA

British Library Cataloguing-in-Publication Data
A catalogue record is available from the British Library

Library of Congress Cataloguing-in-Publication Data
New feminist art criticism / edited by Katy Deepwell.
 p. cm.
 ISBN 0-7190-4257-7. — ISBN 0-7190-4258-5 (pbk.)
 1. Feminism and art. 2. Feminist art criticism. I. Deepwell, Katy, 1962–
 N72.F45N45 1995
 701'.03–dc20 94–5414
 CIP

ISBN 0 7190 4257 7 *hardback*
ISBN 0 7190 4258 5 *paperback*

Typeset in Centaur
by Servis Filmsetting Limited, Manchester

Printed in Great Britain
by Bell & Bain Limited, Glasgow

Contents

Figures

Contributors

PAULINE BARRIE is Managing Director of Women's Art Library. She is an artist and a founder member of WAL.

PENNINA BARNETT is Critical Co-ordinator, B. A. Textiles, Goldsmiths' College, London. She has worked as an arts administrator, freelance curator and television researcher. She has contributed to several journals, including *Crafts* and *Women's Art Magazine*.

CHRISTINE BATTERSBY is Senior Lecturer in Philosophy and also teaches at the Centre for the Study of Women and Gender at Warwick University. She is the author of *Gender and Genius: Towards a Feminist Aesthetics* (Women's Press/Indiana, 1989) and numerous articles in feminist philosophy, visual arts and feminist literary criticism. She is currently working on a book on feminist metaphysics.

FRANCES BORZELLO is a publisher of books about the social history of art and feminist art. She is the author of *Women Artists: A Graphic Guide*; *Civilising Caliban*; *The Artist's Model*, and editor with A. L. Rees of *The New Art History*.

FRAN COTTELL is an installation and performance artist. She is Visual Arts Co-ordinator for the London Borough of Merton, based at Wimbledon School of Art. She is also a freelance lecturer and an exhibition researcher and curator.

PEN DALTON is an artist who teaches on the M.A. in Art Education at the University of Central England in Birmingham.

SALLY DAWSON is a performance artist. She was co-ordinator of *Feminist Art News* (1988–93, until the magazine ceased publication). The Feminist Arts News Collective currently organises workshops and is working towards a retrospective publication/anthology. She is currently administrator of the Yorkshire MESMAC Sexual Health Project.

KATY DEEPWELL is an artist and critic. She is a member of Women's Art Library's Executive Committee (Chair, 1990–94) and writes regularly for *Women's Art Magazine*. She curated 'Ten Decades: The Careers of Ten Women Artists born 1897–1906', a Norwich Gallery touring exhibition, April 1992. Her Ph.D. was on 'Women Artists working in Britain between the two World Wars' (Birkbeck College, London, 1991).

ANNA DOUGLAS is a free-lance arts producer, writer and lecturer. She is currently employed by the BBC, producing specialist arts features. She is a regular contributor to *Women's Art Magazine*.

DEBBIE DUFFIN is an artist and visiting lecturer. She is the author of *Organising your own Exhibition: A Self-Help Guide* (Artists Newsletter Publications, 1991) and *Investigating Galleries: An Artist's Guide To Exhibiting* (A. N. Publications, 1994). Her next major exhibition will be at the Stansell Gallery, Taunton in September 1995.

JANIS JEFFERIES is a textile artist and critic. She is Study Area Head for Textiles and Programme Leader for Postgraduate Textiles in the Visual Arts Department at Goldsmiths' College. She is a member of the Foundation Board and Joint Co-ordinator of the Education Group for the European Textiles Network (P.O. Box 5944, Friedenstrasse 5, D-30059, Hanover, Germany) and an Advisory Board Member of the International Tapestry Network in Anchorage, USA. Recent work includes a joint exhibition with Ann Newdigate (Montreal, Canada, September 1995); catalogue contributions to the Lausanne Biennial, Switzerland (June 1995); and work as the UK selector for the Lodz Triennial textile exhibition, Poland (June 1995).

JOAN KEY is a painter and is represented by the Curwen Gallery, London. She teaches fine art as a visiting lecturer. Her recent exhibitions include 'B.E.L.L.O', Bahnhof Westend, Berlin (September 1994) and 'Rear Window', London (January 1994). She is contributing to J. Steyn (ed.) *Beyond Identity/Other than Identity* (Manchester University Press, 1995).

MARY KELLY is director of Studio and Critical Studies at the Whitney Museum Independent Study Program in New York City. Her latest project *Gloria Patri* has been shown in Vancouver, the ICA (London) and as part of 'The Masculine Masquerade' (MIT List Visual Arts Center, Cambridge, Massachussetts), and is to tour the USA in 1995–96. Her publications include *Post-Partum Document* (Routledge, 1984) and *Mary Kelly: Selected Writings* (MIT Press, 1995).

ELIZABETH A. MACGREGOR is Director of the Ikon Gallery, Birmingham. She was responsible for the first European exhibition of the Afro-American artist Adrian Piper and for the first one-person shows of Zarina Bhimji and Lucien Noguira. She is a contributor to *Curatorship: Critical Alliance or Confrontation* (Museo Funacion Gallerie de Arte Nationale, Caracas, 1994).

ANN NEWDIGATE is a Canadian textile artist. She currently chairs the Visual Art Committee of the Saskatchewan Arts Board and teaches drawing for the University of Saskatchewan. She recently completed a major commission *Many Voices/Miltunkasik* (a 15×11 ft mixed media triptych, designed by Moshe Safdie) for the Council Chamber, New City Hall, Ottawa. Her most recent solo exhibition was 'The Arrival of the Brides Transcribed' (Hart House Gallery, University of Toronto, April 1995).

MAUREEN PALEY is the founder and director of Interim Art, London. She also works as a free-lance curator and she is an occasional broadcaster on *Kaleidoscope* (BBC Radio 4). 'Wall to Wall', an Arts Council Touring exhibition in 1994, is one of her recent major projects.

DINAH PRENTICE is an artist. She is studying for an M.A. in Psychoanalytic Studies with Parveen Adams at Brunel University (1993–95). Her work is represented in collections at the Victoria and Albert Museum and Shipley Gallery, Gateshead.

HILARY ROBINSON teaches Fine Art theory and practice at the University of Ulster, Belfast. She edited the anthology *Visibly Female* (Camden Press, 1987) and was editor of *ALBA* (1990–92). She has written many articles and catalogue essays on feminist art. Currently she is researching towards a Ph.D. on how the trace of the body of the artist is left in her artwork and the implications this has for both artist and audience.

MOIRA ROTH is Trefethen Professor of Art History at Mills College, Oakland, California. Her latest publications include 'The Voice of Shigeko Kubote' in *Shigeko Kubote* (American Museum of the Moving Image, New York, 1991); 'Two Women: The Collaboration of Pauline Cummins and Louise Walsh' in *Sounding the Depths* (Irish Museum of Modern Art, Dublin, 1992); and is co-author (with Volande Lopez) of 'Social Protest: Racism and Sexism' in M. Garrard and N. Broude *The Power of Feminist Art* (forthcoming, 1994). She is currently editing *Rachel Rosenthal: An Anthology of Essays by and on the Artist* (John Hopkins University Press) and co-editing *Fierce Dreams: Asian-American Art*.

NAOMI SALAMAN is an artist and curator of 'What She Wants', a touring photographic exhibition (Impressions Gallery, York and Orchard Gallery, Derry, 1993–94) which explores images of female desire about the masculine body. She is the editor of *What She Wants* (Verso, 1994). Other recent exhibitions of her own work have been at the Akehurst Gallery, 1994 and Stills Gallery, 1995.

RUTH SCHEUING is an artist and currently teaches in the Textile Arts Program at Capilano College, North Vancouver, Canada. Her major solo exhibitions include: 'Anatomy of a Suit' (Textile Museum, Toronto, 1993); 'Geometry of the Body' (Owens Art Gallery, Sackville, New Brunswick, 1992); 'Radical Textiles' (Southern Exposure Gallery, San Fransc180, 1992); and 'Penelope or 13 Men' (Canadian touring exhibition, 1989).

GILANE TAWADROS is Director of International New Initiatives for the Visual Arts (INIVA), an Arts Council of England funded project. Before 1994 she was Education Officer at the South Bank Centre.

VAL A. WALSH is a freelance writer, researcher, teacher and critic, based in Liverpool. Her recent research includes 'Women's Experience in Art Education and Art', an Arts Council funded project (1994). Recent publications include 'Unbounded Women? Feminism, Creativity and Embodiment' in G. Jasser and M. Verloo, *Feminisms in Europe: Cultural and Political Practices* (WISE, Netherlands, 1994) and 'Virility Culture: Managerialism and Academia' in M. Evans and A. Seller (eds.), *Agenda for Gender* (University of Kent, 1994).

JANET WOLFF is Professor of Art History/Visual Studies at the University of Rochester, USA. Her latest publication is *Resident Alien: Travel/Memoir/Gender* (Polity Press, 1994). She is also the author of *Feminine Sentences: Women, Art and Culture* (Polity Press, 1990), *The Social Production of Art* (Macmillan, 1981) and *Aesthetics and the Sociology of Art*. She is currently working on modernism and gender, and on memoir and cultural history.

Preface PAULINE BARRIE

The writings contained in this book present a diversity of feminist perspectives. They can be identified through a shared belief that art can have a political impact. Women's art practice through the making of art and the meanings of its cultural artefacts identifies a distinctive role within our present culture. This book is another stepping-stone for feminist art in that it contains many distinctive voices who have evolved and are evolving through the feminist ideals of progress and change. Within the writings there seems to be a process of demystifying 'art and its production', while simultaneously developing new languages, criticisms and theoretical discourses. But what has the last twenty years actually achieved?

Perhaps it has helped to focus, enabling instant recognition of the systematic discrimination which still exists against women within so many aspects of the UK art world today. The significance of gender cannot be ignored despite our understandings of our own cultural complexities (in terms of race, sexuality, generation and ethnicity). Since the seventies there has been a form of backlash giving rise to extensive discussion concerning 'post-feminism', a rejection of the notion of feminism as positive and certainly a denial of very basic forms of discrimination. It is interesting to note that various statistics produced by the Women's Art Library reveal that the position of the woman artist has deteriorated and that in the nineties women are still not appointed as professional fine art lecturers despite forming 68 per cent of the student population. There is still a marked 'difference' in the way that women artists are referred to in general critical reviews, and women artists are still not properly represented in history books. Even in books on the seventies and eighties the acknowledged contribution of women artists is minimal.

Yet the ever-expanding collection of The Women's Art Library provides astonishing evidence of women artists and their creativity. The seventies gave rise to an increase in separate exhibitions for women artists, and many strands of involvement emerged, from separatist groups to women who believed that you could infiltrate the various levels of the art world, including education, and instigate change from within these various systems. There were also those who believed that to attain a mainstream position was most significant for a feminist artist and her future. All these different strands provided exposure, and in the 1980s greater numbers of women artists showed collectively and individually in many public and private galleries throughout the United Kingdom. Yet many of these shows were poorly funded, with a press release as the only piece of written information and no catalogue. Many of these exhibitions survived because of the effort which the artist herself put in; not only did she produce the actual artwork but she also curated it, hung it, drew up the press release and preview card, produced the mail-out, and often had to market the show once it opened in the hope of getting a review or a much-needed sale. In some instances she even had to pay for the space. Although this kind of self-help situation

seemed to flourish during the 1980s both in the UK and in the rest of Europe, it contributed to the marginalisation of women artists generally. Although it would seem that a wealth of work was being shown, too much of it fell into this self-help situation. This is a common situation for the younger woman artist striving for her first show, but it is often also the case for artists who have been practising for twenty or thirty years and who already have solid reputations. How will things change? The Women's Art Library supports change through the provision of information and evidence about the work of women artists, past and present, by actively producing statistics, lobbying and by drawing the public's attention to the many forms of discrimination which exist and flourish within the art world. This book gathers more evidence on the debates around feminism and the production of art. Its publication provides another example of the feminist determination to work together and force change in a hostile world which operates within traditional male boundaries, informed by misogyny, bigotry and sexist frameworks of thought and practice. This book will be a flagship for the 1990s.

Acknowledgements

The editor would like to thank all the contributors and the artists whose work is reproduced here for their work. For their help in obtaining photographs and copyright, special thanks are due to Women's Art Library, Rebecca Scott, Robin Shaw, Interim Art, Serpentine Gallery, Ikon Gallery, the Arts Council Collection, Tate Gallery, Institute of Contemporary Art in London, Deanna Petherbridge, Sutapa Biswas, Galerie Rene Blouin (Quebec), Terry Dennett of the Jo Spence Archive, Impressions Gallery in York, The Art Museum of Princeton University, Galerie Crousel-Robelin (Paris) and the organisers of the International Lausanne Biennale.

The majority of contributors were initially brought together at the Decennial Conference of the Women's Artists Slide Library in June 1992 at Morley College on 'Feminist Art Criticism: into the 1990s'. This large conference was funded by the Visual Arts Department of the Arts Council of England. The editor, who also convened the conference, would particularly like to thank the staff at WAL who worked on the conference, all those who presented papers on the day and Alan Haydon, then the Visual Arts Officer at ACE. Women Artists Slide Library changed its name in September 1993 to Women's Art Library.

Hilary Robinson would like to thank Pauline Cummins and Louise Walsh for inviting her to write a catalogue essay for their exhibition at the Irish Museum of Modern Art (1992): that essay formed the basis of her essay in this anthology. Janis Jefferies would like to thank Juliet Steyn and Diana Wood Conroy for their supportive comments and Marlene Miller for typing the text. Ann Newdigate would like to thank John Mills, Janis Jefferies and Gail Youngberg for their assistance. Fran Cottell would like to thank Debbie Duffin for typing and Mike Richards for correcting her manuscript.

Introduction KATY DEEPWELL

Feminist art criticism
in a new context

In 1986 Rosika Parker and Griselda Pollock described the activities of the women's art movement in the period from 1970 to 1985 as being marked by a shift from 'practical strategies to strategic practices'.[1] They used this phrase to summarise the emergence of specific forms of feminist art practice by the mid–1980s, a development which was distinct from the initial coming together of women artists to discuss and exhibit their work in the 1970s. Feminism was thus defined by political strategies manifest in a set of practices, marked by an engagement with debates around representation and a critique of modernism, rather than by the association of women artists to exhibit their work, to support and encourage each other's activities or to protest against discrimination in the art world. A similar argument had been put forward somewhat more dogmatically by Judith Barry and Sandy Flitterman-Lewis in 'Textual Strategies: The Politics of Art Making' (1980)[2] who sought to identify particular practices in terms of essentialist versus anti-essentialist and feminist as opposed to feminine approaches adopted by women artists during the 1970s. The latter's influential analysis had attempted to define an avant-garde feminist art practice by privileging the employment of deconstructive strategies over those they regarded as essentialist, the use of psychoanalytic, semiotic and Marxist theorisations of the subject over expressions of female experience, and a critique of the latter in particular because it often failed to address the political. This controversial analysis of the development of feminist art practice forms one of the major reference points in the debates explored in this book.

Feminism is not a singular approach but a broad umbrella term for a diverse number of positions and strategies amongst women involved in the production, distribution and consumption of art. The contributors include critics, curators, academics and artists. Each explores a different aspect of women's art practice, feminist art criticism and women's role in the art world in the late 1980s and early 1990s. Although there are shared concerns and reference points amongst these women, they do not present the reader with a singular position on women artists, the work they produce, or the role for feminist criticism (see below). Emphasis has been placed through the selection of contributors on demonstrating the broad framework of debate in which a diversity of feminist art practices and forms of criticism operates.

Across the book there is a general consensus about the need for feminist art criticism in the 1990s and beyond, and for women to continue a dialogue which draws on the rich heritage of sustained feminist art practice, criticism and art history of the

1970s and 1980s. How to meet the challenges and shifting political and cultural situations of the 1990s is where their individual critical strategies start to emerge. On whether feminism has succeeded in being the catalyst to questioning critical practices and values in the same way that Linda Nochlin suggested feminism would challenge art history in 1971,[3] most would agree that much more remains to be done in art schools, public galleries and museums, the art market and in reviewing practices before the position of women really changes. While the relationship of feminism to postmodernist debates is discussed the idea of post-feminism, floated by the media in the mid-1980s, is firmly rejected. The persistence of discrimination against women, the marginalisation, containment or tokenistic attitude to women artists in gallery programmes and the absence of considered published debate on women's art practice in the mainstream press, remain key issues.

The five sections of the book address important areas for feminist criticism and art practice which have emerged in the late 1980s. Within each section the contributors highlight a different set of questions for the development of feminist strategies in the 1990s. Different perspectives on the sites, strategies and positions of contemporary women artists emerge as each outlines her own particular position.

The impact of post-structuralist theories has undoubtedly had an effect in transforming the terms of feminist debate since the early 1980s.[4] The majority of the contributors make reference to the ways in which both criticism and the relationships between theory and practice have been transformed by interest in French feminism, deconstruction, theories of the subject, and critiques of narratives of history and the boundaries between disciplines.

In the first section, **Between theory and practice**, Janet Wolff identifies an impasse in feminist art criticism, of which Barry and Flatterman-Lewis's account is but one example, with divisions into essentialist and anti-essentialist camps; for and against theory. She considers the implications of current critical theory for feminist practice in overcoming such binary oppositions, and the inadequacy of such binary oppositions to classify and debate women artists' work. Gilane Tawadros then analyses how the 'postmodern' analysis of identity is closely related to contemporary black women artists' analyses of the narratives of history in their practice. Moira Roth's analysis of Sutapa Biswas's project *Synapse* offers her own account of the mutual recognition and challenge presented to her by the artist in terms of a post-colonialist encounter. Roth's account seeks to situate and question her own responses to Biswas's work as much as it presents the artist's explanation of her own approach.

In the gap between theory and practice, there is the role played by institutions in validating and maintaining particular ideas, values and beliefs. Frances Borzello examines the institutional constraints upon the appearance and circulation of feminist ideas from a publisher's perspective. She examines how little mainstream art writing is devoted to women artists, be it in newspaper reviews, art and literary journals and magazines, catalogue essays, TV and radio, etc. Feminist perspectives in art criticism, she argues, occupy a still smaller area of coverage within these spaces. The period from 1985 to 1988 saw a flurry of publications in Britain on this topic, e.g.: Gisela Ecker's *Feminist Aesthetics* (Women's Press, 1985); Hilary Robinson's *Visibly*

Female (Camden Press, 1987), Rosika Parker and Griselda Pollock's *Framing Feminism* (Pandora/Routledge, Kegan and Paul, 1987); Leslie Saunder's *Glancing Fires* (Women's Press, 1987); and G. Elinor *et al.*, *Women and Craft* (Women's Press, 1988). Two specialist magazines have also been published between 1987 and 1992, *Women's Art Magazine* (formerly *WASL Journal*) and *Feminist Art News*; these have worked hard to initiate new debates about women's art practice.[5] However, since 1988 only three other books on feminist art practice have been published: Janet Wolff's *Feminine Sentences* (Routledge, Kegan and Paul, 1990); Wendy Beckett's *Contemporary Women Artists* (Phaidon, 1988) and Maud Sulter's *Passions* (Urban Fox Press, 1990). Borzello's argument raises important questions concerning access to writing about women in the visual arts as well as the inaccessibility or not of certain forms of academic debate.

The section concludes with two contrasting essays about feminist interventions in the culture of another major institution, the art school. Val Walsh provides an outline of a potential framework for feminist teaching while Pen Dalton's piece questions the underlying models from developmental psychology on which much 'modernist' studio teaching since 1945 is based in an attempt to lay bare the male bias in teaching practices.

In **Curatorship and the art world** two gallery directors, Maureen Paley (Interim Art) and Elizabeth Macgregor (Ikon Gallery), present how they see the pleasures and pitfalls of their respective positions in the commercial and public sectors. How to intervene as a feminist and initiate change in public and commercial exhibitions is a question which all the contributors in this section explore.

From her experience as curator of the touring exhibition 'The Subversive Stitch' Pennina Barnett analyses audience reaction to the contemporary work selected. She argues that although the show attempted to renegotiate definitions of art/craft, feminine/feminist, much of the press reception and audience reaction remained trapped within more conventional critical categories, closing down on the debates which the exhibition aimed to initiate. How women negotiate making and exhibiting their work in gallery and non-gallery settings is explored by Debbie Duffin's analysis of her own and other artists' exhibiting strategies. Both Debbie Duffin and Fran Cottell argue against the idea that the artist waits to be discovered by the dealer and stress that she must actively seek and make choices about the context and display of her work. Fran Cottell's piece offers her own experience of exhibition across painting, performance and installation, highlighting the ways in which she renegotiated her practice to meet new audiences.

The marginalisation of women's concerns and the handling of the presentation of their work when it deals with controversial subjects are analysed by the three contributors in **On the question of censorship**. Anna Douglas's discussion of the pre-emptive removal of one of Deanna Petherbridge's works from a solo exhibition highlights the misconceived pressures and institutional prejudices in the public sector. Douglas employs Annette Kuhn's theorisation of censorship as regulation and argues that the actual content of the work made by the artist becomes an irrelevance because of the troubled reception of the 'politically' charged signifier ('Rushdie') in its title when the work travels from a private gallery to a public gallery. By contrast, in Naomi

Salaman's chosen examples it is purportedly the 'sexual' content of the work which underlies the removal of works from sale or exhibition in her three case-studies. Sally Dawson pursues a very different argument; aligning censorship with the taboo on women's perspectives which discrimination in our culture enforces, she presents the work of four women who address different aspects of women's experience and history. These works are not 'censored' in the conventional sense of being removed, not displayed, not seen, but they address areas of women's social and political experience which appear 'censored' by a patriarchal culture.

The engagement with psychoanalysis addresses the impact of one of the most powerful influences on feminist art practice in Britain in the late 1980s. The legacy of Lacan is supplanted by the impact of Irigaray and Kristeva. Christine Battersby's piece argues that the adoption of psychoanalytic terms and models, specifically from Luce Irigaray, may prove fraught for feminist art practice if we do not address these writers' own analyses of the place of painting. Hilary Robinson enthusiastically demonstrates how critical terms from psychoanalysis have nevertheless enabled a rethinking of representation of the body and shows how it has been used as a critical and methodological tool for a broad range of women artists in the late 1980s. Joan Key with reference to her own practice, presents how pyschoanalysis, particularly Kristeva's discussion of the abject and the repression of the maternal body, provides a position for painting enabling her to address the physicality of colour. A very different approach is offered by Mary Kelly, who provides a discussion of 'Historia', the fourth and last section of her project *Interim* which analyses the attitudes of women who were members of the 1968 generation involved in women's liberation and who are now (1994) between forty-five and fifty-five years old, to their body, money, power and history. In 'Historia' Kelly questions what is at stake in how a subject positions itself historically; particularly how a feminist identifies a particular 'ideal' moment of radicalism (1968) only to be challenged by the different perspectives of a younger generation. Kelly approaches Kristeva's analysis of 'Women's Time' and redeploys Foucauldian ideas of history as a form of genealogy and archaeology, continuing her critique of and dialogue with Lacan concerning femininity and the construction of women's identity, evident in the other sections of both *Interim* ('Corpus', 'Pecunia', and 'Potestas') and *Post-Partum Document*.

The shifting definitions of practice and the employment of new theoretical frameworks from post-structuralist theories of language, deconstruction and decoding are taken up again in Janis Jefferies's piece which introduces the last section, **Textiles**, linking it back to but extending in a different direction the analyses provided by J. Wolff, G. Tawadros, and H. Robinson. The situation of textiles on the boundaries, at the margins, as a 'hybrid', the relationship between text/textile and the use of metaphors from embroidery and weaving provides textile practitioners with a specific relationship to postmodern debates, she argues. The position of textiles both inside and outside the fine art or craft arenas, crossing and at the same time challenging hierarchies and definitions, myths and ideologies, theory and practice are explored here (see also P. Barnett). The debates from the 1970s on the revaluation and transformation of 'traditional crafts' reinvested with radical feminist messages are offered a

different critical framework by her argument. Ann Newdigate, Dinah Prentice and Ruth Scheuing then each present their own practice in the context of these debates, demonstrating how, through tapestry, piecing and weaving respectively, the artist works to undo politics and patriarchal myth-making while creating feminist work.

New contexts for feminist art criticism

Without models, it's hard to work; without a context, difficult to evaluate; without peers, nearly impossible to speak

J. Russ[6]

What is the role of feminist art criticism? Joanna Russ's comment provides a useful starting point for defining the key tasks of feminist art criticism. It should offer models of women's art practice to its audiences; provide contexts for interpreting works and language(s) or theoretical frameworks to communicate with one's peers.

Feminist art criticism remains criticism with a cause. It is committed to challenging the representation of women's work in a culture which continues to devalue, denigrate and ignore it. Feminism is still the tool through which women empower themselves, assume the right to name and describe their perspectives and take part in a self-reflexive, developing, open-ended set of debates about what it means to be women (plural) in a patriarchal culture. Feminist debate conceived in this sense is a political process and a set of strategies. It is not a singular method nor a science confined to the academy.

Crass stereotypes about feminism and 'women's interests' in our society abound and the culture of the 'art school' and the 'art world' has a particularly virulent and vested interest in their continued circulation as a means to halt the exposure of male privilege. A variety of social and intellectual strategies are well known and much practised by the male-dominated establishment to contain the influence of feminism and the small numbers of women lecturers in the art school when compared to the majority of women in the student population. This occurs not just in the deliberate failure to invite well-known and critically acclaimed women in to teach but also in the failure to appoint them to jobs or to promote them to positions where they might influence decision-making. The intellectual strategies appear more subtle but are no less damning. They include the stigmatisation and dismissal of feminism as a blanket 'boring' entity with no political influence or intellectual interest in the world of 'critical theory' and the active discouragement of feminist projects, ideas or works, manifest in social isolation or active hostility towards the young women who wish to produce such work and the most open bias in the awarding of marks and degrees.

Even in what are considered some of the more sophisticated of postmodern debates, feminism appears as a homogeneous noun – old-fashioned and *passé* – never defined or expanded, only invoked to be dismissed.[7] The heterogeneity and plurality of issues, debates and voices within feminism are removed with one full sweep. And this, in spite of the fact that 'postmodernism' has been named by some critics as the first avant-garde movement which included women not as marginal players but central to its definition of allegory and anti-aesthetic strategies.[8] Howev

delimitation of the references to the practices of a handful of women in New York can equally be called the first stages of a repititious form of tokenism – the effective containment of the central role that women artists play by the creation of a few success stories.

Although the 1980s can be characterised by the engagement with post-structuralist theories, many of those who write art history and criticism employing insights about the displacement of the centre, 'marginality' and 'difference' seem happy to declare that feminism is no longer the principal site of struggle. The academy has learnt some of the jargon on 'difference', but the men, in particular, remain 'indifferent' when it comes to applying this insight to the political and economic marginalisation of women or any analysis of their work.[9] It should not go unremarked that renewed interest in such concerns arrived as a mark of 'professionalism' just at the moment in the late 1980s when reductions in government funding in universities and art schools and recession in the art market had increased women's economic marginalisation.[10] However sophisticated the intellectual postmodern/post-structuralist enquiry seems to have become as the stakes in critical theory engage philosophy, sociology and pyschoanalysis, however difficult the theoretical terms of engagement with these issues now appear, feminist art criticism continues to engage, critique and consider the implications for women.[11] Feminism's aspiration to call attention to the gendering of all relations, to the intrusion of patriarchy into the most private arena of everyday life, is not so easily disavowed.

What is it about criticism which makes it 'feminist'? Or put another way, are there specific forms of criticism for which there are labels reserved as 'feminist'? Writing about women artists does not make a critic (female or male) feminist. Nor is the vast majority of writing about women artists feminist in its approach to their work. Feminist art criticism, while it may place great emphasis on the interaction between works produced by women artists is not about defending a feminine sensibility – some mystical unique quality present in all women's work – for this has actually been an old misogynist strategy for defining feminine difference.

The feminist art critic may place writing about women artists at the centre of her activities. She may see her role as informing her audience, perhaps even educating or enlightening them about women's work and feminist issues. Generating interest about women's work is, nevertheless, at the centre of her activities. This may have the effect of 'raising consciousness' or positioning some women artists as potential role models for younger artists. Her strategy may ultimately reverse or intervene critically in the endless privileged attention to male artists and masculinist concerns in the art world. She may act as an advocate for particular constituencies within the ＿＿＿＿alised majority of women or refuse such a position, engaging ＿＿＿＿he diversity or practices with which women are actually engaged. ＿＿＿＿time drawing even finer distinctions between feminine and femi-＿＿＿＿ progress of the women's art movement. ＿＿＿＿ith literary criticism are informative in the contrast Sydney ＿＿＿＿ between two approaches in feminism: that of the gynocritics as ＿＿＿＿ critique.[12] The former is identified as a 'genuinely women-centred,

independent and intellectually coherent' approach which attempts to read women 'not as anomalous, eccentric or precious, but as vital active precursors and innovators'.[13] It traces patterns of influence and common concerns, including ideas about women's body, language and psyche, but interpreted in relation to the social contexts in which they occur. This focus on women writers is contasted by the concerns of feminist critique with the images and stereotypes of women in literature, the omissions and misconceptions about women in criticism and 'woman-as-sign in semiotic systems', exposing the myriad ways in which patriarchal attitudes affect literary criticism.[14] Central to feminist critique has been the identification of feminine/feminist stereotypes which seek to create separate categories for 'women' and 'Art' (defining art-making as an exclusively male category).[15] It is clear, however, that feminism needs both approaches, and they are not mutually exclusive. Feminist criticism's primary purpose may be about women, for women and concerned with women's issues but it is also a perspective, a set of questions, that can be brought to bear on criticism of male artists' work. This, however, remains a marginal issue when so little is published on women.

While feminist critique approaches patriarchal assumptions and the privileging of the masculine view as the 'norm', women's work (past and present) still needs to be recontextualised. Modernist accounts of art history continue to present the work of women artists in the twentieth century as followers and their work as derivative of the achievements of 'major' male artists, ignoring important questions about the social production of art. The research into women's art practice offered by feminist art history; the articulation of the distinctive contributions made by female artists; and social-historical as well as psychoanalytic/semiotic models for the analysis of contemporary projects are still vitally important to changing the canon.

Annette Kolodny describes the need for 'a playful pluralism, responsive to the possibilities of multiple critical schools and methods but captive of none', coupled with a recognition that 'the many tools needed for our analysis will necessarily be inherited and only partly of our own making'.[16] For gender difference is not separable from other marks of distinction or categorisation in criticism like class, race, creed, generation or sexual orientation.

Feminist art criticism should be, like all good criticism, 'an invitation to dialogue'[17] not just between the spectator and the work, the reader and the text, but specifically in opening up questions about the way social/political issues and ideas are addressed through particular artworks, events, and the position or representation of women offered. In this sense, feminist art criticism engages not just with art practice but with questions of audience, building and sustaining debates about the representation of women and their diverse activities inside and outside the art world. Feminist art criticism charts the shifts and changes in the arguments, issues and theories it addresses as much as it intervenes to outline positions, give voice to experience and identify the relative, complex, often contradictory, positions of women as artists, curators, critics, teachers and viewers.

Contemporary criticism places enormous emphasis on the positive and affirmative, yet women's work is frequently described only in terms of its lack: the measure

of women's difference from a male norm (some approaches in psychoanalysis do little to reverse this trend). We need to scrutinise and examine the terms of reference by which we discuss and contextualise women's art practice for language, visual and verbal, is not a transparent medium for expression, but coded and conventionalised. As Christine Battersby has shown, the attribution of 'genius' is thoroughly gendered[18] and like other common critical terms (e.g. 'vitality', 'strength', 'vigour', 'decorative', 'pleasurable') has often been used to devalue women's work.[19] Similarly we need to consider what place intentionality has as a validation of women's voice in an art market which sells the artist as much as it sells the product.[20] The process of legitimation in our culture continues to come from large male-dominated institutions in which only a minority of women artists appear.

In contemporary reviewing, journalism often replaces any form of in-depth criticism. Shows are discussed as fashion items only and always topically, renowned for their banality or gimmicks and *not* for their ability to make us think about the boundaries within which we view 'Art'. Status-conferring references, the cheapest short cut in the hazy atmospheric writing of art journalism, continue to position all artists as inheriting only from men. Women artists are frequently positioned as an isolated 'phenomenon' in a male-dominated canon via the interminable vague and often totally inappropriate references to patriarchal precedents. Matrilineal inheritance is ignored[21] because it is assumed that readers will not be familiar with women artists and comparisons with well-known male artists command a pseudo-credibility. However, women are rarely positioned as the inheritors of the legacy of Picasso, Pollock, Beuys or Warhol.

Feminism's critique of the disinterested observer exposed the partisan nature of all readings (when that 'neutral' figure was identified as white, male and middle-class), and began to explore how reading is inevitably informed by political positions.[22] Critics' vested interests, in spite of this powerful critique, continue to be disavowed as the 'genius' of each (male) artist's work is elaborated through traces detected in the fabric of the work itself[23] and their links with or relations to other artists in the grand tradition. If feminism, including feminist art criticism, remains inextricably linked to an agenda that is by women, for women and about women, what choices will women critics make when they situate women's work in the future? Will they take up the challenge feminism offers in terms of a new set of references, issues, or an alternative tradition? Feminism will continue because women will continue to build alliances *as women* against a culture which discriminates against them *as women*, as an undifferentiated 'Other' whose subjecthood, even individuality, is denied and where the collectivity of women is forgotten.

Painful though it has been for many individual feminists to have learnt to recognise the diversity of women's needs and interests in the 1980s, as fractured by experience, generation, race, ethnicity, religion, sexual orientation, the plurality of positions which feminism *of necessity* contains frequently remains unrecognised. In the 1980s the range of different forms of radical feminism, socialist feminism, Marxist feminism and lesbian separatist feminism appeared to fracture the early-1970s' notion of a 'melting-pot' in a united sisterhood. Women (in all their diversity, black and

white, lesbian or heterosexual and of different creeds and generations), continue to be marginalised as a sex/class[24] within the dominant discourses and the institutional hierarchies which maintain discrimination against women as a repetitive and routine part of the status quo. In spite of the divisions and recognition of differences between women, feminism remains an important 'conceptualization with sufficient relevance and malleability to sustain coalition',[25] a united coalition which is both political and strategic in order to initiate change for women, while respectful of the diversity of interests and needs. What appear as the paradoxical characteristics of feminism, its simultaneous arguments for the elimination of gender roles (equal rights) and the valorisation of female being (the recognition of difference) are not mutually exclusive oppositions but a valuable part of the 'spectrum of conceptualizations from "socialisation" to "oppression" to "patriarchy"' which creates feminist debate.[26]

The equation: artists produce, critics comment, art historians contextualise, reasserted itself in the 1980s as a 'logical' division of labour. Boundaries to the novel types of expanded artistic practice which emerged in the 1970s are increasing in spite of the current fashion for neo-minimalism/conceptualism. Single-mindedness and obsessive dedication to one's area of expertise became the order of the day; all else meant you dabble – re-enter the little woman as amateur and the artist (male) as media star. It is increasingly difficult to be identified as an artist in this country outside the masculine norm of artist/lecturer (if women can get employed as such – an argument still for equal rights). The feminist model of artist/theorist/political activist/community worker/feminist/lecturer/curator/administrator, let alone what used to be known as theorist/practitioner, is less prominent today. Feminist artists took up such positions to act as advocates and promoters of women's work, to illuminate shared concerns and build new audiences. This is not to say that artists, particularly women, have ceased to adopt these multiple roles (as examples in this book testify) but like much of women's work in general these positions go unrecognised and are devalued (a potential argument for difference and the recognition of the specificity of women's practice).

The contradictions of the feminist art critic intervening and promoting women artists within a limited art market system was the subject of much writing by Lucy Lippard.[27] As she argued, a slice of the pie still has value when 'Pie is pie for the starving'[28] even where the idea that women are getting a bigger chunk of the pie leads to tokenism and the worse kind of complacency coupled with absolute denials that discrimination exists. Art administrators, curators and editors remain horrifically complacent about the representation of women. They argue that because they held a women's show or edited a special feminist issue three/ten/fifteen years ago, there is no need for them to concede to a new project. Why, after all, should 52 per cent of the population receive more than Modernism's well-practised limited representation of women: between 10 and 20 per cent of an exhibition programme?[29] Mention the 'natural' justice of a quota system for the late twentieth century, and they turn quite pale and start mumbling about 'quality' (an old and thoroughly discredited tactic!). The limited space women have ever been permitted to occupy is only a rationale of women artists' unimportance to misogynists. For everyone else, particularly feminists,

it is simply more evidence of discrimination against women at work. The majority of women artists are still fighting for decent spaces to show their work, and to gain a better income, and feminist critics for an opportunity to discuss it in the mainstream press. While women continue to seek participation and space in the mainstream, they still question its value systems and its pseudo-meritocracy (based on all that is shown in a mainstream gallery being 'flavour of the month'!). The question still on the agenda is, are these the only arenas, the only spaces which women artists want to occupy, and are these the only audiences women want to reach?

The absence of an American-style art-world feminism in Britain where older, more established women artists have identified with women's struggles, using the woman question to gain space for their work, has often been remarked upon.[30] However, the model of feminists intervening in the institutions of official culture here is not the same as the idea that feminist practice is based somewhere outside the art world in a political mass movement and desires only to build a counter-culture.[31] Defining and redefining the shifts in debates and strategies within the women's art movement and the relationship between feminist concerns and contemporary critical debates in the art world remains an important task for feminist art criticism.

Feminism's ethical question may be the analysis of patriarchy but feminism's primary concern is to initiate debate within and for the major constituency that women represent amongst practising artists. Feminist art criticism should regard itself as just one area of empowerment in a broader feminist coalition, an opportunity to consider the implications of women's work and a means of spreading the word about women's contribution and feminist issues to new audiences.

Notes

1 R. Parker and G. Pollock, *Framing Feminism: Art and the Women's Movement 1970–1985* (London & New York, Pandora, 1987), p. 3.

2 J. Barry and S. Flitterman-Lewis, 'Textual Practices: The Politics of Art Making', pp. 313–21, originally published in *Screen* 21, 2 (1980). See also the critique by A. Partington, 'Feminist Art and Avant-Gardism' in H. Robinson, *Visibly Female* (London, Camden, 1987) pp. 228–49.

3 L. Nochlin, 'Why have there been no Great Women Artists?' (1971) in *Women, Art and Power* (London, Thames and Hudson, 1989), p. 146.

4 See Chris Weedon, *Feminist Practice and Post-Structuralist Theory* (Oxford, Basil Blackwell, 1987); S. Hekman, *Gender and Knowledge: Elements of a Postmodern Feminism* (Cambridge, Polity Press, 1990); S. Benhabib and Drucilla Cornell, *Feminism as Critique* (Minneapolis, University of Minnesota Press, 1987); R. Braidotti, *Patterns of Dissonance* (Cambridge, Polity Press, 1991); and A. Jardine, *Gynesis: Configurations of Woman and Modernity* (Cornell University Press, 1985).

5 *Feminist Art News* ceased publication in the spring of 1993.

6 J. Russ, *How to Suppress Women's Writing* (London, Women's Press, 1983), p. 95.

7 See H. Foster, *Postmodern Culture* (London, Pluto Press, 1985); B. Wallis (ed.) *Rethinking Representation: Art After Modernism* (Boston, Godine and New York, New Museum of Contemporary Art, 1984); and Linda Nicholson, *Feminism/Postmodernism* (New York and London, Routledge, 1990).

8 S. Rubin Suleiman, 'Feminism and Postmodernism: A Question of Politics' in C. Jencks, *A Postmodern Reader*, pp. 318–32; B. Buchloh, 'Allegorical Procedures: Appropriation and Montage in Contemporary Art', *Artforum* XXI, 1 (September 1982), pp. 43–56; C. Owens 'The Discourse of Others: Feminists and Postmodernism' in H. Foster, *Postmodern Culture* (London, Pluto Press, 1985), pp. 57–82.

9 C. Owens, 'The Discourse of Others' and A. Huyssen 'Mapping the Postmodern' in Linda Nicholson, *Feminism/Postmodernism* (New York and London, Routledge, 1990), pp. 234–80.

10 Janet Sydney Kaplan, 'Varieties of Feminist Criticism' in G. Greene and C. Kahn (eds) *Making a Difference: Feminist Literary Criticism* (London and New York, Routledge, 1985), p. 56.

11 See J. Butler and J. W. Scott (eds), *Feminists Theorize the Political* (London and New York, Routledge, 1992) or Somer Brodribb, *Nothing Mat[t]ers: A Feminist Critique of Postmodernism* (Melbourne, Spinifex, 1992).

12 J. Kaplan, 'Varieties of Feminist Criticism' in G. Greene and C. Kahn (eds.), *Making a Difference*, p. 53.

13 J. Kaplan in G. Greene and C. Kahn (eds), *Making a Difference*, p. 49.

14 J. Kaplan in G. Greene and C. Kahn (eds), *Making a Difference*, p. 53.

15 R. Parker and G. Pollock, *Old Mistresses: Women, Art and Ideology* (London, Routledge, Kegan and Paul, 1981), pp. 8–9.

16 A. Kolodny, quoted in J. Kaplan, 'Varieties of Feminist Criticism' in G. Greene and C. Kahn (eds), *Making a Difference*, p. 54.

17 L. Lippard, 'Change and Criticism: Consistency and Small Minds' in *Changing: Essays in Art Criticism* (New York, Dutton, 1971), p. 33.

18 C. Battersby, *Gender and Genius* (London, Women's Press, 1989).

19 C. Battersby, 'Situating the Aesthetic: A Feminist Defence' in A. Benjamin and P. Osborne (eds), *Thinking Art: Beyond Traditional Aesthetics* (London, ICA, (Philosophical Forum), 1991), p. 42.

20 Linda S. Klinger, 'Where's the Artist? Feminist Practice and Post-Structuralist Theories of Authorship', *Art Journal* 50, 2 (summer 1991), pp. 39–47.

21 M. Schor, 'Patrilineage', *Art Journal* 50, 2 (summer 1991), pp. 58–63.

22 See Battersby's critique of Kantian aesthetics in C. Battersby, 'Situating the Aesthetic: A Feminist Defence' in A. Benjamin and P. Osborne (eds), *Thinking Art: Beyond Traditional Aesthetics* (London, ICA, (Philosophical Forum), 1991), pp. 31–44.

23 See G. Pollock, 'Painting, Feminism, History' in M. Barrett and A. Phillips, *Destabilizing Theory: Contemporary Feminist Debates* (Cambridge, Polity Press, 1992), pp. 138–76.

24 For critical discussion see N. O. Keohane, M. Z. Rosaldos and B. C. Gelpi, *Feminist Theory: A Critique of Ideology* (Brighton, Harvester, 1982).

25 Nancy F. Cott, 'Feminist Theory and Feminist Movements: the Past before us' in J. Mitchell and A. Oakley, *What is Feminism?* (1986), p. 59.

26 Nancy F. Cott, 'Feminist Theory' in J. Mitchell and A. Oakley, *What is Feminism?*, p. 59.

27 See L. Lippard, *From the Center: Feminist Essays on Women's Art* (New York, E. P. Dutton, 1976), pp. 15–27, 28–37, 139–48 and 'The Pink Glass Swan: Upward and Downward Mobility in the Art World' in J. Loeb, *Feminist Collage* (Columbia University, Teachers Press, 1979), pp. 103–14.

28 L. Lippard, *From the Center*, p. 141.

29 K. Deepwell, *Ten Decades: Careers of Ten Women Artists born 1897–1906* (Norwich, Norwich Gallery, NIAD, 1992); D. Cherry and J. Beckett, 'Sorties: Ways Out Behind the Veil of Representation', *Feminist Art News* 3, 4, pp. 3–5; G. Pollock, 'Feminism and Modernism' in R. Parker and G. Pollock, *Framing Feminism*, pp. 79–122.

30 G. Pollock, 'Feminism and Modernism' in R. Parker and G. Pollock, *Framing Feminism*, pp. 81–93.

31 G. Pollock, 'Feminism and Modernism' in R. Parker and G. Pollock, *Framing Feminism*, pp. 81–93.

Between theory
and practice

JANET WOLFF

The artist, the critic and the academic: feminism's problematic relationship with 'Theory'

I had intended to begin by stating that my hope for feminist art criticism in the 1990s is that we can go beyond the divisions and antagonisms of recent years, and in particular the opposition once set up between theory-based art practices (including the so-called 'scripto-visual' tradition) and humanist or celebratory image-making. I'm not sure, though, that it will be quite so easy. For one thing, there are problems in thinking in 'decades', though it has seemed useful to categorise seventies feminism as humanist (in its several variants), for example, and eighties feminism as post-structuralist and anti-humanist. But to identify new and perhaps dominant trends is not the same thing as to characterise a whole period by that trend. In any case, decades don't start and end where they should: the sixties didn't really begin until about 1963, and certainly continued well into the 1970s. The eighties started late, and spilled over into the early 1990s (which may be why we are only now (1994) talking about criticism 'into the nineties'). But the main point about such thinking is that it risks overlooking the important *continuities* from one decade to another, and thereby offering false resolutions to the difficulties and debates of an earlier period – issues which were, in fact, never quite resolved.

I should not have been surprised to find, then, that the 'eighties' issue of theory versus experience is not quite dead. This was made clear to me in two recent publications. The first was an essay by Griselda Pollock, in which she revives the issue by taking on the critics of 'the orthodoxy of scripto-visual work' (by implication, and often explicitly, Pollock herself), and defending once again the importance of a theory of representation in art criticism and art practice.[1] On the other side, and also, not entirely coincidentally, on the other side of the Atlantic, Cassandra Langer reviews in rather vicious terms an exhibition at the New Museum of Contemporary Art in New York in 1990 of Mary Kelly's work *Interim*, and especially the essays in the accompanying catalogue, including one by Griselda Pollock.[2] At a symposium organised in connection with the exhibition, she claims, many in the audience were 'revolted' by the emphasis on Kelly herself; the essays seem like 'recycled hybridizations of the postmodern linguistic left', which 'prop up a prevailing poststructural ideology'; the artist's presence in the work is 'controlling and manipulative'; and so on. Langer raises the old (eighties?) point about 'access' and elitism – who can understand Kelly or her

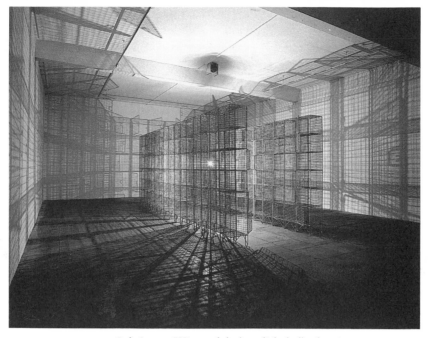

1 MONA HATOUM *Light Sentence.* Wire mesh lockers, light bulb, electric motor, 1992.
From the exhibition 'Four Rooms', held at the Serpentine Gallery, 7 May–6 June 1993

commentators? – and affirms the value of celebratory work of artists like Judy
Chicago and Miriam Schapiro against work which 'eliminates the possibility of expe-
rience from a woman's physical, bodily point of view'. This opposition is perceived
in national terms, moreover; Langer refers to the 'circle of British feminists' and to a
'strand of English feminist thinking'. There is something in this new fear, three
decades after the Beatles, of another 'British invasion', inasmuch as feminist art history
in North America has, more than feminist film studies and quite unlike feminist liter-
ary studies, been strongly influenced by work by British feminists.

Despite these texts, I do want to suggest that we can go beyond this opposi-
tion. To begin with, it's worth trying to sort out the different issues involved here.
What is sometimes presented as a single dichotomy in fact disguises a more complex
scenario, in which a range of binaries converges into one. Four of the primary opposi-
tions in play are: 'scripto-visual' work versus painting; deconstruction versus celebra-
tion; theory versus experience; elitism versus accessibility. Others, often also deployed
as if equivalent to these, include: theory versus practice, and postmodern versus
modern. In the first place, these are not even necessarily binary oppositions; for
example, there is no real reason why scripto-visual texts cannot employ painting
(though they have for the most part been photographic works). More importantly,
these are not at all the *same* oppositions. For example, painting does not ensure access-
ibility; not all theory is deconstructionist (or elitist); experience is not necessarily
manifest in painting; and so on. What happens, then, is a kind of slippage, as a result
of which a composite hardline case is made; against 'British feminism', for example.

This works both ways. Just as it is illegitimate to generalise about 'theory' and dismiss theory-based work and criticism out of hand, so it is a mistake to reject all 'humanist' work as identical in status, purpose and, importantly, context of reception.

I believe that the key question is the relationship between theory and feminism, as well as between feminist academic work and feminist art practice. Against the persistence of such oppositions. I would make three points. First, *there is no 'correct' feminist aesthetic.* This is something that Rita Felski has argued persuasively in relation to feminist literary criticism, with regard to questions of modernism and realism.[3] So there is nothing inherently wrong with (or, for that matter, necessarily good about) 'celebratory' art practices, which foreground experience and the body and portray these in positive ways. Although it is an absolutely crucial project for feminism to analyse such images and see how they work, to demonstrate, in particular, the *construction* of gender and of 'woman' in our culture, that is not always the immediate project. The question is what is at issue at a particular moment, and what is the appropriate strategy of cultural politics. In the case of women of colour, for example, there has necessarily been an important investment in the politics of the subject (the same has been said, by Nancy Miller and others, about women in general), in the face of a dominant culture which has traditionally not granted them subjectivity. Secondly, then, such practices (humanist, celebratory) are not necessarily essentialist: a common charge from the side of theory, by those committed to the decentring of the subject and to the demonstration of the production in representation of gender and identity. Rather, they may operate as the strategic and always provisional articulation of identity. And thirdly, theory-informed work (deconstruction, postmodern theory, post-structuralism) is not necessarily elitist; or rather, in so far as it may be difficult and address particular constituencies, it is relevant to ask who it is *for*. I would argue strongly against a false populism, which maintains that nobody should say anything unless everyone can understand it. Who is excluded may not be the point at all. It is important to acknowledge that it is a valuable project in its own right for artists and critics to engage with small communities of others in some cases in analytic and critical work. For similar reasons I would resist charges of classism, racism and heterosexism levelled at those engaged in the exploration and critique of the lives of white, middle-class, heterosexual women. Of course this focuses on only one group of women – and a group which has long been dominant. But unless its project is a universalising one, claiming to speak for or to all women, and as long as part of its project is the critique of its privilege, then it cannot be challenged on grounds of exclusion.

Why has feminism had an ambivalent relationship to theory? On the one hand, it is clear that theory is necessary if we are to produce a systematic understanding of gender inequality in our society. (*Which* theory or theories might be most useful has, of course, been a contested question at least since debates between Marxist–feminism, radical feminism and liberal feminism in the 1970s; these days, the question of 'theory' tends to be the issue of whether or not theories of representation are employed, loosely and generically referred to as 'post-structuralism'.) On the other hand, we also know that theory has traditionally been 'male'. Feminist philosophers and historians of science have shown that scientific theory and practice operate in

masculine ways, both institutionally through the exclusion of women from science and in terms of subject-matter, when funding and research interests have historically given priority to men's lives and ignored, for instance, the medical concerns of women. In addition, as Evelyn Fox Keller and, Susan Bordo have argued, there is a more integral connection between the practices of science (objectivity, distance, measurement) and the social construction of masculinity, which is itself founded, according to psychoanalytic theorists like Nancy Chodorow and Dorothy Dinnerstein, on separation and distance rather than relationality.[4] Cultural theory, too, has its gender biases – for example the way in which metaphors of *travel*, itself a highly gendered activity, work in critical studies.[5]

It has also been the case that feminism has found an important ally in the project of postmodernism which undertakes to challenge monolithic narratives of social theory, premised as they are on the white, male subject.[6] The critique of 'master narratives' opens up a space for the articulation of other, excluded subjectivities, including that of women. But this alliance produces its own ambivalence, since a position antithetical to theory undermines the basis of feminist critique. To argue for the partial and provisional nature of all accounts is to accept the same status for feminist theory. Inasmuch as this registers a commitment by feminists to remain alert to the exclusions of feminism itself (of women of colour, third-world women, lesbians), this has been crucial in recent years. But the consequent abandonment of a certain grounding for feminist critique has proved problematic to many of us.

I want to argue, then, for the importance of theory, despite the historical male-centredness and exclusions operating in its name. The importance, first, of theory in the most general sense, as *knowledge* – as giving an account of the social world and specifically its structuring around gender. The importance, too, of theory as *critique* – that is, as a more systematic analysis of how gender divisions have been constructed and maintained historically and in the present. And the importance of theory, lastly, when 'Theory' has a capital T – its most usual meaning in current debates in art criticism, signifying post-structuralist theories which investigate the cultural construction of gendered identity in language, representation (including visual representation) and psychic processes. But this does not mean that all art practice has to be 'theory-based' in this way. Art-as-theory (that is, cultural work which participates in the demystification and analysis of gender identity, and is committed to a certain self-reflexivity about the medium itself) is an extremely important feminist project. But it is not the only one.

I think a significant aspect of the resistance to theory has to do with the difficulty of much recent work. I have already argued against anti-elitism, which I find much too simplistic in its assumption that all work (written or visual texts) must be popular and accessible. But I also want to argue against obscurantism, which is unfortunately quite prevalent in contemporary theoretical work. Here it may be useful to talk about particular locations and readership. Although I also don't see any advantage in unnecessarily abstruse writing in academic contexts, I do think that writing for a narrow, academic audience is fine – in fact, critical advances depend on this level and depth of work. I am particularly resistant, though, to efforts to incorporate such

difficulty and complexity into journalism. Writing art criticism in the wider public sphere brings with it a commitment to clarity and accessibility. As always, it is a question of constituency and readership, and, in the case of art practice, of viewership. At a colloquium in Canada a couple of years ago, I heard an artist object to the increasingly rarefied nature of art criticism, and insist that any artist ought to be able to understand anything that was written about his/her work. I don't agree with this position, which ends in a ridiculous situation of figuring out the lowest common denominator. But I have a real sympathy with the view that critical writing, and here, of course, I am thinking of feminist art criticism, should not be exclusive and forbidding.

The academy, in all this, is a privileged space for the exploration of ideas, histories and inter-disciplinary projects. It is also a primary arena for education and the dissemination of such ideas. Of course, as we know, it is also privileged in the sense that most women do not work in the academy and very many women do not even pass through it. But I see no reason either for guilt about inhabiting this space, or for apologies for the marginal activities that go on there. It is one place amongst many in which the feminist project is carried out. But it is vital that it works in conjunction with feminist practice; with regard to art history and art criticism, in conjunction with feminist art practice. To that extent, what seems to be a growing tendency, at least in the United States, to separate studio from art history programmes is rather worrying. On the other hand, the growth of integrated critical art studies programmes, both in North America and in Britain, is more encouraging. For although there is no cause for guilt and apology, neither is there reason for a sense of superiority. Academic work is productive in relation to art practice, at the same time as it is parasitic on it.

I hope, therefore, that we will continue to see a real collaboration between the feminist artist, critic and academic. In some cases these may in fact be the same person, since, for example, feminist academics also write criticism for journals and newspapers. It is a mistake to set up Theory as inimical to feminism in general and feminist art practice and criticism in particular. Although, as Barbara Ehrenreich has pointed out, there are certainly dangers inherent in the academicisation of feminism, to the extent that this becomes a self-sufficient and self-serving practice,[7] there is also a crucial need for intellectual work, in the academy and outside, which is grounded in practice and the object. Given the marvellous proliferation of diverse work by women artists and the establishment of feminist art studies in education, if we can abandon the obsolete battle about theory this will prove to be an exciting moment for feminist art criticism.

Notes

1 Griselda Pollock, 'Painting, feminism, history', in Michèle Barrett and Anne Phillips (eds), *Destabilizing Theory: Contemporary Feminist Debates* (Cambridge, Polity Press, 1992).
2 Cassandra Langer, 'Mary Kelly's *Interim*', *Women's Art Journal*, spring/summer 1992.

3 Rita Felski, *Beyond Feminist Aesthetics; Feminist Literature and Social Change* (Cambridge, Mass., Harvard University Press, 1989), especially chapter 5.

4 Susan Bordo, 'Feminist scepticism and the "maleness" of philosophy', *The Journal of Philosophy* 85, 11, 1988; Evelyn Fox Keller, *Reflections on Gender and Science* (New Haven, Yale University Press, 1985); Nancy Chodorow, *The Reproduction of Mothering: Psychoanalysis and the Sociology of Gender* (Berkeley, University of California Press, 1978); Dorothy Dinnerstein, *The Mermaid and the Minotaur* (New York, Harper & Row, 1976).

5 See my article 'On the road again: metaphors of travel in cultural criticism', *Cultural Studies*, 7, 2, 1993, pp. 224–39.

6 See Craig Owens, 'The discourse of others: feminists and postmodernism', in Hal Foster (ed.), *The Anti-Aesthetic: Essays on Postmodern Culture* (Port Townsend, Washington, Bay Press, 1983), pp. 57–77.

7 Barbara Ehrenreich, 'The professional–managerial class revisited' in Bruce Robbins (ed.), *Intellectuals: Aesthetics, Politics, Academics* (Minneapolis, University of Minnesota Press, 1990), pp. 173–85.

Preaching to the converted?
Feminist art publishing in the 1980s

Despite media shrieks of post-feminism and the death of feminism, feminist art crit-
icism has survived into the nineties. In fact, in the late eighties, at the height of pre-
dictions of feminism's demise, there was a flurry of feminist art publications and so
far the nineties has continued the trend.

 For the purposes of this article, I am defining feminist art criticism as all
writing about art — history, journalism, theory — that is informed by a belief that the
interaction of women with the world of art in all its guises — education, practice and
galleries — is different from the interaction of men with that world, for the simple
reason that the world of art operates on the assumption that the norm is male.

 Feminist art criticism's habitat includes books published by small, radical,
academic or feminist publishing houses; academic art journals with an interest in
the 'new art history'; catalogues of exhibitions by women artists; specialist journals
focusing on women and art; and magazines with a feminist slant on an assortment
of areas and issues including the arts. Less frequently, feminist art criticism can be
sighted in the mainstream, which it enters via a fitful trickle of books from the
major publishing houses. Reviews of books and exhibitions of women artists'
work, articles about contemporary feminist artists or women artists of the past on
the feature or women's pages of the serious newspapers also contribute to its vis-
ibility.

 For a subject supposed to be in its death throes, it seems to have done pretty
well for itself. So why do I feel uneasy? It is because however satisfactory the situation
of feminist art criticism appears on the surface, it is still confined to a ghetto of the
converted. The situation is fine for those who know their way around the subject, and
not bad for those who know a bit and think they would like to know more. But it is
difficult to imagine how someone ignorant of the stimulating attitudes and
approaches of feminist art writing could ever come across them by chance. Handsome
but pricey art books from mainstream publishers and books from small publishers
without the prestige to get their portion of shelf space in the branch of W. H. Smith,
which is often the only bookshop in town, do not make for satisfactory accessibility.
It seems particularly distressing that just as the national curriculum has acknowledged
the existence of women artists, schools under local management are being run increas-
ingly on business lines. Art teachers are desperate for books about women artists, but
schools accounting for every penny must weigh the merits of general interest books

against required texts. The current national parsimony towards local government has meant that central library holdings for schools have been cut or else offered as packages for schools to buy into, which comes to the same thing. And it is no use students turning to public libraries, whose book budgets and opening hours have shrunk in the 1980s and early 1990s.

Art journalism is not much better at spreading the word. It is true that the exhibitions of the work of Georgia O'Keefe (Hayward Gallery, 1993) and Angelica Kauffmann (Brighton Museum and Art Gallery, 1992–93) were covered by the national press, but then, since these were major public gallery shows, it would have been peculiar had they not been. And while many readers were surprised and impressed to learn about these major women artists, most of the information they received was not informed by a feminist perspective. In the case of O'Keefe, all sorts of intriguing questions about her place in a programme to develop a specifically American art (rare for women artists until the nineteenth century and not common in the twentieth) or the reasons for her American status as an ikon, were ignored in favour of spurious debates between male and female journalists of the 'how good was she really?' variety. Male artists, too, are slotted into a hierarchy of greatness and originality and awarded marks for their place on the scale, but they do not have to carry the weight of responsibility for the artistic ability of the whole of their sex, which is the unspoken text of all these debates about women artists. Nevertheless, some feminist points slipped through. But when the exhibition is of a man's work, feminist comments are unheard. After visiting the Tate Gallery's Richard Hamilton exhibition in 1992, I waited with interest for the critics of the national press and weekly journals to comment on the disturbing sequences of paintings centred on women and cars, women and consumer goods, women and cosmetics. I waited in vain, of course. But it was equally pointless to look for a feminist critique in the academic journals, since they habitually ignore exhibitions of contemporary work, or in the feminist magazines, which understandably concentrate their resources on reviewing works by women artists.

Language is another barrier which prevents feminist art criticism reaching a wider audience. Much feminist art writing comes from academics and is couched in a language which many who are interested in the topic of women and art find opaque. Feminist book reviews in the journal *Art History* are like reading a foreign language, the language of academia, to be precise. On the other hand, the language of the less academic feminist art magazines can seem so simple that many readers, female as well as male, regard the points made, often unfairly, as the equivalent of supermarket chat. The issue here is not whether it is true that complex ideas demand a complex vocabulary, but whether the use of this language hinders outsiders' access to ideas they might find exciting. In winter 1992, this feminist in-house controversy over language surfaced in the mainstream in an article in *Modern Painters* attacking the opacity of feminist writing. Two issues later, the language was defended, not, it must be said, by any particularly convincing reasoning, but by supporting the research of one of the writers whose language had been pilloried. Although it was irritating that some interesting feminist ideas had to wait for an

attack to reach a wider audience, I'm sure the result was to make as many converts as to fuel existing prejudices.

The important question for feminist art writing in the nineties is whether it can break through the glass ceiling into the larger world of general art criticism. If you believe as I do that feminist art criticism asks stimulating questions of art history and artistic practices, then you want to see it challenging the lazy received ideas mouthed by the mainstream art world. Its ability to do this depends on the publishers' conviction that feminist writing about art is no longer a fringe affair. However important it may be to its makers and followers, in the eyes of the mainstream publishing industry it is a slightly mad and misguided minority interest where perhaps a few scholars have made their mark. Though feminist art criticism has changed the face of the art world, though the ideas and findings of its practitioners have permeated the most chauvinist institutions, though it has a constituency of academics, students, artists and the just plain interested, though it has – just – touched the national curriculum with its fingertips, although, in short, it does not exist in a vacuum, it is not uncommon for people in publishing to feel that feminist art criticism has made only a little dent in the smooth, smug surface of the art world. From their point of view, feminist art books represent a small subsection in the field of art publishing.

The small presses with feminist sympathies which in the eighties invested their time, conviction and cash and acted as the research and development arm of the publishing industry put feminist art criticism, feminist aesthetic theory and feminist art history on the map. By giving status to feminist art criticism by producing it in book form, they raised the consciousness of the mainstream publishers, some of whom began to feel it would be safe to venture into this area. Inevitably, however, this aura of the fringe still clings to some publishers' perceptions of feminist art writing.

Bias is another perception, one which frustratingly stems from feminism's honesty in showing its hand. This honesty makes feminist writers vulnerable to accusations of special pleading from those who, by denying they have a position, pretend to be disinterested and value-free. Since all historians know that the answers you get are related to the questions you ask, I find such naivety bewildering. All kinds of art historians had access to nineteenth-century art academy records and regulations but it was only because Linda Nochlin was interested in women's history that she searched them for an answer to the question 'Why have there been no great women artists?'. Her findings are now engraved on art history's tablets of stone.

The priorities of publishing also affect what gets produced. All publishers have to make money, not just the commercial publishers but academic presses too. Sometimes belief in a book's importance will lead them to subsidise its inability to cover its costs with the proceeds from better-selling books on their list, but publishing companies are not charities. The process is equally risky for publishers of all sizes. The giants have ambitious sales figures which feminist books – a 'minority' subject – must reach, while small firms find the combination of production costs and small print runs results in books priced too high for their market. Producing an art book with its complicated layout, need for decent illustrations and reproduction fees is

expensive, and it can happen that the small companies most sympathetic to feminist subjects are those with least cash to play with. Small publishers are frequently jugglers, catching money from book sales in one hand and then throwing it to the other in order to pay the printer's bill. That is why books of theory or anthologies of articles with just a handful of black and white illustrations are so appealing to small presses.

Authors' horror tales of the difficulties in getting published stem from the simple fact that the publisher's agenda is not theirs. All publishers want a good idea but there is often a difference between what the potential author thinks is a good idea and what the publisher or agent think it is. Put baldly, if it won't sell, it isn't. Agents and commissioning editors can sometimes seem like censors, but whatever their personal sympathies, support for feminism is an irrelevance to someone who has to argue for a book's viability at a finance meeting. Big names attached to either the author or the artist help get an idea taken seriously, as does a subject's sales track record. One reason that there have been several books on the female Impressionists and the women of the Pre-Raphaelite circle is that they have proved to sell. An appealing pre-production package is necessary to attract co-publishers to cut costs and build advance sales. A book that is too insular is not a good bet for sales overseas. I suspect that mainstream publishers see books dealing with the nude, gender and relationships as a safe way to dip their toes into the feminist stream; the subject, signalled by the title, is an alluring wrapping for the awkward questioning inside the covers.

All of this assumes that there are hundreds of books waiting to get into print. But how realistic is this? It takes a long time to write a book. A *catalogue raisonné* or a monograph takes several years of research and writing and women artists do not usually attract such devotion. Writers may not be convinced that enough will be found on their chosen woman artist to warrant their investment of time, money and reputation. The Ph.D. student may find her enthusiasm waning when years of digging into the archives fails to reveal the vein of gold. One reason that collections of essays are published is that they are quick to assemble. They can also deal with topical issues.

The glass ceiling will be breached if the major publishers decide there is a growing market for feminist art writing. The nineties opened hopefully with Whitney Chadwick's *Women, Art and Society*, Thames and Hudson's feminist answer to Gombrich's *Story of Art*. Thanks to the efficient economics of the company's production and marketing format, this generously illustrated book is published at an affordable price no small press with a print run of two thousand could hope to match.

Whether the trickle of feminist art books will continue to increase only time and the sales figures of the books in print will tell. An unknown factor is whether feminist art criticism can follow feminist literary criticism and lose its niche marketing tag. While publishers' catalogues show that the latter's adoption by literature courses in the English-speaking West has made feminist literary criticism a safe subject, this is not the case with feminist art criticism. The catalogues for Oxford University Press for the first half of 1993, for example, list no feminist art books. Instead the *Oxford Art Journal* is offered, a less expensive and more comprehensive way

for the publisher to appeal to art historians of assorted radical persuasions. The Government's attempt to encourage science students by cutting university funding for the arts and humanities may also discourage the production of art books.

The fear that a feminist art book will not generate enough sales to cover its production costs will result in publishers playing it safe. Publishers who are only too happy to bring out six books on Impressionism will point to their one book of feminist art as evidence of having 'done' the subject. Much-needed overviews of recent work by feminist artists will be seen as too costly for the small presses and too limited for the big ones. Publishers may minimise the risks by deciding to aim for as wide a market as possible, a path which points to biographies of female giants like Cassatt and O'Keefe, preferably with unruly private lives. Feminist becomes neutralised to female and the subject-matter becomes less specialised. Since I believe that the more work by women that is made accessible, the better, this is not necessarily a bad thing, but it should be understood that it is not necessarily a feminist approach that is being offered.

If the big publishers tone down feminist to women, the small publishers may find an empty niche to fill – that of feminist art criticism. There is much critical work going on in France and Germany which requires belief in its importance before money is paid out for translations. To produce feminist art books publishers need cash, business sense, knowledge, courage and commitment, not necessarily all of them at once but some of them in a variety of permutations. The books that result should range from sparsely illustrated theory, through challenging polemic and academic art history, to something infinitely more glamorous and no doubt ideologically impure. We need them all and I hope we get them.

GILANE TAWADROS

The Sphinx contemplating Napoleon: black women artists in Britain

In 1987, Stuart Hall (Professor of Sociology at the Open University) speaking at a conference seductively entitled 'The Real Me' addressed the question of postmodernism and identity. Hall commented that one of the things which he found fascinating about current debates about identity was that he found himself centred at last: 'Now that in the postmodern age, you all feel so dispersed', he said, 'I become centred. What I've thought of as dispersed and fragmented comes, paradoxically, to be *the* representative modern experience.'[1] The experience which Hall was talking about was the experience of the Black diaspora. According to Hall, it has become the representative modern experience, in so far as the discourse of postmodernism, rather than producing anything new, has made possible a general recognition of where identity was always at; namely that identity is something defined in relation to a whole set of other narratives, *narratives of history* and *of a culture*. This book is not exclusively dedicated to a discussion either of identity or of postmodernism. However, it does address particular historical narratives and particular producers of visual culture: women artists. The fact that they are being discussed here, I would argue, also suggests the increasing centrality of female identification in the narratives of Western history and the production of Western visual culture. We too are finding ourselves centred at last.

I will argue here that this is precisely the position in which many Black women artists in Britain have found themselves in recent years, but it also suggests that in the process of becoming centred (and I use the phrase advisedly), the work of many of these artists has instigated both openings *and* closures in the historiography of art in Britain and in theoretical writings around Black arts as a defined area of artistic practice.

The work of a number of black women artists has brought issues of race and gender into the central frame of artistic production and aesthetic discourse in Britain and contested Eurocentric notions of history, identity and sexuality. It is important to note that these artists position themselves not on the periphery of Western art and art history but at its very core. They do this by articulating the contingencies of ambivalent identities, discontinous but intertwined histories and the diasporan experience against the grain of the prevalent historiography which privileges notions of fixed, exclusive identities and linear, progressive histories.

It is significant that for many of these artists history is not something which lies out there in dusty academic tomes, buried beneath the weight of the past. Rather, like the designs which paper our walls, the pre-existing frame of history is conceived of as something which envelops our everyday life. In other words, history's designs decorate our present and it is those designs – in every sense of the word – which the artist Sonia Boyce appropriated and transformed in an early work entitled *Lay Back, Keep Quiet and Think of What Made Britain so Great* (1986) (Figure 2). The black woman who stares out at us from the final panel – a self-portrait of the artist herself – suggests that this English rose, as woman or as identity, inherits a history of resistance as well as a history of oppression, that is, separate histories but ones which are locked together inextricably. Boyce is saying something else too about history. Into the four panels of her work are inscribed the words: Mission – Missionary – Missionary Position – Changing. These are not fixed words, but subtly shifting words which incline, slowly bending with the bough of the black rose. Like language, Boyce seems to suggest, history and historical relationships are subject to change from *within* the very frame of representation.

Artists like Boyce have articulated other histories and positions of difference within the dominant cultural and epistemological frame and they have deconstructed Western historical narratives within the very frame of representation. In epistemological terms, notions of ambivalence and difference are central to this process of deconstructing history and identity in so far as they stand in stark contrast to the nineteenth-century Western impulse to index, tabulate and define things in terms of fixed, immutable and neatly-delineated categories, while in material terms, aesthetic strategies such as collage and bricolage are used by these artists to contest the apparently seamless, linear and unifying logic of Western visual culture.

2 SONIA BOYCE *Lay Back, Keep Quiet and Think of What Made Britain so Great.*
Charcoal, pastel and watercolour on paper, 1986, 152.5 cm × 65 cm each panel

But deconstruction is a dangerous business for artists and academics alike, not least of all for Black artists and academics in Britain. It seems to me that in the late 1980s and early 1990s we have reached a critical watershed in Britain after a decade of prolific artistic production and theoretical debate. The factors which have brought artists to this watershed are slightly different to those which face academics and writers, although in both cases they are of course interrelated. Let me look at the artists first of all. It is important to begin by noting the cultural environment in which many of these artists found themselves when they graduated from art school in the late 1970s and early 1980s. The struggle to be seen and heard had then to be waged not only in the context of predominantly white art institutions but also in the nascent and male-dominated Black arts movement where a didactic and often polemical type of visual arts practice seemed to prevail. The process of moving from silence to speech, of 'talking back', in the words of bell hooks, was not simply one of visibility and speech in and of itself but also a process of finding an appropriate visual language and aesthetic strategies with which to picture notions of ambivalance and difference and conceptions of history and identity which came out of the experience of the diaspora (in all its permutations) in late twentieth-century Britain.[2] This is a process which takes space and time, something which was denied many of these artists as demands for them to exhibit their work and to produce new work increased. The burden of representation has exacted a heavy penalty. Not only have these artists been compelled to speak on behalf of an imagined, homogeneous community of black women and men, but they have consistently lacked the space, both financial and intellectual, to resolve aesthetic and conceptual problems and to continue developing their work over time in new and different directions.

In the meantime, writers and critics have been searching for an appropriate language with which first of all to *describe* and then to *critique* the various and varied interventions being made by Black artists in the arena of British visual culture. Like the process of unravelling the Sphinx's riddle, the process of deconstruction and critical analysis proffers a tacit prize, that of resolution, of a single answer which will sweep away the debris of established discourses and hegemonic narratives to reveal an underlying universal truth. The seductive and compelling nature of this prize harbours particular dangers for those of us who have been, and still are, searching for an adequate critical language with which to articulate the ideas contained within the work of contemporary Black artists.

As the sociologist and cultural historian Paul Gilroy has pointed out, the value of the term diaspora and its symbolic character resides precisely in the fact that it dispenses not only with the universalising and transcendental claims of the 'grand narratives' of Western culture, but equally with the notion of 'a pure, uncontaminated or essential blackness anchored in an originary moment'.[3] The implications of this for critical writing which addresses itself to the cultural production of artists in the diaspora are that it must articulate the ways in which these artists displace and contest those grand narratives without, in the process, inventing an alternative, totalising 'grand narrative' which is equally fixed and exclusive.

Then there is the problem of what it actually means to 'become centred'. Does it mean that the artistic production of Black artists and the contingent critical language which is formulated to describe it have quite literally entered the central frame of Western representation and systems of knowledge? Or does it mean, that within the logic of late twentieth-century Western discourse, all positions of difference – whether sexual, political, racial or cultural – have simply become subsumed under what Nelly Richard has described as a 'new economy of sameness' which continues to be administered from the centre?[4] Or alternatively, perhaps the politics of difference in terms both of visual representation and of critical writing *has* indeed become centred and in the process has effected its own closure, a sort of discursive full stop which we have written into our own argument with Western historiography?

For now, let us assume, as Stuart Hall maintains, that every full stop is provisional and that what we are engaged in represents what he calls an 'unfinished closure'.[5] The fact remains that we are all acutely aware that these artistic practices and critical debates can only take place *within* the parameters of the mainstream, Western cultural politics, but, to the same extent, we are aware that they cannot be delimited or prescribed by established aesthetic practices or hegemonic discourses.

This leads me to the fundamental question of language, and by language I mean here both the terminology we use and the ends to which we use a given set of terms. We have, in recent years, become accustomed to using a kind of critical shorthand which has led us to talk about 'the margins' and 'the periphery' as a position diametrically opposed to the 'centre'; we talk about 'blackness' in antithesis to 'whiteness'. We do this, as Kobena Mercer has said, at the same time as we reject the dichotomies and binarisms which inform Western culture.[6] In the process, we risk falling headlong into what is perhaps the greatest pitfall of all, that of constructing from the politics of difference, ambivalence and the experience of the diaspora yet another unassailable fortress which will be absorbed into the canon of Western art and the historiography of art.

I want to end, not with a resolution to these problems or even some tentative answers, but rather with some adjectival thoughts . . . I want to recall the words inscribed into Sonia Boyce's work *Lay Back, Keep Quiet* . . . (Mission – Missionary – Missionary Position – Changing) and the notion that history and historical narratives, like language itself, are subject to change from *within* the very frame of representation. The implications of this notion, I believe, are twofold. First of all, it suggests that we must embrace the dynamic of change (as distinct from progress or evolution) as an intrinsic part of our critical armour, accepting that what we say at this particular point in time and from this particular place is provisional – not fixed, unalterable or exclusive. Secondly, it emphasises that this dynamic of change takes place *within* the frame of representation. In other words, it is the visual practice and its aesthetic, cultural and epistemological frame which should mould our critical language. I want to finish by quoting from the Russian philosopher Mikhail Bakhtin and his thoughts on the struggle in language which seem particularly pertinent:

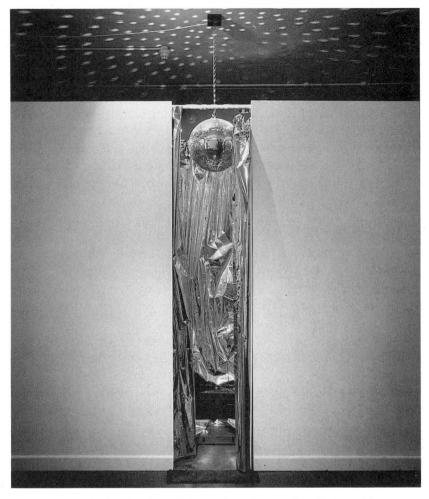

3 SONIA BOYCE *Is it Love that you're After, or Just a Good Time?* Installation,
Ikon Gallery, Birmingham, 1992

The word in language is half someone else's. It becomes 'one's own' only when the
speaker appropriates the word adapting it to his own semantic and expressive inten-
tion. Prior to this moment of appropriation the word does not exist in a neutral or
impersonal language . . . but rather exists in other people's mouths, serving other
people's intentions: it is from there that one must take the word and make it one's
own.[7]

Notes

1 Stuart Hall, 'Minimal Selves', *Identity: The Real Me*, ICA Documents 6 (London, Institute of
Contemporary Arts, 1987), p. 45.

2 bell hooks, *Talking Back*, (London, Sheba Feminist Publishers, 1989).

3 Paul Gilroy, 'Cruciality and the Frog's Perspective: An Agenda of difficulties for the Black Arts Movement in Britain', *Third Text*, 5, autumn/winter 1988/89, p. 35.

4 Nelly Richard, 'Postmodernism and the Periphery', *Third Text*, 2, winter 1987/88, p. 11.

5 Stuart Hall, 'Minimal Selves', p. 45.

6 Kobena Mercer, 'Black Art and the Burden of Representation', *Third Text*, 10, spring 1990.

7 Mikhail Bahktin, 'Discourse in the Novel', *The Dialogic Imagination* (Texas, University of Texas, [1934–35] 1981), pp. 293–4.

Reading between the lines: the imprinted spaces of Sutapa Biswas

Prelude: the summer of 1991

For two weeks in May I travelled around the coast of England, Scotland, Wales and Ireland in a cruise boat. My ticket had been bought for me by a woman of eighty-five, my mother's dearest friend, and one of mine, too, who wanted to travel in comfort while showing me British medieval castles, and eighteenth-century to modern homes, estates and gardens.

I discovered abruptly when we joined the cruise that the boat's passengers were exclusively white, mostly in their seventies and eighties; that its staff of stewards, stewardesses, waiters and rank-and-file sailors were all from the Philippines; and that the ship's ranking officers were Scandinavian and German. During the next two weeks I oscillated between gratitude to my friend for her generosity, curiosity about the cultural meanings of the sites we visited, and political shock. I felt as if I was on a boat in the last days of the Empire. But, equally, I was confronted with contemporary international versions of colonialism.

I have never worked through the implications of my personal and emotional relationship to Britain's colonial past. Given the particularities of my upbringing and my way of living in America it was not until this cruise that I had ever been so literally, intimately and personally confined within such a classic colonial experience. My parents were left-wing and anti-colonialist, and I attended a highly progressive school with an international student body. I later studied at the London School of Economics, and then left for America where I now live in a culturally diverse community. After the cruise I returned to London and there – obsessively, and in hindsight surprisingly unconscious of its impulses – began to immerse myself for the first time in the history of the cultural exploits of the British Empire. I purchased *The Raj: India and the British, 1600–1947*, a catalogue of a huge exhibition at the National Portrait Gallery in London in 1990. I went to the Victoria and Albert Museum – a few days before I had seen Edward Said on English television remarking that 'museums are the archives of the Empire' – and saw its famous Indian collection, which had begun to be assembled in the eighteenth century, the days of the *de facto* rule of Bengal by the English East India Company. I also went to the British Museum, another 'Empire archive', to see an exhibition of Benin sculpture, much of it taken from Nigeria after the British

sacked Lagos, the Benin capital, in 1897, killing many of its inhabitants. Bringing Benin art to England was part of a systematic attempt to subvert a political and cultural revival in the Benin kingdom. Surely there is a parallel to this in Indian history? I went from museum to museum, bookstore to bookstore, reading a mixture of art, political and cultural history texts.

It was during this intense time (I was still staying with my eighty-five-year-old friend) that I spent an illuminating afternoon with Sutapa Biswas. We sat for hours in an English pub talking about the Empire, India, history, culture, race, and gender; and we talked, too, about what we were doing in our respective work. Biswas had grown increasingly impatient with the relentless stream of publications on the cultural and artistic impact of colonialism on India, regardless of the often politically correct tone of the authors. A year ago (1990) she received a grant to research the influence of Indian art on the West. She is now conceptualising an exhibition that may include loans from the Victoria and Albert Museum's Indian collection. We talked about cultural cross-currents, cultural exchanges and multiple cultural identities and homes, as well as cultural imperialism and post-colonialism. In many ways we continued a conversation that had started when we first met in the fall of 1990 when Biswas participated in the 'Disputed Identities' exhibition held at Camerawork, a San Francisco gallery.

The 'colonial' boat experience continued to haunt me after I returned to the USA. It dramatically brings forth, like some giant visual allegory, the albatross

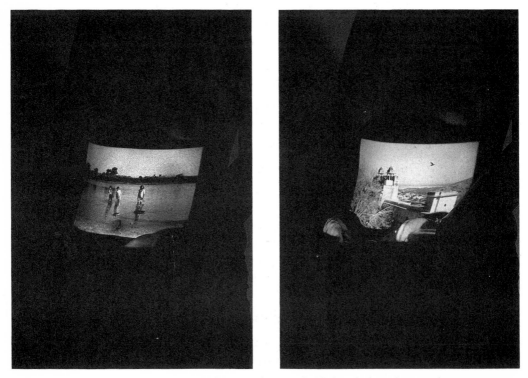

4, 5 SUTAPA BISWAS *Synapse I* (Nos 1 and 5 images). Black and white photographs, 1992

of the colonial heritage of my own culture. In a recent phone conversation with Biswas, she spoke about synapse as a metaphor for this Canadian exhibition and laughed as she amplified it, 'In other words, undefined territory'. Perhaps the experiences of looking and thinking about Biswas's work and the process of this diary-like essay combined with the 'memory' images of the colonial-cruise episode, will encourage new impulses to be transmitted in this undefined, unruly terrain of multiple cultural identities which I inhabit more and more by choice.

I realise that this is the first extensive piece of writing I have embarked on – the metaphor of a journey is most apt – since my visit to England. An interesting coincidence that it should be about Biswas.

30 September 1991, Berkeley, California

Synapse series photographs (eight out of the series' twelve) came Federal Express a few days ago from England together with a package of slides and texts. Biswas is so complex and layered an artist that I think it might be easier, even reassuring, for me first to immerse myself in these texts written by her and writings on her rather than in looking. I might read them to find a theoretical context for my looking, in order to avoid cultural and political pitfalls in my essay. By reading the texts, I might begin to wrestle with the recent bombardment of theory (in anthropology, literature, and cultural and art studies) that takes on questions of cultural difference, colonialism,

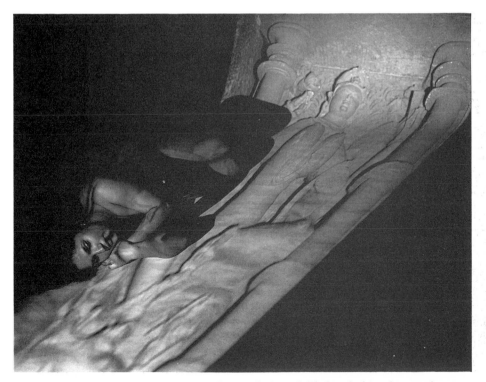

6 SUTAPA BISWAS *Synapse II* (No. 1 of 2 images). Black and white photograph, 1992

imperialism and post-colonialism. I might begin by studying Biswas's art in terms of concepts of representation and artistic practices in England and India, postmodernist and deconstructive strategies, distinctions between foregrounding and subtexts, the concept of 'the other', and the notion of the woman's body as a site of cultural discourse. Instead, I have elected to begin this encounter with Biswas — which I hope will become a conversation — by recording my immediate responses to the *Synapse* series photographs.

In some of the *Synapse* series photographs a nude woman 'holds' memory images: these are projected slides supported or cradled by her hands, or resting upright against her bare stomach. They are of people standing in water, edifices in a landscape, scaffolded façade of a building and fragments of figurative sculpture. In other photographs, the woman herself is 'held' by similar images. In one she lies curled up on her side, with her cheek resting on her hands, her eyes open. She reclines on a strangely slanted stone bed, a sculptured female figure at her feet. Is she showing or displaying these memory images to us? Protecting them with her own body? Being protected by them? How does memory work here, and how shall I read these images of a woman and her world? Is this the world of 'a woman', of 'Woman', or of Sutapa Biswas? Of an Indian woman in an Indian world, or an abstract portrait of human presence in a world of nature and art?

Some of Biswas's images remind me of x-rays. Such exposure both on and of the body evokes the vulnerability of a woman in a hospital examination, and the possible disclosures that may result from such an investigation.

Perhaps most apparent of all in the series is the sense of a constantly shifting terrain of the body, of the landscape, of the buildings, of the art and of memories. Restful and restless multiple perspectives.

As I reflect on these representations of a woman crossing and exploring space and time, the words *dream, beauty* and *home* keep recurring in my mind.

In my *Oxford American Dictionary* I find this definition: *dream n.* 1 a series of pictures or events in a sleeping person's mind. 2 the state of mind of one dreaming or daydreaming, *goes around in a dream.* 3 an ambition, an ideal. 4 a beautiful person or thing.

To speak of beauty in art seems almost forbidden these days, yet Biswas's art *is* beautiful. There are, however, so many loaded cultural readings in viewing beauty: for example, the woman's body as object of desire, the alienating and racist history of Oriental exoticism, and the voyeurism of the 'male gaze' in so much Western art. It is not accidental that Biswas's work allows us a sense of pleasure but simultaneously reminds us of our boundaries; there is an edge to the work, a treading of a fine line. Since cultural discourse has tested the parameters of Eurocentric art history, one must now consider these issues within an international framework: a synthesis of a transcultural experience. This is the space in which Biswas lives and makes her art.

The title for my essay, 'Reading Between the Lines: The Imprinted Spaces of Sutapa Biswas', came to me yesterday while she and I were talking long-distance on the phone about the nature of exile and home. Since she was three

and a half years old, she has lived in England, not India where she was born in 1962. I, on the other hand, who was born in England in 1933, have now lived in North America since my early twenties. We both locate ourselves in dual cultural homes. We both work out of a passion to deal with issues that are transcultural. For me, Biswas's recent art and thinking provides a liberating space at arms length from certain prevalent theoretical constructs in contemporary discourse, despite her most sophisticated awareness not only of their existence but also of their impact on her.

1 October 1991

Today I have looked for the first time at Biswas's own typed statement about the proposed exhibition. About the title, *Synapse*, she explains: 'This in medical terms is the anatomical relation of one nerve cell with another, the junction at which a nerve impulse is transferred, which is affected at various points by contact of their branching processes. The state of shrinkage or relaxation at these points (synapses) is supposed in some cases to determine the readiness with which a nervous impulse is transmitted from one part of the nervous system to another.' Biswas's recurring fascination with scientific and medical terminology is connected to her general interest in the technological world. Interestingly, her brothers and sisters are all research scientists.

In her text there is a striking use of nouns and verbs about exchanges, conjunctions, proximities, and shifts from one system to the next in her text. Perhaps most interesting to me is the idea of 'shrinkage or relaxation' as the synapse points, which may determine the readiness of the transmission of impulses from one system to the next.

Biswas stresses 'the notion of synapse as a metaphor for the human condition with particular reference to the experience of memory. Synapse here is symbolic of an undefined territory or space. Memory is itself of a shifting nature, vivid in places, with blind spots. Desire becomes an important element in this process. Sometimes connected to real experience, conceptually it is an imagined space or territory.' She goes on to speculate on the work's 'complex dialogue between "real" and "imagined" spaces'.

Memory and desire. Undefined territory/space. The real and the imagined.

How is memory transferred? What contacts are made in memory between 'real' and 'imagined' spaces? In the *Synapse* installation, Biswas creates an in-between zone, a space inhabited by a woman on whose body are imprinted memory images. Hers are of India, and any visitor to the exhibition space will surely think of India. But while in her world, her visitors may also speculate about theirs. Her work may make us think of our own relationships to memory and desire, about the processes in the triggering, transferring and transforming of our memories.

I am increasingly immersed in the effect of Biswas's metaphors on me. I am drawn to the process of 'journey' in her work, and the placing and mapping of

the fragments of her memories. It is becoming a balancing act to write on Biswas and yet also locate myself within all this.

Biswas has been influenced by early Indian miniature paintings, and by eighteenth- and nineteenth-century Indian religious maps of sites and landscape, which contain detailed drawings of the profiles of temple buildings and their surroundings inhabited by small figures and animals.

At this moment in the process, she envisions a component of 'mapping'; she likens the tracing of maps to the tracing of memories. She writes that 'like notations in a diary, I may install an aerial-like view of an incomplete map, landscape-like. A topographical relationship is important to the notion of memory in that, likewise, memories occupy a sense of landscape'.

In my mind's eye I imagine an aerial view that can provide an overall sense of these landscapes of memory and desire. How does one learn to fly over them, to survey them from above? (When I showed a draft of this essay to Lucy Lippard, she said it reminded her of the ancient Peruvian Nazca earth patterns, which are most readable from the air, and also of Shaker inspirational drawings.)

Biswas ends her speculations by writing that 'the themes of migration, separation and displacement which echo throughout are not straightforward equations but are, in fact, delineated by repeated conflicts, between near and far, intimacy and estrangement, integration and alienation and between pleasure and pain'.

Migrate v. 1 to leave one place and settle in another. 2 (of animals, birds) to go periodically from one place to another, living in each place for part of a year.

2 October 1991

Today I am rereading a special issue of the quarterly publication *SF Camerawork* devoted to the 'Disputed Identities' exhibition, and discussing its rich range of American and English work. In her essay 'What Are We Doing Here? Cultural Difference in Photographic Theory and Practice', Judith Wilson quotes from a statement by Biswas: 'I want people to research into my culture, as I've been doing into European and Western culture.'[1]

This brings up the whole notion of 'cultural homework', a task for the critic writing across cultures.

The package Biswas has sent me contains notes from an unpublished 1990 autobiographical essay. In 1981, at the age of eighteen, she began to study art at Leeds University. In its theory-based programme she encountered the art of Artemisia Gentileschi, Edward Hopper and Robert Rauschenberg, amongst others. She was drawn also to notions of European and American art/life theories of the 1960s and 1970s and to early performance history. The ideas of the European Situationists attracted her: that lively, contentious, anarchistic and loosely structured international group that emerged in the late 1950s and was officially dissolved in 1972. Equally, she studied the Happenings movement, and was especially intrigued with Claes Oldenburg's events. At a certain point, she experimented with performance work herself. Twice she presented *Kali* (1984–85) to a single invited instructor at the college.

Each watched, head hooded, and seated in a chair around which a circle had been painted on the floor, demarcating his/her territory. Each was enveloped by a blend of masks, puppets – life-size and miniature – and taped languages, Bengali and Bantu. For Biswas (and, as Griselda Pollock discusses in her catalogue essay, for her instructors, too) this performance was a pivotal assertion of her own ideas about art and culture in the context of the intellectually heady but simultaneously deeply Eurocentric focus of the Leeds art department. (For me, there are parallels between this early *Kali* event and *Synapse* – both have strong performance elements, set up cultural worlds of language and symbols, and invoke issues of territory, literal and metaphysical.)

It was also in 1984 that Biswas began to work on her first major piece, *Housewives with Steak-Knives* – a huge painting in which a modern Kali-esque woman confronts the viewer. This painting is the beginning of a group of canvases (1985–88) about Indian women whose characters, moods and voices are suggested by their titles: *As I Stood, Listened and Watched; My Feelings Were This Woman Is Not For Burning; Last Mango in Paris;* and *The Only Good Indian . . .*

I reread Gilane Tawadros on Biswas in her powerful *Third Text* essay 'Beyond the Boundary: The Work of Three Black Women Artists in Britain'. She writes that 'Biswas's *Housewives* defies the distinction drawn between the private and avowedly 'feminine domestic sphere, in this case exemplified by the kitchen, and the public, allegedly "masculine" domain of political action . . . [I]n . . . *The Only Good Indian . . .* (1985) . . . a[n] Indian woman is sitting watching the television, quietly peeling a potato which has metamorphosed into an uncanny resemblance to the former Home Secretary, Leon Brittan. Kitchen utensils have become the tools of defiance where the domestic space is conceived as the arena in which the hegemonic order is contested.'[2]

Tawadros's text makes me consider the relationship of these painted domestic spaces and iconographies to those of the *Synapse* installation. Surely this new space constitutes an extension of Biswas's explorations of the notion of the domestic space of women, 'the arena in which the hegemonic order is contested'.

Domestic adj. 1 of the home or household or family affairs. 2 of one's country, not foreign or international.

In 1987 Biswas returned to India for the first time in twenty-one years, visiting among other places the cave temples of Ajanta and Ellora, and the temple sculptures of Orissa and Khajuraha. She also visited the town where she had been raised as a young child. It was during this visit to India that she took slides of the temple sculpture, buildings, landscapes and people, images that were later to appear in *Synapse*.

In Santinekethan, among the belongings of her grandmother who had died before Biswas could see her, she found an image of Kali. The tunic was exactly the same as the one in her 1985 painting. 'The thought of having carried this information in my subconscious from such early infancy was bound to have repercussions in my work.'

This is a vivid literal example of memory imprinting; and imprinting is shortly to become a major theme, visually and metaphorically, for Biswas in her art.

Imprint n. a mark made by pressing or stamping a surface: *the imprint of a foot*, a footprint. *Imprint v.* to impress or stamp a mark on.
To be imprinted upon, to have a mark stamped upon
passive
To imprint the surface, to make a mark
active
The imprinting of spaces
Space(s)
reflective and meditative
real and metaphorical
spiritual and secular
public and domestic
cultural and personal
The spaces in Indian towns, temples and landscapes, and in English, American and Canadian galleries
The space of my Berkeley home in which Biswas and I are to meet

16–19 November 1991. Visit of Sutapa Biswas

She has brought the *Synapse* project with her. As we unwrap the works and spread them out informally on my living-room floor, we talk about the history of their evolution.

Biswas had returned from her 1986–87 visit to India with several hundred slides: 'The transparencies were both records of memories and potential raw material. I was very conscious that I didn't want to use them in any nostalgic way. In 1989, with this archive of slide transparencies, I began to work with screen prints. I was drawn to the physical and aesthetic qualities of the litho film used in the screen-printing process. I was drawn to the idea of being able to see either side if one held them up to the light – in this sense, they were membrane-like. I was trying to reinvent a way of using a photographic material, allowing the viewer to experience it but shifting the context.'

In 1989, two years after her Indian visit, Biswas created *Infestations of the Aorta – Shrine to a Distant Relative*. In the first version of this in England, three litho transparencies of an Indian woman and child (Biswas's aunt and her daughter) were hung suspended some three feet in front of the gallery wall – which provided, as the artist stresses, 'enough space for viewers to pass between, their own shadows becoming part of the dynamics of the piece'. These transparent photographs were lit so that their images were imprinted on to a large photograph of the Buddha's mouth mounted on the wall. 'The Buddha's mouth both speaks to us and simultaneously conceals. It becomes an obvious site for exchange, and in its sumptuousness reminds us of a desire to kiss.'

The following year Biswas created the installation piece *Sacred Space*, in which she continued to experiment, metaphorically and literally, with the physical installation space. Halogen lights installed outside the room's window cast the shadow of

this intervening window into the room itself, reminding one of both the outside and inside. The interior revealed two walls flanked by pastel and line drawings; three on one side, one above the other altogether measuring some eighteen feet. On the other side were two large drawings similarly arranged. Placed between were a series of ten small photographic litho films revealing ritualistic imprints of feet treading sand. Sand itself is symbolic of eroded rock, also shifting in nature.

In the fall of 1990, following an invitation to take up a fellowship at the Banff Centre for the Arts in Alberta, Canada – where she was to stay for four months – Biswas began the *Synapse* series by turning to the slides taken in India. She set up a studio space in which she projected particular images on to a paper screen, experimenting with them, and finally engaging in what was essentially a private performance mode – the literal interaction of her self with the projected slides. The resulting work, a documentation of this, is moved from a private to a public context, that of the gallery space. In this public space we are confronted by a woman's body that crosses into an imaginary projected space.

In her original conception of the installation, Biswas had thought to employ more representational references to maps. She had toyed with collaging map fragments on to a drawing, but after much consideration decided that it was the concept of mapping, as opposed to the literal transfer of information, that was significant. 'In this, it is close to the concepts behind the early religious and socio-geographic Indian maps.' What resulted, in lieu of an image more literally representing the topography of her psycho-geographic journey, was a huge line-and-graphic drawing of a woman on nine assembled sheets of sumptuous handmade cotton-rag paper. The woman appears to float rather than lie upon the white space of the paper. Her face and weighty figure, with its strong breasts and thighs, are meticulously drawn, while her arms and lower legs are faintly outlined. What is so extraordinary about this woman is that her eyes are open, her gaze fixed. She is unabashedly, comfortably and formidably present: she appears also quite unknowing of our gaze. Her powerful body has begun to emerge from the paper just as the body of Biswas appears to emerge from or sink into the various projections. In no way do any of the figures recall the formidably long tradition of the prone female nude by the likes of Titian, Rubens, Ingres, Manet and Matisse. The female nudes they might recall are either by women artists – Frida Kahlo and Käthe Kollwitz – or in Indian sculpture.

The nine photographs are large (52 × 44 in). They astonish me with their scale and the richness of their blacks, the subtleties of their surfaces, their lights and shadows.

In several of the *Synapse* series we see a recurring motif: a certain stone statue of an armless female figure. Biswas is not bothered by the particulars of which goddess the figure represents; indeed she prefers its anonymity. The goddess sits comfortably in a narrow stage-like space framed by two columns, and towards the bottom of the image we experience a fluid sense of the projection, which reminds us of its impermanence. In some of the *Synapse* series there is the traditional contrast of flesh and stone; at other times the stone is soft and the flesh solid.

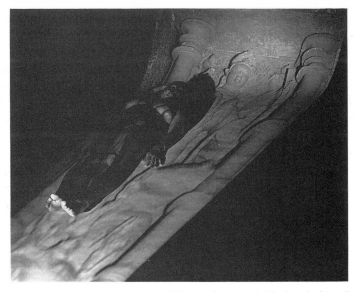

7 SUTAPA BISWAS *Synapse II* (No. 2 of 2 images). Black and white photograph, 1992

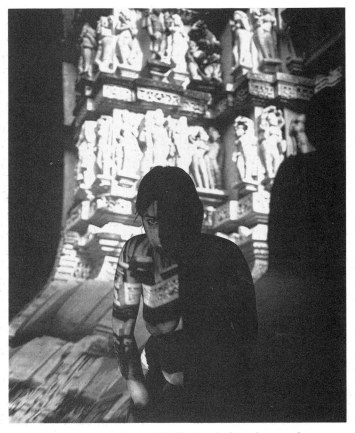

8 SUTAPA BISWAS *Synapse III.* Black and white photograph, 1992

But most strongly of all, I feel and see the body, the literal female body present in the work. Always there is the body of Biswas: sometimes whole, sometimes close-up parts – the belly, the hands – as she stands, extends herself lengthwise or sits on her knees. Only once do we fully catch her gaze. In this particular image, her seated figure is half immersed in an almost black shadow that plays across her body and face – indeed, we can only see one of her eyes. On the lit side of her body are tattoo-like striations created by the projected patterns of the sculptured temple façade behind her. (Significantly, the façade is from one of the famous Khajuraho temples in central India, temples rediscovered by the British in the nineteenth century.) Her fierce gaze and her centrally placed body in the front plane, together with her shadow which looms to her left and the water-like blurred reflections of the building to her right, block our access to the illuminated world of the temple behind her.

The *Synapse* installation marks a confluence of what is the definite, indeed defiant, presence of the women characters in Biswas's earlier paintings and the metaphorical spaces of the 1989–90 installations. It is an intriguing set of sequences. First, she sets out in paint the active, powerful and highly tangible

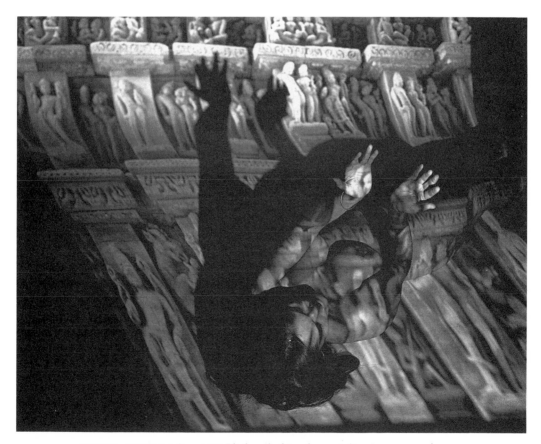

9 SUTAPA BISWAS *Synapse IV.* Black and white photograph, 1992

presence and voice of the women. Second, she employs oblique lightings and projections to create the literal spaces of *Aorta* and *Sacred Space* in which the imprints of the sacred are to be found. Third, in *Synapse*, her own body becomes a sort of lightning-rod, a touchstone for memory. Only now does she herself enter the sacred space. Yet we do not witness a live performance but rather the traces of such: the photographic representation of the artist's body enmeshed with the projections. Dreamlike, these images represent a complex psycho-geographic journey in which the language of representation is contested.[3]

22 November 1991: Postscript

Biswas has returned to Canada to prepare the installation in Vancouver. Her work is no longer here, only the ghostly resonances of its images and the echoes of the conversations between us. For me, the last two months have been a journey of increasing immersion in Biswas's cultural and visual worlds. Equally, I have explored my own worlds. I have re-immersed myself in my English background, and for the first time have begun, despite the particularities of my background, upbringing and shift of homes, to acknowledge the inescapable impact of colonialism on my own cultural 'imprinting'. I have been immersed not only in Biswas's art but more broadly in speculating about the role it may play in the cultural debates that are currently taking place internationally, including in England, the United States and Canada. She has much to contribute to these various debates. Biswas's transcultural perspective encourages/allows her to return unabashedly, yet with elegant theoretical complexity, to the subject of a woman's body, conflating her body with those of Indian goddess sculptures. To represent the woman's body with such presence is highly unusual these days, given the charged critical debate around the politics of such a representation. Biswas's entrance into this contested territory suggests that it may well be artists like Biswas – rather than critic–historians – whose new ways of representing the body will allow us all to re-enter the space of the body and female sexuality, which belongs to us as women. In this arena as in others, Biswas is mapping old lands that need fresh topographical surveys, as well as foraying into new lands. It is in these terrains that we will be able to expand our exchanges, in the context of art-making, about the ways culture, race, gender, class and memory help share our identities. It is within these imprinted spaces that we may be able to speak with more freedom to one another about our shared future in this world of ours.

Notes

Several people have read various versions of this essay and I am particularly indebted to the suggestions of Whitney Chadwick, Lucy Lippard, May Stevens and Diane Tani. I am also grateful to Rupert Jenkins of Camerawork, as it was in this gallery's exhibition, 'Disputed

Identities', that I first saw Biswas's work, and at that time also met her. Above all I would like to thank Sutapa Biswas herself for her art and friendship and for the productive intensity of her recent visit, during which this essay was completed.

1 Judith Wilson, 'What Are We Doing Here? Cultural Difference in Photographic Theory and Practice', *SF Camerawork*: 17, 3, Fall 1990. Biswas's statement is drawn from 'Reworking Myths: Sutapa Biswas' by Yasmin Kureishi, in *Visibly Female: Feminism and Art Today*, ed. Hilary Robinson, New York, Universe Books, 1988.

2 Gilane Tawadros, 'Beyond the Boundary: The Work of Three Black Women Artists in Britain', *Third Text*, 8/9, autumn/winter 1989, p. 145.

3 Biswas draws this term, 'psycho-geographic', from the Situationists. In an essay entitled '"Everyone will live in his own cathedral": The Situationists, 1958–1964', Christopher Gray writes: '"Psychogeography" was the study and correlation of the material obtained from drifting. It was used on the one hand to try and work out new emotional maps of existing areas and, on the other, to draw up plans for bodies of "situations" to be interlocked in the new Utopian cities themselves'. (*The Incomplete Work of the Situationist International*, translated and edited by Christopher Gray, Free Fall Publication, 1974.)

Modernism, art education
and sexual difference

Most of the theories which underpin the practices of art education in schools and colleges today can be traced back to the early part of this century, to the thirties and forties, in the midst of a ferment of exciting intellectual ideas about the future within what we now look back on as the moment of high Modernism. Art education has continued growing from that time, but without much disturbance of its basis of knowledge, rooted in Modernist values and ideas.[1]

Feminist theorists have demonstrated how sexual difference is inscribed into and produced by the structures of Modernist paradigms, and how Modernism's gaze is productive of sexual difference in relations of power.[2] It follows then that if we want to transform power relations between the sexes we need a reassessment of Modernism and its practices in institutions and social relations. This essay is concerned with Modernism's art education and its constitutive role in the production of sexual difference in power relations which have oppressive consequences in women's lives.

In spite of its modern and progressive image in the spectrum of school subjects 'art' in the higher education and school curricula has been slow to make changes in contrast to critical debates which are challenging the canon in the curricula of English and history.[3] Economic restraints since the seventies have persistently and effectively strangled much of what appears to have been successful in arts education, but the response has been retrenchment and reaction. On the one hand there has been a continuation of pseudo-scientific approaches to art education which have become increasingly supported by the psychologisms and work practices of mass production and business management. In opposition to these approaches there has re-emerged an essentialist, humanistic notion of the child from progressive art theories, supported by some feminist art theorists and teachers who regard the scientific Modernist approach as 'masculine' and who argue for the valorisation of a feminine sensibility and a return to feeling and emotion in arts education. This leaves problematic areas of self-expression, representation and creativity more or less intact. More often, these two approaches are muddled together, being the two sides of the same coin of Modernism. What has largely been ignored in critical debates in art education is the vast amount of theoretical work that has come from the area of cultural studies, feminist psychoanalysis and film theory. These intellectual debates are simultaneously critical and part of Modernism's discourse: debates about what constitutes 'the person'; about what happens between the mind and the image; about how images and

subjects work together to produce meanings; and about how institutions and power operate. All these are areas of knowledge which have profound implications for the theorising and practice of art eduction. But art education seems to have lost contact with this intellectual field; contemporary ideas have either been ignored altogether, misunderstood or rejected as 'unresolved', or potentially radical ideas have been reworked into existing traditional Modernist paradigms.[4] Most contemporary art education theories continue to be trapped within the discourses of the high Modernism of the thirties and forties.

The field of art education and its resistance to change can partly be accounted for by its constitution of itself within the terms of Modernist art. Within Modernist tenets there is no acceptable way to examine Modernism's own assumptions and expose them to the light of criticism; Modernist art disassociated itself from any other legitimising or critical discourses and valued its autonomy, only allowing that criticism which came from its own traditions and practices. The notion of sticking to its own specific practices and materials has been central to high Modernism and has explicitly and implicitly been the measure and definition of art in education and continues to be so in spite of new initiatives in the secondary school curriculum. In contradiction to this notion of categorical purity, however, Modernism has grown with and drawn sustenance from the naturalising narratives of science: Its claims to purity and autonomy were unfounded from the start, since it has always relied on scientific rationales in the psychology of perception and scientific theories of human development for its justifications. As Clement Greenberg, usually represented as one of the most articulate spokesmen for Modernist ideas in visual art, argued:

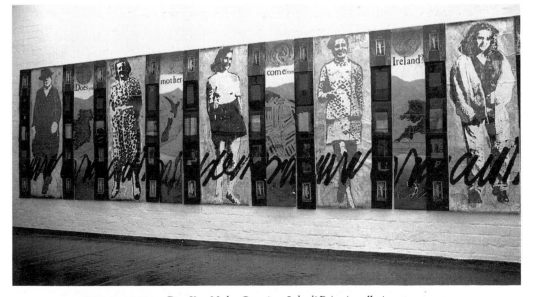

10 PEN DALTON *Does Your Mother Come from Ireland?* Print installation
from the exhibition 'News', held at the Spacex Gallery, Exeter, 1992

visual art should confine itself exclusively to what is given in visual experience, and make[s] no reference to anything given in other orders of experience, is a notion whose only justification lies notionally in scientific consistency. Scientific method alone asks that a situation be resolved in exactly the same kind of terms as that in which it is presented – a problem in physiology is solved in physiology, not in terms of psychology; to be solved in terms of psychology it has to be presented in or trans-lated into these terms first. Analogously, modernist painting asks that a literary theme be translated into strictly optical, two-dimensional terms before becoming the subject of pictoral art – which means its being translated in such a way that it entirely loses its literary character . . . the best art of the past 70 or 80 years approaches this consistency.[5]

Science and science's legitimising and normalising narratives were given a privileged place within modern art and subsequently found a legitimate place within art education's theories. The dominant belief persists that the *best* art and art criticism grows out of the practice of art itself, supported by the values, beliefs and methods of science. Approaches and critiques from other narratives such as those centred in feminist, linguistic, political or economic discourses were and are simply not regarded as relevant to the concerns of art.

Some recent art education theory has recognised and criticised the dominance and narrowness of Modernist practices in art education. A new 'critical studies' curriculum has been put in place in secondary education which challenges the limitations of focusing on just art *making* and in higher education feminist lecturers are now invited to teach about women's art. It is accepted that art education can relate to a wider field of artistic discourse and that 'content' can now be included legitimately alongside Modernism's privileged formal and purely visual approaches: the art curriculum can now include art history, art criticism, aesthetics, professional practice, feminist art, community art and non-Western approaches.[6]

While this widening of the curriculum makes sense, it continues in the Modernist tradition of relying on its own internal debates within the aesthetic field for critical stimulus. For feminists, then, it can not seriously challenge traditional Modernist practices which constitute part of the discourse of sexual difference. Women's art can be added to the curriculum as a variable, as an alternative point of view, or as representing a new approach in content, but the main agenda remains intact. The Modern structures of seeing and the dominant structures within which meanings and sexual difference are produced remain untroubled. In order to disturb those practices which produce sexual difference and women's oppression it would be necessary, at least to begin with, to uncover and deconstruct the basis of the Modernist knowledges underpinning art education: to re-examine what is meant by concepts such as 'art', 'seeing' and 'the child': assumptions upon which educational theory is built.[7]

The uncovering of the relationships between gender, power and knowledge in recent years has been a fruitful beginning in movements for change in all kinds of social relations. Critical work deconstructing art practices and art history,[8] Modernist art criticism,[9] psychology and normalising theories of child development,[10]

schooling[11] and Modern structures of seeing all have important implications for how we think about art and art eduction.[12]

In this chapter I would like to focus on one area of knowledge that underpins art education's theories but which has received less attention in this particular context, that is the field of psychology. Psychology as the science of the person and of visual perception has been privileged in Modernist art and art eduction. It is that field of knowledge which is nowadays rarely made explicit and which concerns the development of the normal boy and girl, the subject of art education, as well as theories about how this normal child sees and understands. The influential art educational theorist Rudolf Arnheim provided clear examples of how the science of psychology and abstract Modern art could be beneficial to the teaching of art to children. Both Modernist art and psychology are founded on evolutionary notions of growth and development, and Arnheim supported them as having a natural place in the education of psychology's growing and developing child. He wrote:

> Modern art is, among other things, a return to an approach that derives commonly and naturally from the psychology of spontaneous observation and from the inherent conditions of the media. Indeed it has gone back further. The modern artist's pleasure in primitive daubing, his emphasis on action, his playful experimenting with materials, his preference for elementary shapes and pure colours are typical of the earliest phases of artistic activity. The new appreciation of primitive art and children's art suggests in turn that the modern style has created a favourable climate for art education . . . A more direct and continuous evolution can be established from the early daubings of the child to the adult craftsman's highly controlled and significant shapes.[13]

It is now argued amongst critical psychologists themselves that psychology, including developmental psychology – indeed the whole notion of 'stages' in growth – is at least questionable and is becoming suspect in the part it plays in the construction of a normalised and controllable child.[14] Historically psychology can be seen as a project of Modernity and the heightening of interest in art education can be located alongside and as part of the growth of the science of psychology. In all educational theories, and privileged within art education, is a notion of the individual, the person: the growing child who is subjected to education. What constitutes a 'child' or 'adult' is both theorised and unproblematically assumed within different theories in the teaching of art.

Critical psychologists have demonstrated that psychology works in the process of the continual production of subjects as sexed in social relations of unequal power.[15] They have shown how developmental psychology is implicated in and administers the production of the social, and of children as normalised subjects in relations of sexual difference. Scientific observation and measurement and empirical studies in the classroom have 'discovered' and produced normalising categories defined according to key stages in perceived emotional, social and mental growth related to chronological age. These normal categories are based on a model of the ideal person, the rational, European, self-aware, male. For this normal (male) child, programmes of teaching are produced, pedagogic practices developed, classrooms built

and organised, materials adapted and activities and curricula devised. The choice of materials, the size of brushes and the selection of colours are limited to match the perceived needs of different categories of children as determined by psychology's findings. Assessment and evaluation procedures are worked out in relation to the aims of teaching various groups and when they are externally examined, are seen to work — which is hardly surprising given that different categories are also *produced* within these pedagogic practices. Upon these successes, even more complex theories are devised based on the model of the normalised male and ignoring political and economic differences in power relations between male and female. The pedagogic practices in art education based in psychology's classifications act to produce sexual difference.

Psychology, it is accepted, can provide at best only partial accounts and it is in the issues of sexual difference, desire, the body, and unconscious processes where psychology's accounts have been inadequate. Feminists in attempting to alter power relations between the sexes are more likely to find contemporary approaches from psychoanalysis, film theory and feminist theory more rewarding. Psychology has also provided the dominant account of how vision works. Its theories in the psychology of art are bound up with biological accounts of the stages of human physical and cognitive development. The ability to see, to take in information, and to represent or express what is seen have been couched within psychology's individualist accounts. Indeed it is within its classifications that the viewing subject as separate from a social world 'out there' has been constructed. Psychological theories of art and perceptualist accounts of visuality, most influentially Gestalt and cognitive approaches dominate art education's understanding of the visual and of the making of art, and it is Ernst Gombrich's work in the psychology of art and visual perception which has dominated our thinking in educational theory and practice. His body of work has now been substantially appreciated and criticised. In recent years different approaches to the understanding of how vision works have come from feminist critical theory, from critical psychology, from art history and film studies, which build on yet fundamentally challenge Gombrich's perceptualist accounts. Yet none of these critical insights about vision and visuality have made their appearance in art education's discourse, and Gombrich's explanations of the visual continue to be uncritically reproduced at all levels of art education.[16]

These psychological explanations of perception have always been represented as neutral in terms of gender, so it has not been possible within these accounts of vision to raise issues or debate ideas about the active part played by the visual in the production of sexual difference. Feminist critical theory in particular has revealed the constitutive part of the sexualised gaze in the construction of gendered subjectivities and in the construction of sexual difference which cannot fit into a notion of the person as pre-existing or in any way outside society or neutral in terms of gender. The viewing subject produced in Modernist discourse, it is argued, has been the eye and brain of the dominant white, Western male. What is left, the woman's body, has been the object of that gaze. Any attempt to explain or change these relations of sexual difference and the underlying assumptions about vision would, at the very least, mean some engagement with these new critical approaches on the part of educational theorists.

The science of psychology has become so ingrained in art education that there is no longer any need explicitly to justify its findings. It has been naturalised and normalised and become a hidden part of our everyday language and belief about people and their relation to the arts and visual perception. Even art educators in attempting to criticise and overcome the worst effects of scientific pedagogy fall into using Modernism's assumptions and categories. New psychologisms and classificatory systems are devised reproducing the language and assumptions of Modernism's creative individual who 'responds to stimuli', 'explores' and then 'reviews' and 'modifies behaviour', 'observes' the world and 'develops visual perception'.[7] This view of the humanist, individualist person, as a rational, logically developing, unitary entity essentially separate from 'society' is fundamentally different from the 'subject' theorised in approaches from cultural studies and feminism. This subject is theorised as being continually produced and is productive within discursive practices such as education and a subject for whom sexual difference, far from preceding education, is continually being produced in unstable and often contradictory relations within gendered pedagogic discourses.

Subjectivity and visuality have been the continuing issues of intellectual debate within art history and cultural and feminist theory for many years now. Both fields of knowledge have implications for change in the theory, practice and criticism of the arts for change in power relations between men and women. Art education needs to review its complicity with high Modernist values and begin to engage at a professional level with questions about subjectivity and the field of vision.

Notes

1 For discussions of Modernism see G. Pollock, 'Feminism and modernism', in R. Parker and G. Pollock (eds), *Framing Feminism*, (London, Pandora, 1987), pp. 101–22 and C. Harrison and F. Orton, (eds), *Modernism, Criticism, Realism*, (London, Harper and Row, 1984), pp. xi–xxviii. A review of art education's place within Modernism can be found in R. Taylor, *Visual Arts in Education*, (London, Falmer Press, 1992), pp. 22–5.

2 For debates about women and Modernism see A. Huyssen, *After the Great Divide*, (London, Macmillan, 1986), pp. 44–62 and J. Wolff, *Feminine Sentences*, (Cambridge, Polity Press, 1990), pp. 51–66. For debates on Modernism's gaze see H. Foster, (ed), *Vision and Visuality*, (Seattle, Dia Art Foundation, 1988); R. Krauss, *The Optical Unconscious*, (MIT Press, 1993); L. Mulvey, 'Visual pleasure and the narrative cinema', *Screen*, 16, 3, (1975), pp. 6–18; and J. Rose, *Sexuality and the Field of Vision* (London, Verso, 1986), pp. 167–97.

3 See P. Lauter, *Canons and Contexts* (Oxford, Oxford University Press, 1991).

4 See D. Hulks, 'The critical curriculum' in *Journal of Art and Design Education*, 11, 2, (1992), pp. 335–45 and P. Abbs, *Living Powers*, (Hampshire, The Falmer Press, 1987), p. 31.

5 C. Greenberg, 'Modernist painting' in F. Frascina and C. Harrison (eds), *Modern Art and Modernism*, (London, Harper and Row, 1982), pp. 5–10. For a critique of Greenberg see V. Burgin, *The End of Art Theory* (London, Macmillan, 1986), pp. 1–28.

6 For examples of practice see descriptions in Taylor, *Visual Arts in Education*.

7 The debate begins with J. Wolff, 'Questioning the Curriculum: Arts, Education and Ideology' in *Studies in Art Education*, 31, 4, (1990), pp. 198–205.

8 R. Parker and G. Pollock, *Old Mistresses* (London, Routledge, 1981).

9 M. Kelly, 'Re-viewing modernist criticism', *Screen*, 22, 3 (1981), pp. 41–62.

10 J. Henriques, W. Holloway, C. Irwin, C. Venn and V. Walkerdine, *Changing the Subject* (London, Methuen, 1984) and V. Walkerdine, *The Mastery of Reason* (London, Routledge, 1988).

11 K. Jones and K. Williamson, 'The birth of the schoolroom', *Ideology and Consciousness*, 6, (1979), pp. 59–110.

12 N. Bryson, *Vision and Painting* (London, Macmillan, 1986), and Krauss, *The Optical Unconscious*.

13 R. Arnheim, *Towards a Psychology of Art* (London, Faber and Faber, 1966), pp. 343–52.

14 See the debates on Modernism and psychology in S. Kvale (ed), *Psychology and Postmodernism* (London, Sage, 1992) and J. R. Morss, *The Biologising of Childhood* (London, Lawrence Erlbaum publishers, 1990).

15 Henriques, *Changing the Subject*.

16 See Bryson, *Vision and Painting* for a critique of Gombrich and perceptualist accounts.

17 See Abbs, *Living Powers*, pp. 56–65 and Taylor, *Visual Arts in Education*, pp. 32–41.

VAL A. WALSH

Eyewitnesses, not spectators – activists, not academics: feminist pedagogy and women's creativity

science of teaching

> Ceasing to be spectators viewing an artistic rendering of sex and violence . . . we too are changed. We are eyewitnesses. Our seeing attests to the actuality of what – however unthinkable – is before us. Our shared reality with the artist can be the bedrock for building a powerful, authentic bridge from personal testimony to political analysis and practice. But first there is rage when we begin to face the truth (about rape).[1]

Arlene Raven's words summarise the essential features of the conjunction between art and feminism. She identifies the importance of contextual and experiential factors in 'our shared reality' and the mutual redefining of art and politics which ensues once we challenge the social and cultural boundaries which maintain the separation between living and cultural practice, between violence and art. Raven attests to transformational potential in identifying ourselves as women and with women.

Women/art: crisis

In the art world outside the Academy, while obstacles certainly remain (not least the underfunding of women's art work[2] and women's poverty as temporary, part-time teachers), women artists are now more visible, more influential, and more inspiring than ever.[3] Women artists' collaborative and participatory projects have been both prominent and important. Much of the very best work by women artists is openly rooted in women's experience and produced within the embrace of a feminist identity and politics.

 In art education, however, the stereotype persists of the bearded, white, older, male heterosexual art tutor faced with mainly young white women art students. Female art students have accounted for 50 to 60 per cent of all students since the 1890s (and mainly drawn from the middle and upper classes): acceptable, even necessary perhaps, given the woman as muse/mistress/model/child syndrome so persistent in Western art practice.[4] The lack of full-time, women tutors, in particular within the fine art studio, compared to art history or complementary studies, suggests a taboo at work.[5]

Opposition to 'independent' or 'feminist' women in art education can still be virulent and damaging.[6] After years of struggling for access to Higher Education as tutors, with very limited numerical and promotional success, and because of women's historical role within men's art and the prevailing concepts of Art, Creativity, and Genius in Western culture,[7] women in art education are perhaps among the most vulnerable, most colonised of women in academia.

> What a shock it was though to realise that the art school was not a safe place, free of racism and sexism and all this from men, many of whom claimed to be the heroes of the working class! . . . Why and how did so many women during the 1980s in British art schools become undermined, undervalued, discouraged and in some cases defeated?[8]

The discrepancy between the visibility, community even, of women artists in Britain and the absence and isolation of women tutors in art education[9] may be partly explained in terms of the difference for men between representation and experience, the imaginary and the material. Women's presence as tutors in art education appears to be organised mainly in two ways: occupational segregation, and what I will call 'art femininity'.

Occupational segregation can mean tokenism, for example, being brought in as a repair kit: 'So in one hour or occasionally one day's teaching . . . one is asked to redress mis-education, mis-information and mis-direction'.[10] It involves particular areas of work being identified with femininity, as 'women's work', even when dominated by male 'heroes' – such as fashion, textiles, jewellery. Others are so identified with masculinity, for example fine art, that it is very difficult for men to conceive of women being able to do the job (the equivalent of 'you couldn't lift that' in industry). 'Tenure will always be the overriding issue':[11] in 1990 there were only five Black women art tutors.[12]

Art femininity, on the other hand, is a 'professional' aesthetic, which condenses two codes, 'art' and 'femininity' (both stereotypically white, affluent and able-bodied, in a spectacle designed to embed the woman within the fine art aesthetic, not as knowledge-maker, but as confirmation of the artist as hero (male and heterosexual).[13] The pressure on women in art education is to produce/present themselves as bodies/art objects, in terms of a sexualised aesthetic which emphasises appearance and sexual availability. In the studio, women are expected to be girls, and visually compete with the art; to be unconventional, visually interesting, even shocking, but not speaking subjects.[14]

Femininity is consumed here as part of 'a rhetoric of sexuality; . . . encountered in terms of the entire social system (intertextual, institutional – discursive)'.[15] The woman's body becomes 'the terrain on which patriarchy is erected'[16] and this has a specific resonance within art education and art; many contemporary women have shown imagination and ingenuity in using their bodies as sites of resistance in their art.

As 'wise women' (artists/intellectuals/teachers) we *realise* the incompatibles within Western masculinist binarism: which suggests that these binary oppositions and categories are sexual, not academic; that they should be viewed as pathological

rather than scholarly. Do they also put us into the category of 'women who have dared to come too close'?[17]

The white male psyche produces and experiences us as a turbulence within the Academy: an indecipherable presence/*body*. The female lecturer provokes and intensifies men's sexual ambivalence: as both the bad woman, the 'castrating woman' (Theweleit's 'red nurse'), who (as female) confronts male colleagues with their own sexuality; and the good woman, sexless and 'pure', the sister, the gentlewoman

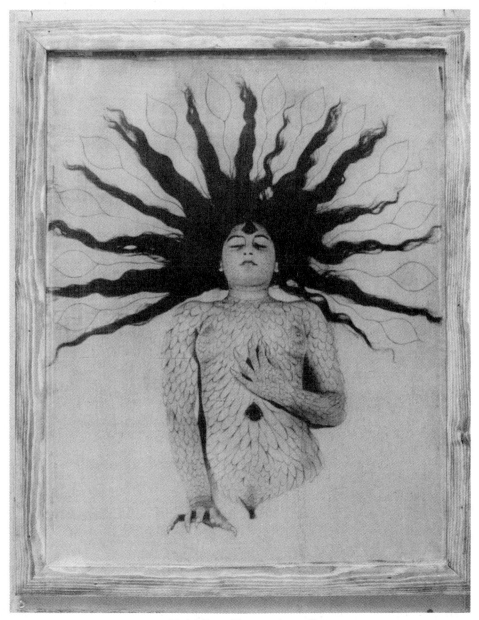

11 ADDELA KHAN *Black Soliloquy.* Photograph on silk, 1992

(Theweleit's 'white nurse'),[18] who (as teacher/colleague) commands authority and respect, even chivalry. Our presence as teachers embodies us, physically/sexually, as *Nature*. But because the role of teacher confers authority (normally reserved for white men) in relation to what counts as knowledge, our teaching also embodies us intellectually, as *culture*. This contradictory identity thereby transgresses and throws into question the boundary between nature and culture, so central to white Western systems of thought.

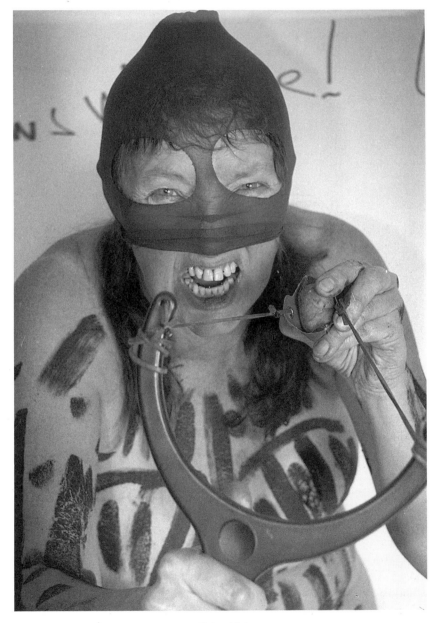

12 JO SPENCE/DAVID ROBERTS *Cultural Sniper*

As *knowledge*-makers, women are *trouble*-makers and denote an epistemological/sexual crisis, which needs to be viewed creatively and positively, as a way forward. The Chinese word for crisis, wei-ji, is composed of the characters for 'danger' and 'opportunity';[19] wei-ji confirms the proximity of crisis and creativity. This conjunction makes possible a reconceptualisation of both, divesting crisis of its negative and perjorative connotations (something to be avoided or ashamed of), and creativity of its esoteric and elitist connotations. Creativity becomes a function of 'crisis', that is, *a situation in which something significant is at stake*; crisis becomes both function and feature of creative process as transformational and risky. Women *as* crisis then becomes a statement of our creative potential, of hope.

As women, our presence and diversity (for example in age, class, colour, disability, ethnicity, sexuality) pose a challenge to the fictive woman produced within men's epistemologies, and disrupt men's appropriation of 'femininity' for their own purposes.[20] While the products of our creativity (our art and writing) can be assigned safely to the category 'woman', as live women we may trigger 'the anxiety generated by the erotic woman, capable of orgasm'.[21]

Feminism, interdisciplinarity and art education

The resistance to women as teachers testifies to the liberatory potential of a feminist pedagogy in art education, as the first thing feminist process does is to counter the taboo on women being together for their own purposes. As women, we must claim not just access to materials and methods, to institutions and cultural spaces, but our right of access to ourselves and each other. Women's courage, confidence, creativity and community are vitally intertwined.

In the pedagogic relation between female student(s) and feminist tutor *as women*, we can do this either on the basis of our common fear (including of each other), as women disempowered by 'femininity'; or our common courage, as women prepared to transgress the prescribed boundaries and features of that femininity, and work towards empowering ourselves and each other. 'But first there is rage':[22] our purposes cannot be simply artistic or academic, for we live in 'a culture whose values produce rape'.[23]

Feminist process involves the production of useful and accessible knowledge/art. Along the way, 'usefulness', 'uses', 'accessibility' are reconceived, breaking boundaries and hierarchies such as aesthetics/ethics, culture/nature, art/ecology.[24] Feminist pedagogy develops collaboratively and creatively. It highlights the sharing of experience, information, ideas, feelings and skills; a sense of mutuality and reciprocity; an equalising of power relations between student and tutor, as we construct *a dialogue* in which the stakes are high and not merely academic.[25] With its emphasis on the interrelational and process, feminist pedagogy embodies opposition to the subject–object dualism which underpins white Western thought, and unavoidably also risks being perceived as non-academic and non-professional.[26]

In coming together we pool our individualities and aspire to community. We discover that 'art is not genetic'[27] and that 'we didn't lose our identities by working together, we expanded them'.[28] Crucial to this process is the question of our purposes in speaking, and 'to make the liberated voice, one must confront the issue of audience – we must know to whom we speak'.[29] bell hooks reminds us that 'the language we choose to use declares who it is we place at the centre of our discourse'.[30] As Lubaina Himid suggests, 'Art is about dialogue and there are many entry points . . . If work addresses a particular audience this does not mean it excludes all other audiences.'[31] In this conjunction of voice and audience, we create contexts in which our work can make sense to others.[32]

Feminism weakens traditional boundaries and demarcations, including subject boundaries (aesthetics/ethics/politics/therapy) and social boundaries (for example between 'private' and 'public'). Feminist process is integrative, and highlights the connections and continuities between different cultural practices and areas of social life.[33] Feminist art practices in the curriculum can situate themselves not just within Women's Studies, but *as* Women's Studies. By networking more systematically across the curriculum, art feminists can learn from other women's lives, activism and work, as well as demonstrating the relevance of women's art for those who have never seen themselves as 'artistic'; never felt able to 'understand' visual artwork; see art as frivolous compared to, say, family, public transport or welfare policy; or sociology, history, and literature; who see aesthetics as a peripheral and elite academicism dominated by white men.

Feminism offers the possibility of a syncretistic, integrative transdisciplinarity, which challenges racialised gender power relations in society and women's vulnerability within these arrangements. The re-vision and re-making of our social/cultural forms and relations requires a poetics as much as a politics,[34] and aesthetics is central to both. Academic methods which result in women or women artists being discussed 'merely as signifiers'[35] are to be avoided, for this simply repeats the male Academy's concern with 'advancing the frontiers of knowledge',[36] with women serving as incidental material for this 'neutral' project.

The work of increasing numbers of female art historians exemplifies the key feminist insight that 'Separability allows context-free abstraction of knowledge . . . creates criteria of validity based on alienation and non-participation, then projected as "objectivity"'.[37] But it is possible to contribute to the modern and academically respectable field of Representation, without showing any commitment to women artists[38] – or women generally. Working so close to the framework of men's History, female art historians are more vulnerable to incorporation and co-option than female studio tutors, who remain numerically marginal and institutionally scattered by comparison.

In the context of white men's science and its 'objectivity' culminating in 80 per cent of scientific research going towards the war industry,[39] women's creativity necessarily embodies our rejection of men's 'objectivity' and its consequences for women and nature. Art can be reclaimed as everyday evidence of 'non-violence as power',[40] and as a basis for community, not separation.

Women's community and feminist creativity

> It is always the love that will carry action into positive new places, that will carry your own nights and days beyond demoralization and away from suicide.[41]

Each time we speak a sister's words or cite a sister's work, we acknowledge the part played by her in our own sense of life and possibility. We acknowledge the collectivity of women's words and actions, which support our resistances and subversions in the face of

> a universal experience factor for women which is that physical mobility is circumscribed by our gender and by the enemies of our gender ... Everywhere in the world we have the least amount of income, everywhere in the world the intensity of the bond between women is seen as subversive.[42]

In the past 'wise women ran the risk of being declared witches'.[43] I am suggesting this is now more likely to be the fate of women tutors inside the Art Academy than woman artists on the outside. Yet we all must share 'the poet's need to identify her relationship to atrocities and injustice, the sources of her pain, fear, and anger, the meaning of her resistance'.[44]

As June Jordan stresses, we need to identify and connect with 'what we are trained to ignore, what we are bribed into accepting, what we are rewarded for doing, or not doing'.[45] This is the knowledge and courage we need as teachers in the Academy, and it has no less relevance for art and aesthetics (be it fashion or fine art), than any other area of women's life and work.[46]

As eyewitnesses and activists, our art and feminism are life-support systems, which must be cherished and developed in terms of each other, as living politics and creativities. Moving away from powerlessness, without becoming exhausted, bored, or burnt out, involves much more than deconstruction and critique. It requires

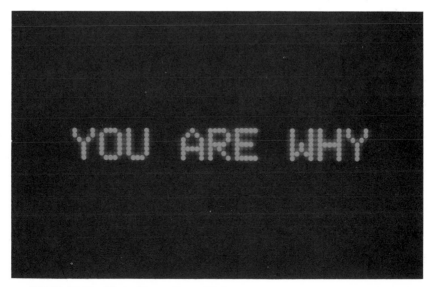

13 TANYA URY *Moving Message: You are Why?* 1992

collective as well as individual intervention and subversion; the unbridling of our creativity as women, as we challenge the academic voice (women's as well as men's), its exclusions and interests, its purposes and consequences. We have to find our hearts and speak from there, echoing and emboldening each other with hope and insistence that 'We will be'.[47]

Notes

1 Raven, Arlene (1988), 'We Did Not Move from Theory/We Moved to the Sorest Wounds' (Dedicated to the memory of Ana Mendieta) in *Crossing Over: Feminism and Art of Social Concern*, London, U.M.I. Research Press, p. 158.

2 Fanny Adams (6 March 1993) reported that solo shows by male artists formed 93 per cent of all solo shows at the Tate Gallery and 95 per cent at the Royal Academy between 1987 and 1992; *Notions of E-Quality: Women in the Arts*, Arts Council Conference, Birmingham.

3 See Sulter, Maud (1990), Preface and Acknowledgements in *Passion (Discourses on Blackwomen's Creativity)*, Hebden Bridge, Urban Fox Press, pp. 9–11. 1993 saw conferences for women in the arts held in Birmingham, Exeter, Sheffield and Leeds; *Women's Art Magazine* and the Women Artists Slide Library continued to develop; sadly *Feminist Arts News* lost its Arts Council funding and ceased publication in 1993. See also Allthorpe-Guyton, Marjorie (7 March 1993), 'Let Us Now Praise Famous Women', in *Notions of E-Quality*.

4 See Walsh, Val (1990), '"Walking on the Ice": Women, Art Education and Art', *Journal of Art and Design Education*, 9, 2, pp. 147–61; and (1991) 'Femininity and Fine Art: Women Artists and the Female Man', research paper (see 6 below). Part of this latter was presented as a paper (in 1989) at the National Society for Education in Art & Design Annual Conference and (9 March 1989) at Exeter College of Art (now the University of Plymouth).

5 Skelton, Pam (May/June 1985), 'Women and Art Education', *NATFHE Journal*, pp. 18–21; Kharibian, Leah (1991), 'Survival in the Arts', *Women's Art Magazine*, January/February, pp. 12–14.

6 Himid, Lubaina (1990), 'Mapping: A Decade of Black Women Artists, 1980–1990' in Sulter (ed.), *Passion*, p. 66. My research project, 'Women's Experience in Art Education and Art: The Relation between Creativity, Pedagogy and Society' (part-funded by the Arts Council of Great Britain) using questionnaire and interviews, provides examples of what we now name sexual harassment.

7 See for example, Battersby, Christine (1989), *Gender and: Genius: Towards a Feminist Aesthetics*, London, The Women's Press; Bronfen, Elizabeth (1992), *Over Her Dead Body (Death, Femininity and the Aesthetic)*, Manchester University Press; Chadwick, Whitney (1985), *Women Artists and the Surrealist Movement*, London, Thames & Hudson.

8 Himid, 'Mapping', p. 66.

9 While Fanny Adams is now providing documentation about the position of women artists, there is no current systematic documentation available on women art tutors.

10 Sulter, *Passion*, p. 10.

11 MacGregor, Elizabeth A. (1991) Introduction, *Adrian Piper*, Birmingham & Manchester, Ikon Gallery & Cornerhouse Gallery, p. 8

12 Himid, 'Mapping', p. 67.

13 See Lowe, Nick (1986), 'Heterosexism in Art Schools', *Lesbian and Gay Socialist*, autumn, p. 14.

14 Women art students I interviewed in 1987 explained their dress codes in terms of what would make them safer on the street/in the studio: how they could dress without attracting men's sexual attentions (Doc Martins, men's jackets, very short hair, no make-up, dark or dull colours).

15 Burgin, Victor, cited in Godfrey, Tony (1982), 'Sex, Text, Politics', An Interview with Victor Burgin in *Block* 7, p. 2.

16 Rich, Adrienne (1977), New York, Bantam Books, p. 38.

17 Carter, Erica and Turner, Chris (1986), 'Political Somatics: notes on Klaus Theweleit's *Male Fantasies*' in Burgin, Victor, Donald, James and Caplan, Cora (eds), *Formations of Fantasy*, London, Methuen, p. 203.

18 Theweleit, Klaus (1987), *Male Fantasies*, vol. 1: 'Women, Floods, Bodies, History', Cambridge, Polity Press, p. 79.

19 Capra, Fritjof (1983), *The Turning Point (Science, Society and the Rising Culture)*, London, Fontana, p. 7.

20 See Battersby, *Gender and Genius* and Brodribb, Somer (1992), *Nothing Mat(t)ers: A Feminist Critique of Postmodernism*, North Melbourne, Spinifex; Walsh, Val (18 March 1993), 'Virility Culture: The Convergence of Academia and Managerialism', in M. Evans, J. Gosling and A. Sellars (eds), *Agenda for Gender: Women in Higher Education*, (University of Kent, 1994).

21 Theweleit, *Male Fantasies*, vol. 1, pp. 79–138.

22 Raven, 'We Did not Move from Theory', p. 158.

23 Raven, Arlene, (1988), 'Close to Home' in *Crossing Over: Feminism and Art of Social Concern*, p. 168.

24 Walsh, Val (1993), 'Moving Beyond Abstraction: Nature, Art and Creativity. An ecological and feminist perspective', paper presented at the WSN (Women's Studies Network (UK)) Annual International Conference, Nene College, Northampton.

25 Kennedy, Mary, Lubelska, Cathy and Walsh, Val (eds), Introduction to *Making Connections: Women's Studies, Women's Movements, Women's Lives*, London, The Falmer Press, pp. ix–xvi.

26 See Walsh, Val (1992), 'Transgression and the Academy: Feminism, Feminine Values and Institutionalization', paper presented at the WSN (Women's Studies Network (UK)) Annual International Conference, University of Central Lancashire. Also Kennedy, Lubelska and Walsh, Introduction to *Making Connections*.

27 Sulter, *Passion*, p. 18.

28 Edelson, Mary Beth cited in Raven 'The New Culture: Women Artists of the seventies' in *Crossing Over*, p. 5.

29 bell hooks (1989), *Talking Back (Thinking Feminist – Thinking Black)*, London, Sheba Feminist Publishers, p. 15.

30 hooks, *Talking Back*, p. 15.

31 Himid, 'Mapping', p. 70.

32 Macleod, Katy (1992), 'Innovation and Disclosure', M.Ed. dissertation, Polytechnic South West, now the University of Plymouth, is a perceptive exploration and exposition of a seminar and placement scheme which openly sought to address such interconnections as part of undergraduate art education.

33 See Dossor, Dinah (1990), 'Gender Issues in Tertiary Art Education', Journal of Art & Design Education, 9, 2, pp. 163–9.

34 It is above all Black women who are articulating and promoting a feminist poetics/politics: for example, Audre Lorde, Maya Angelou, June Jordan, bell hooks, Toni Morrison. In their multiple identities as poets, activists and scholars, they activate our possibilities.

35 Sugg, Deborah (1990), 'Misrepresenting Representation', *Women's Art Magazine*, 37, (November/December), p. 30.

36 Dodson, Mo (1990/91) 'The Crisis in the Art Academy', *AND: Journal of Art and Art Education*, No. 23/24, p. 45.

37 Shiva, Vandana (1989), *Staying Alive (Women, Ecology and Development)*, London, Zed Books, p. 22.

38 Sugg, 'Misrepresenting Representation', p. 30.

39 Shiva, *Staying Alive*, p. 22.

40 Shiva, *Staying Alive*, p. xviii.

41 Jordan, June (1978), 'Where is the Love?' in *Moving Towards Home (Political Essays)*, London, Virago Press, 1989, p. 83.

42 Jordan, June interviewed in Parmar, Pratibha (1990), 'Black Feminism: The Politics of Articulation, in Rutherford, Jonathan (ed.), *Identity (Community, Culture, Difference)*, London, Lawrence & Wishart, p. 113.

43 Shiva, *Staying Alive*, pp. 21–2.

44 Rich, Adrienne (1977), 'Power and Danger: Works of a Common Woman' in Rich (1980), *On Lies, Secrets & Silence (Selected Prose 1966–1978)*, London, Virago, p. 251.

45 Jordan (1975) Notes of a Barnard Dropout, in Jordan, *Moving Towards Home*, 59.

46 Coward, Rosalind (1993), *Our Treacherous Hearts*, London, Faber & Faber, concludes that 'women are scared of a fundamental confrontation with men' which has resulted in 'a collusion with men's expectations of women' (pp. 8, 199). For these (heterosexual) women, the gap between activism and daily life, principle and practice, dream and reality, has widened, with social and political consequences for the lives of other women and relations between women.

47 The title of an artwork by Lubaina Himid.

Curatorship
and the art world

Exhibiting strategies

If things are taken at face value, all is well for women artists in today's art world: the development of part-time and evening study, frequently aimed at mature students, has enabled many more women to study Fine Art; equal opportunities policies are in place in subsidised galleries, arts organisations and educational institutions; gallery directors (subsidised and commercial) select work purely on the basis of 'quality' – gender doesn't come into it. Yet the dissatisfaction amongst women artists continues to be highlighted at conferences such as 'Bookworks: A Women's Perspective', 1992; WASL's 'Feminist Art Criticism', 1992; and the Arts Council's 'Women in the Arts' Symposium, 1993. So, what are we complaining about?

In 1991 (the latest figures available from the Department of Education) over 65 per cent of British Fine Art graduates were women; the proportion of practitioners is roughly fifty-fifty; and yet in 1991 84 per cent of solo shows in top London commercial galleries went to men. Women are vastly underrepresented in historical, theme and survey shows as well as in national contemporary collections, and women artists still find it infinitely more difficult to show their work, develop careers and rise up gallery hierarchies than do men.

When questioned about statistics, directors fall back upon the idea that 'quality' rules – women have the same chance as men if their work compares, or that gender shouldn't enter into selection at all. If women artists equal men in numbers as practitioners, but don't reach the top in proportion, the implication remains that women artists are not as 'good' as men. The next logical step is to question the nature of criteria used to judge artists' work.

Our art history is dominated by male artists, and largely written and taught by men. Students may not be introduced to a single woman artist throughout their Fine Art course, and most gallery directors, critics and funders have been brought up on a similar diet of male imagery, concerns and directions.

However, this is not the whole picture and many other factors appear to affect women as exhibitors. Directors have described how male artists are frequently more ambitious, more determined and more likely to hustle and hassle for shows, while women tend to be more polite, requesting rather than demanding.

Just as many women as men want to show, judging by the proliferation of women's work in less prestigious, less commercial and less well-funded spaces, and by the numbers of women taking part in artist-run events such as open studios – where women number approximately 50 per cent (East End Open Studios 1989 and 1992). Women outnumber men at my workshops on exhibiting – most artists' greatest

ambition. So what are women artists doing to create opportunities to show their work?

On leaving college I found it impossible to show; my response was to begin organising shows for myself. Realising the importance of personal contacts (I had none in the art world), I went back to my home town to borrow spaces from the local arts centre and university. For the following few years this was largely my arena. Organising shows for myself was hard work and expensive (though I usually covered costs through sales); I learnt by bitter experience how to plan ahead, work and negotiate with others, follow up contacts who might visit and/or buy and make the most of the show to attract other opportunities and promote my work. I gradually developed a following and invitations to show elsewhere began to come.

While relative success with the work I showed and sold was satisfying to some extent, I increasingly felt at odds with the struggle to work within inherited traditions. A period without making led to experimentation with wire, fabric, and a combination of three-dimensional forms and slide projections. The resulting works, far more 'me', have invited comments from established galleries and critics: 'I've never seen anything else like it', 'I wouldn't know who to show you with', 'I can't place your work in a context'.

Early on these responses caused great frustration, but turning to artist-run spaces, which have welcomed my open-ended approach and been willing to trust me as an individual rather than needing outside confirmation of acknowledged success, has led to exciting collaborative exhibitions. In 1988 I made a large-scale installation at Unit 7 Gallery, London. Nici Oxley and Nico D'Oleviera were happy to accept my open-ended proposal for the space, rather than a detailed description of the end result. This was followed in 1991 with *Trespass* (Figure 14A, B) at Adam Gallery (run by Adam Reynolds). Again, I was given two weeks to work in the space, and I used much of the time to absorb its atmosphere, react to original architectural features and explore ways to define and develop a relationship with it.

Both opportunities allowed me to explore new avenues through a flexible and open-ended approach. At Unit 7 I pushed the boundaries of a relationship between the large-scale – the space was approximately 40 ft square – and the minute elements from which I constructed forms. It wasn't until I had completed the work at Adam Gallery that I realised for the first time that my work was mirroring my life-experience: issues of identity, personal transformation, psychological space and a relationship with a physical and historical context were raised and to some extent resolved through the show.

Mine is not an uncommon experience: the search for a new language, new contexts, new ways to express ideas and explore identity have led women to seek new paths through alternative media such as tape/slide, film, video, installation and use unconventional materials, combinations and juxtapositions.

For Lily Markiewicz, installation has enabled her to explore her identity and issues of power, territory and relationships with others: 'Space loses its neutrality and becomes territory – as a woman the definition of space is important'. She goes on to explain: 'Space possesses a dual reality . . . Space, both in its physical and conceptual

dimension, is a place where historical, economic, cultural, social, gender issues etc., manifest themselves. Installations, too, exist in this dual reality, yet not as mere reflections of it, but as interventions in time and space.'

Lily expressed feelings of distance and dislocation from her audience; she originally worked in film and video. She began to explore the need for space, both physical and psychological, as a result of her experiences: 'women tend not to occupy space and to allow themselves to be made to feel small'; and, as a Jew of the Diaspora, 'there is no space'. Installation allowed her to create a space in which to explore 'who I am and what possibilities I have for being (as a Jew or as a woman)'.

In tandem with installation, the making of books as artworks has attracted many women artists – a publication frequently provides the only physical reminder of a show. The Bookworks conference provided a platform for women making imaginative and extraordinary books to question, draw attention to, explore and celebrate a wide range of issues.

Lily's book *The Price of Words. Places to Remember 1–26* combines evocative and moving images from the installation (Figure 15) with texts describing experiences and memories. 'I'm from a culture with a limited visual tradition', she says, 'We have a culture of books – the written word has status; for women too, language means power, publication lends weight to what you have to say.'

While these platforms provide opportunities for women to explore essential issues and attend to the personal, intimate and private parts of themselves, exploring the wider context for our work is equally important. Sharon Kivland, another Bookworks exhibitor, has struggled with a context for her work and confronted it via a range of means. She has shown in unusual venues such as a launderette or a health

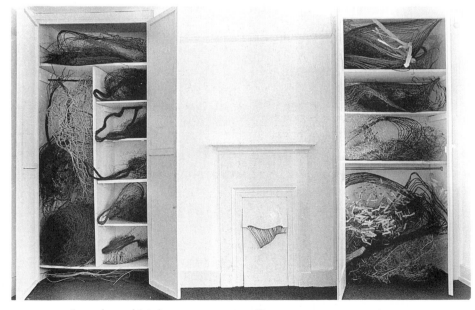

14 (A, B, *above and facing*) DEBBIE DUFFIN *Trespass.*
Installation, Adam Gallery, London, 1991

centre, where she too, can engage with a broader audience, many of whom would never set foot in a gallery and who would be surprised by coming across artworks in places they habitually use.

Sharon Kivland has extended this involvement by curating unusual shows in gallery and non-gallery spaces. 'Curating is a way of trying to establish a context for your own work', she says, 'It's also a way of acknowledging that as an artist I owe a lot to other artists – without them I wouldn't be producing anything.' 'The Souvenir Show' (Camerawork, London, 1985), was her first exhibition during her year as gallery director. She and co-curator Vicki Hawkins contacted all the artists they could think of to bring along work and hang it as well – the result was a highly individual, joyous celebration, which juxtaposed all kinds of objects filling the gallery walls, floor and ceiling. For Sharon Kivland it is important to 'break down divisions and hierarchies by moving from one context to another'.

The earlier shows included her own work as well as that of other artists. In 1987 she was offered a show at Kettles Yard and through discussions with the gallery devised a two-part show 'A System of Support – Conversion of Pleasure into Sickness' in which she showed her own work alongside a mixed show of other artists who each made a piece to be mounted on a shelf.

Helen Smith, based in Sunderland, has also found ways to show and involve others in what she does. One of Helen's projects involved her in documenting 'a day in the life' of Sunderland town centre. She spent a Saturday observing and photo-graphing the events of the day over a two-mile circuit; catching images of early morning workers, daytime shoppers and football crowds, then evening revellers. She then set herself up for two weeks in the local 'Food Giant' supermarket where she

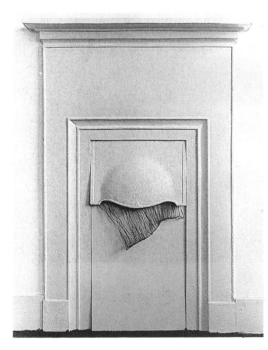

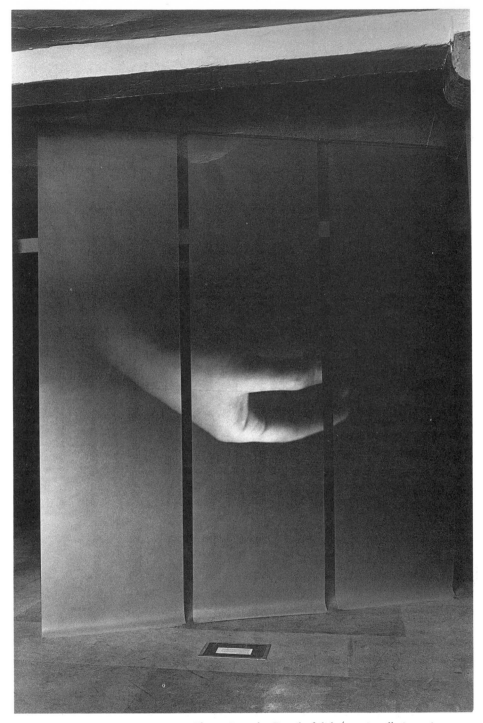

15 LILY MARKIEWICZ *Places to Remember.* Detail of slide/tape installation using tracing paper, sand and projections, 1992

16 HELEN SMITH Photo-documentation of Sunderland City Centre project at Food-Giant, Sunderland

created panels of still images which combined with the moving images of the working supermarket (Figure 16). While making the work, she engaged in conversation with staff and customers who were fascinated and encouraged to relate their own experiences of Sunderland – past and present.

Helen admits she took tremendous risks; capturing images of the town centre at night made her feel physically vulnerable, but vulnerability of another kind surfaced while working in the supermarket; she expressed difficulty in keeping confident about her ideas as she worked in full view of passers-by: 'it looked really scrappy when I started working with the images,' she said, 'deciding how to arrange things in front of people; I had to keep believing it would turn out well and that they'd be able to see what I was trying to do.'

The North-East of England has few gallery spaces and consequently artists have had to find other arenas in which to show. Public art, particularly temporary events, has become an accepted way to show within the region. Helen was successful in securing funding from the Local Arts Development Agency (LADA), whose Sunderland Unit has a particular interest in participatory arts projects.

Making links of this kind is essential to the development of opportunities for exhibiting. But in order to make such links artists must be highly aware of themselves, their concerns and where they want to go with their work. Self-assessment alongside a knowledge of potential opportunities is a strategy well worth cultivating.

Cornelia Parker, whose ephemeral three-dimensional pieces have won her recent acclaim (in 1990 she was shown in the British Art Show at the Hayward Gallery) explains how she directs her career. 'A couple of years out of college with

little exhibiting experience, I'd built up a body of work which I really wanted to show; I sat down and made a short list of three galleries to approach, two of which were public.' She chose galleries which interested her and which she felt might be sympathetic to her ideas. She carefully put together slides of her work and outlined ideas for showing her work relevant to each venue. This considered approach brought her one good opportunity to show in an exhibition which provided a catalyst for future shows.

Several years later, following a number of successful shows which led to commissions, she began to feel uncomfortable about the way things were going – the opportunities presenting themselves were not right for her and her work. 'Many of the commissions offered were for the corporate world and more often than not based on the purely visual appearance of my work', she said. 'For me the ideas behind it are just as important and I didn't want to lose this.' She decided to turn down future opportunities which would take her further down the same path, and take time out to consider where she did want to go with her work.

My own approach to developing a more satisfying context for my work has involved similar periods of reassessment and I have developed a capacity to use natural gaps in making to look at what I have achieved or not, what I would like to do next, how I can deal with any problems which have arisen and make the most of opportunities which present themselves. I have developed ways of combining the necessity to earn a living and to fill gaps in my knowledge, understanding and skills as an artist by organising exhibitions, working for galleries and writing about exhibiting issues. This research and discovery are fed back into my work, and this has helped me make more informed and appropriate approaches to galleries as well as enabling me to meet people with common interests with whom I might work, show or collaborate in future.

Some highly successful women artists operate within accepted art-world traditions and it has been argued that those women who do succeed are those who adopt 'male' strategies for success: aggressive self-promotion, the use of 'old-boy networks', putting careers before issues and people and taking a highly autonomous approach to making and showing. Women have traditionally put self-fulfilment, family life and sharing and caring before their ambitions. However, an increasing number of women feel that they shouldn't have to make such choices and are searching for a balance between success and fulfilment – not an easy route. Conflicts abound and past legacies are still a burden. My workshops for professional artists attract many women wishing to explore ways to develop their exhibiting careers and I am struck by the contradictions deeply ingrained in many female participants. The work presented is usually far more interesting, dealing with issues of great depth through imagery which profoundly communicates their involvement with what they are doing. However, while possessing at least as many artistic attributes as their male counterparts, most suffer from lack of confidence, they frequently put themselves down and 'forget' to acknowledge their achievements; some even find it difficult to call themselves artists – as if they have to pass some unfathomable test to qualify.

Traditional female qualities of sharing, communication, flexibility and a desire to collaborate with and acknowledge the work of others can be seen – and perhaps are seen by traditionalists – as weaknesses which don't lead to career success. It's easy for women to see themselves in this light too, with no power – victims of an arena which doesn't take them into account. At the same time there is a growing recognition that these so-called feminine characteristics are important. The proliferation of artist-in-residence schemes, the burgeoning interest from local authorities, health-care institutions, funding bodies and commercial concerns in public art and participatory work means that artists as well as agencies must address the issues involved. Many women artists already possess a wealth of talent, experience and skills which can be applied to these situations.

The effects of recession also contribute to the development of a broader range of opportunities for artists – empty commercial properties are being used as alternative gallery spaces, commercial galleries are losing their stranglehold as collectors realise they can buy directly from artists; subsidised galleries are asked to bridge the gap between what they show and the present and potential gallery-going public.

The courage to show vulnerability and allow for the possibility of 'failure' is a common characteristic of women artists' attitude to their work. Women genuinely want to share their experiences at a deeper level – whether by making explicit imagery, expressing highly personal concerns, inviting the audience to share an experience or other artists to share a show, or daring to juxtapose unusual materials, the artist is laying herself open to scrutiny which puts her at risk. She may feel frightened by what she is aiming to do, or worried she may fail, but at least she is operating at a genuine level of experience which enables her to relate to others.

It can be intimidating for artists who work with personal issues to show, and the relative safety of sympathetic contexts perhaps makes it more difficult for some to address issues of a less personal nature. But while it is essential to explore our inner selves, there comes a time when a looking outward, beyond the current work, show or book needs to occur. If women artists are to take up an equal place in the art world it is essential to consider our relationship with the wider context. In order to make the most of the fundamental changes taking place, women artists must be prepared to see themselves as powerful and equal. We have a great deal to offer, but we must learn the skills and inform ourselves of the 'hidden' agendas of others so that we can make things happen for ourselves.

Notes

1 Figures from FANNY ADAMS poster campaign, 1992.

The situation of women curators

Mother figure, surrogate wife, confessor, superwoman, hostess, prostitute: the roles of women working in galleries in the nineties?

Can the gallery be regarded as a microcosm for life? It is possible to argue that the roles and relationships which develop in galleries simply reflect the roles that women are often expected to adopt in general. Moreover, there is something specific to the gallery situation which throws gender politics into relief. It is a kind of hothouse situation, especially in the context of organising solo exhibitions, where the relationship between curator and artist can be very intense.

So what are these roles that women adopt, or, perhaps more accurately, what are the roles that are projected on to women curators?

First, the mother figure. This is a role that woman curators easily fall into when dealing with difficult male artists: they soothe the tantrums, nurture, comfort, cajole. Providing such a supportive environment for the artist can all too easily become something more insidious.

Closely related to the mother figure/nurturing role is that of surrogate wife: the curator is expected to 'service' the artist's every need, even outside the gallery, to ensure that the artist is protected from the traumas of everyday life while in the midst of the great creative act! When this behaviour is questioned, all too often the answer is that it makes the curator's life easier.

On occasion the curator may even stray into the territory of the mistress — some artists need constantly to be reminded of their sexual attractiveness and will even attempt to seduce the curator. Tricky, this one! The curator must flirt and play the game without letting things go too far and 'losing the respect of the artist'. Mistresses also take on the role of the good listener, reassuring the artists that their current problems with their wife/girlfriend/partner are not really their fault. Thus women are again forced to collude in the deprecation of other women.

And of course there is the superwoman: curators are expected to perform miracles, often at great personal expense. I was once accused of betraying a project when I insisted on going to bed at four in the morning after two weeks of late nights and constant stress during the day. (The artist, of course, ignored the fact that that exhibition was only one of a number of things for which I had responsibility. This is the closest I have ever come to violence towards an artist but, of course, true to stereotype, I choked back my anger and went to bed.) Miracles are often required: get information panels printed over a Bank Holiday weekend, find

17 SHELAGH WAKELY *Gold Dust.* Bronze powder installation.
Exhibited at the Ikon Gallery, Birmingham, 22 February–28 March 1992

two tons of scrubbed mussels out of season, construct five showcases at a day's
notice . . .

Much of this is an accepted part of being an exhibition curator, of whatever
gender, and difficult behaviour is not the sole prerogative of the male artist. But when
dealing with women artists, women curators seem to have less difficulty standing up
for themselves. Why therefore should women curators put up with behaviour from
men that they would never consider tolerating in their lives outside the gallery?

There is no doubt that the art world has created and continues to pander to
the stereotypical behaviour of the great artist. The myth of the great creative genius
bestowing the fruits of his (and on occasion her) imagination on a baffled public is
too strong and indeed too convenient to be challenged. Artists who are very conver-
sant with the art world (usually white men) tend to take so much for granted.
Curators, of course, have an enormous amount of power, and there are many exam-
ples of how badly artists are treated when working with galleries. Nevertheless, cura-
tors, especially women, can also suffer at the hands of artists and there is no excuse
for artists to behave badly nor for curators to put up with unacceptable behaviour.
Women need to find a balance between recognising and responding to the needs and
aspirations of artists working in what may be a very fraught and nerve-racking situa-
tion and being used (and occasionally abused) to bolster the artist's ego.

It is possible to work in a supportive way with artists without falling into
stereotypical roles, but to do so women have to be aware of what is going on, and
whether such behaviour is conscious or unconscious on the part of the artist. A good
relationship with an artist depends on mutual respect and women need to negotiate
a situation in which they feel comfortable.

It is not just within the gallery that women have to negotiate difficult situations. As arts organisations are forced into the revered market place and terms like 'corporate planning' and 'market segments' replace exhibition programming and potential visitors, the role of women in the management of these organisations is subtly altered.

Again thinking about some of the words you might now apply to women in the arts, one of the first which comes to mind is that of hostess. This is nothing new: many commercial galleries in particular employ women in this role, to entertain clients and add a bit of glamour to the proceedings. This thinking now spills over into the public sector as a result of the need to work with the private sector, with perhaps more disturbing consequences.

Women entering the private sector are fully aware that they are in the business of selling a commodity, even when it is couched in the rhetoric of high art, and this will inevitably bring them into contact with people whose values may be very different. Those of us who naively entered the public sector because of notions about the value of art to society have received a rude shock in the past five years. Indeed I would go so far as to argue that the role of hostess has easily slipped into that of prostitute!

I once found myself with a senior executive of a major company going to a theatre performance and sponsored reception and wondering to myself what I was doing. It was very straightforward – he clearly wanted the company of a younger woman for the evening and I wanted his company's money! This may seem an extreme example but I can reel off many others where businessmen we were trying to interest in the gallery made comments that in any other context I would not have tolerated.

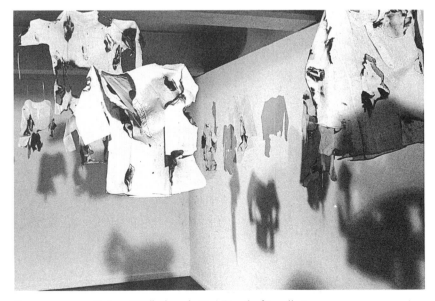

18 ZARINA BHIMJI *I Will Always be Here.* Detail of installation commissioned by the Ikon Gallery, Birmingham, 1992

Comments on personal appearance, sometimes with overtly sexual connotations, are far from unusual. The Deputy Director of Ikon once had to endure lunch with a senior public relations executive of a major public company while he regaled her and a somewhat embarrassed board member, who had made the introduction, with stories of his fantasies about running off with a Swedish au pair girl and asking an artist to do some 'really naughty pictures'. It seems amusing in retrospect but was far from so at the time. How do you retain your self respect on such occasions? We have agonised over how to deal with these situations many times – should you respond as you normally would or is it more important to swallow your dignity in the hope of securing the vital funds? When the pressure is on to raise money from the private sector, curators, especially women, are under pressure to modify their behaviour to avoid alienating those whose funds they are trying to attract. When dealing with a deeply conservative business sector, as there is in Birmingham, you simply cannot afford to jeopardise possible funding by being dismissed as a loony feminist. A wry smile and an attempt to change the conversation to the more serious matters you are meant to be discussing is about as far as you can go. Even this, no matter how charmingly put, sometimes has the effect of undermining the man. (And it has to be said that such behaviour often comes out of a deep insecurity.)

I am aware that there is an issue for men in this too. As the director of a national theatre company pointed out recently, many of us went into the arts precisely because we did not want to work within the business value system. Yet it raises more questions for women. On one level, there is no doubt that it is easier in the first instance for women to attract attention, but I now believe that in the long term we are grossly disadvantaged because businessmen do not take us seriously – back to the

19 BOBBY BAKER *Drawing on a Mother's Experience.*
Performance, the Ikon Gallery, Birmingham, 1989

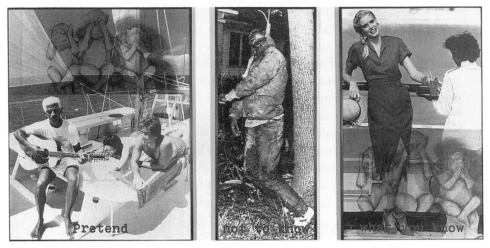

20 ADRIAN PIPER *Pretend 4.* Photos, silkscreened text, 1990.
Exhibited at the Ikon Gallery, Birmingham, 21 September–2 November 1991

hostess role. This attitude is not confined to men outside the gallery – sometimes board members from the business community can be just as guilty of seeing the gallery as a kind of 'hobby' for the female management!

So what impact do women really have in the gallery sector? In the past five years there has been a small but significant shift in the positions that women hold within the art gallery and museum sector. Although most galleries within the local authority sector are still run by men, there is now one woman director of a national museum and of the six contemporaries funded by the Arts Council, five are led by women. It had to happen in the end – after all there are many more female fine art graduates than male, and women have always had a strong presence in the lower echelons of the art world, in the private and public sector. The key question is, how does this affect women artists? It goes without saying that simply having women in positions of power does not necessarily improve the situation for other women. Change only happens when such women consciously choose to question the status quo.

To give one example, I was once involved in a selection procedure which involved submissions from artists as part of the process. After looking at the slides, I was intrigued by the fact that the majority of artists we had selected to visit were men. I therefore looked again at who had submitted: there were many more applications from men than women, a fact that had not been noticed by the curator.

It now seems very obvious to look at such issues and to address the question of why women artists have on the whole been more reluctant to put themselves forward. The obvious answer is a question of confidence. However, this is changing, as it is for minority groups hitherto under-represented in the art world. Curators, and I believe women in particular, are becoming more aware of inbuilt biases in the system and are devising ways of countering them. More women artists are being selected for exhibitions and it is becoming less acceptable for selection panels to be all white and all male. But it is a slow process and it requires more women at the top taking the lead.

There still remains the wider question of the way that the visual arts are regarded in society, where I doubt if attitudes have really changed. We suffer because of the reputation of the visual arts as inconsequential, so no matter how much we adapt to business modes of operation, we will never be taken seriously. Indeed it can be argued that to see women running galleries may reinforce preconceptions about art within the business community.

But the question has to be asked, where do we want to position art galleries in the nineties and whose values do we wish them to endorse? And what can women, curators and artists, do to ensure that we have a situation where art is valued for its ability to question and transform society rather than to reflect a narrow section of interest? The questioning of stereotypes and myths is an essential part of this, and one thing is sure — it is too important to be left to the men!

Afterthoughts on curating 'The Subversive Stitch'

Deeply moving – I was at times close to tears.

This work is not what I expected. In fact it is a disgrace.

Reflecting upon these entries (of July 1989) from the visitor's book at Wolverhampton Art Gallery, five years after curating the contemporary exhibition, part of 'The Subversive Stitch', they seem to typify the main reactions to the exhibition: either engagement and recognition or anger and disappointment. The critical response – reviews and articles, most by women and many by feminists – was similar. Those viewers with some knowledge of the issues raised by the exhibition tended to be sympathetic, stirred by the emotional resonances in the work; but many, with a particular interest in textiles, felt cheated.

 'The Subversive Stitch' was the umbrella title for two large touring exhibitions, 'Embroidery in Women's Lives 1300–1900' and 'Women and Textiles Today', which opened in May 1988 at The Whitworth Art Gallery and Cornerhouse, respectively (both in Manchester).[1] The exhibitions aimed to bring debates that had previously circulated within academic and specialist circles to the broader arena of the gallery. At the time they attracted a good deal of interest. Since then few galleries have explored the issues further. Were these concerns particular to a generation of feminists? Or is there, perhaps, a final irony: that it is in the nature of such 'blockbuster' exhibitions to close debates, rather than open them – because mainstream institutions assume that these issues have now, once and for all, been addressed?

 I began writing with the intention of answering these questions. Unable to resolve them, I find myself thinking instead of the critical response to the contemporary exhibition and the questions it raises: what are the most effective strategies for feminists in curatorship and criticism? what tensions are exposed by presenting women's work? and what are the implications for both women and textiles practice?

The 'Subversive Stitch' exhibitions

The two 'Subversive Stitch' exhibitions, although separate, were devised to complement each other and shared poster, catalogue and publicity material. They both explored ideas raised by Rozsika Parker's book *The Subversive Stitch: Embroidery and the*

making of the feminine,[2] which broke new ground by relating the history of embroidery to the social history of women. Unlike most historical studies of embroidery, which concentrate on questions of style and technique, it traces the shifting notions of femininity and roles ascribed to women through embroidery, from medieval times, when it was considered a high art form practised by both men and women, to its current denotation as a 'feminine craft'.[3] Rozsika Parker argues that women's relationship to embroidery has been ambivalent: it became both a means of educating women into the 'feminine ideal' and a weapon of resistance to its constraints: a source of pleasurable creativity *and* oppression.[4]

Although indebted to the book for their title, 'The Subversive Stitch' exhibitions were not intended as literal translations. However, they were informed by its *approach*: the historical exhibition, 'Embroidery in Women's Lives 1300–1900' – which included 200 exhibits, from ecclesiastical embroideries to samplers and suffragette banners – in its insistence on a social context for embroidery in which class and gender are central; the contemporary exhibition, 'Women and Textiles Today', for the questions it posed about the relationship between women, textiles, and femininity – and, implicitly, the hierarchical and gendered value system of the visual arts. Furthermore, the contemporary exhibition broadened its remit from embroidery/stitch to photography, mixed media and installation, to include the work of thirty contemporary women artists/craftswomen, selected for its visual impact and critical content (Figures 21, 22).

After their Manchester showing, both exhibitions travelled to Tyneside. The contemporary exhibition then toured to four more venues during 1989.[5] Although no London venue could be found, a selection of work was exhibited at Watermans Arts Centre in Brentford. Interestingly, all the curators who booked the show were women.

Critical response

The majority of reviews for both exhibitions appeared in specialist textile magazines. Regional response was good: in the north-west, *City Life* described them as 'Manchester's finest and most thoughtful exhibitions in a long time',[6] and in London, *City Limits* as 'a damn sight more interesting than your average painting show';[7] there were also radio slots on *Kaleidoscope* (eight minutes) and *Woman's Hour* (nine minutes). But elsewhere the response was disappointing. *The Independent* was the only national newspaper to cover the exhibition, and only after Bev Bytheway, Exhibitions Organiser at Cornerhouse, had written directly to Germaine Greer. Ironically, the two most interesting reviews, published in *The Independent* and *Women Artists Slide Library Journal*, were also the least positive. Yet in different ways these last two reviews raise crucial points about the nature of 'women's exhibitions' and how they are 'read'.

Germaine Greer (under the cliched byline 'A Stitch in Time') argued that women's embroidery is a living, breathing art, which belongs in the home, not in museums, which for her represent repositaries of dead male culture. She sees contemporary embroidery as one of women's traditional artistic activities analogous with 'the rooms and gardens women make, the food, the flowers and herbs they grow . . .

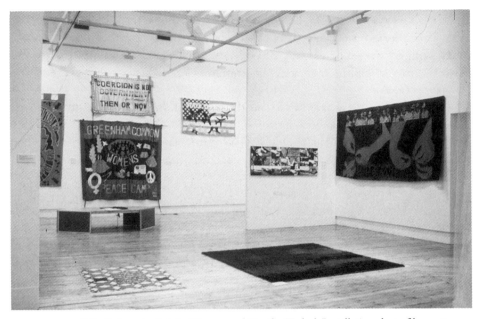

21 'The Subversive Stitch: Women and Textiles Today'. Installation shot of banners section of the exhibition held at Cornerhouse, Manchester, June 1988

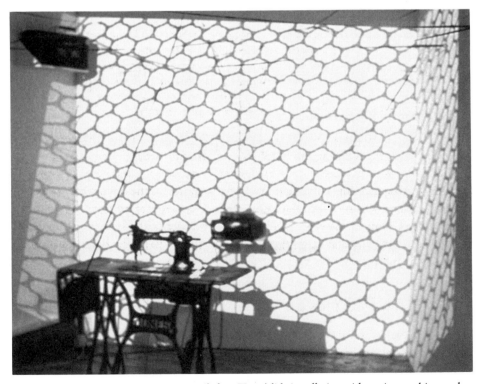

22 ALISON MARCHANT *Shadows.* Tape/slide installation with sewing machine made for the exhibition 'Women and Textiles Today', held at Cornerhouse, Manchester, June 1988

the cloth they weave'.[8] She regarded the artists in 'Women and Textiles Today' as sharing 'a willingness to enter into a polemic about art which is not typical of women artists',[9] and concluded by offering, as evidence of the 'extraordinary continuity and coherence in the female tradition',[10] a 'sumptuous' needlework book called *The Embroiderer's Garden*.[11]

In *Women Artists Slide Library Journal*, discussion of the exhibitions extended over four issues, in a correspondence between the reviewer, Dilys Dowsell, and WASL member, Val Walsh. In the first, Dilys Dowsell writes positively of the historical work at The Whitworth, but is indignant at the contemporary:

> After these blandishments the show 'Women and Textiles Today' at Cornerhouse seemed inhospitable . . . Black, white and shades of grey reinforce the mood created by such titles as *Pity the Poor Bride* (Judith Duffey) and *Cloth with Three drops of Blood* (Verdi Yahooda). *Warmth* (Jo Stockham) gives no comfort . . . Not much fun is being had here, nor anywhere else in this exhibition . . . The participants of 'Women and Textiles Today' are attempting . . . [to widen] the scope of textiles . . . But they need to be more cheerful about it.[12]

While Dilys Dowsell employs terms like 'lovely', 'colourful' and 'exquisite'[13] in her review, Val Walsh speaks of 'colour signif[ied] through absence'; 'objects [which] invite engagement, not contemplation';[14] and 'pleasure . . . forestalled by . . . dissonance'.[15] Her initial response, however, focuses on the connotations of 'inhospitable' and 'blandishments':

> Seeing textiles in terms of its not affording shelter (OED) on the one hand, or in terms of its ability to flatter or coax (OED) on the other, exudes the 'femininity' the writer seems to mourn throughout her review: domesticity at one end, coquetry at the other . . . Is the identification of femininity and textiles so complete here that there is no room for women to problematise that relationship, to expand it or explode it even. Or at the very least to make it their own?[16]

Dilys Dowsell, in turn, asserts: 'Had the title been 'Women's Protest in Textiles Today' the expectations would have been different.'[17] This point deserves analysis. The subtitle 'Women and Textiles Today' was chosen, after much consideration, to distinguish the contemporary exhibition from the historical. It seems, however, to have set up expectations of a *survey* of contemporary textiles by women. Yet for both Germaine Greer and Dilys Dowsell the work exhibited wasn't really textiles, nor was it representative of women. This begs the question: what is textiles and who or what is representative of women?

The question of 'woman'[18]

Germaine Greer's evocation of flowers, herbs and weaving suggests a natural link between women, nature and craft. In this she reflects a discourse prevalent within feminism during the 1970s. Textiles in particular became synonymous with the recovery and revival of traditional female crafts. The classic example was *The Dinner Party* (1979), initiated and co-ordinated by Judy Chicago, where embroidery

and china-painting were chosen to celebrate the lives and achievements of great women.

This celebratory approach to women and their work is not, however, without its difficulties, for it collapses women and 'traditional female arts' in to one continuous category, 'woman'. It also raises a number of questions: does the notion of 'the feminine arts' imply an essential/universal femininity – a belief in the inherently 'female' or culturally 'feminine';[19] and is it really possible to talk of 'women's activities', 'women' or even of 'woman' as fixed categories?

Janet Wolff argues that although celebratory strategies can be useful for mobilising consciousness and offering new and positive images of women, they are naively essentialist and unsatisfactory because they neither problematise the category 'woman' nor analyse its construction.[20] The essentialist position assumes that all women's experiences are the same regardless of age, class, ethnic identity, and sexual orientation. By contrast, 'deconstructive' or 'destabilising' strategies, which she considers more effective, expose the ideological limitations of male thought to create space for women – no longer the singular fixed category 'woman' – to articulate their diverse experiences.[21]

In surveying a range of feminist writers on the 'question of "woman"', Janet Wolff points out that many have found post-structuralist theories useful. These propose that 'the subject (including the female subject) is constructed in discourse and representation and is thus not a stable, unified category'.[22] 'Woman' is constantly deferred. This deconstructive discourse is double-edged: on the one hand it acknowledges that 'woman' is a historically and discursively constructed category; on the other it asserts that 'it is a category we must continue to employ' and that 'it is compatible to suggest that "women" don't exist – while maintaining a politics of "as if they existed" – since the world behaves as if they unambiguously did'.[23] In other words, we need to acknowledge both the category 'woman' and the lived experiences of real women.[24].

How might these discourses of celebration/deconstruction relate to the *The Subversive Stitch* book and exhibitions? Rozsika Parker examines the belief that 'women embroidered because they were naturally feminine and were feminine because they naturally embroidered',[25] and reveals that what appeared natural, and even biologically based was, in fact, 'man-made'.[26] She exposes (the making of) femininity as socially constructed and unstable, signifying differently across class, cultures and centuries. Similarly embroidery, no longer a unified category, is expanded to include both the activities of the leisured classes and the labour of the working classes. We are offered a different relationship to the past. To think both women and 'woman' is to take into account social reality as well as social construction.

How then to view 'The Subversive Stitch' exhibitions? It could be argued that all exhibitions that focus exclusively on women's art are celebratory and inevitably invite essentialist readings. Exhibitions of 'traditional female arts' accentuate this further, and tend to be inscribed and marginalised as 'women's exhibitions'. The difficulty with the subtitle 'Women and Textiles Today' was that it reinforced this reading.

Paradoxically, perhaps, stereotypes about women and their textile practice were deliberately evoked in both exhibitions; stereotypes set the agenda for debate. The project was to find ways in which to *renegotiate* them. In this sense both exhibitions might be viewed as taking deconstructive and destabilising strategies. In 'Embroidery in Women's Lives 1300–1900' this meant provoking new, critical readings of objects – not simply presenting them in isolation, with printed labels: anonymous, date, materials. But by juxtaposing objects and presenting them alongside visual and textual information, the exhibition focused on the women who made the samplers, waistcoats, or chasubles and the context in which they worked; in this way objects were placed within social and historical relations.

Similarly, 'Women and Textiles Today' examined the role of textiles in shaping social, cultural and individual identities. By exploring cloth as sign and metaphor, its evocative qualities – comfort, softness, sensuality; frailty, restriction and resistance – become a language, with its own grammar and syntax. In displaying work alongside quotations from novels and poems, historical photographs, information panels, and advertising imagery, the aim was to create a critical space for this language to be spoken.

The question of textiles

'Women and Textiles Today' sought to expose and *destabilise* stereotypical assumptions about women and textiles practice. The theory of destabilisation makes this more apparent. Yet writing about the exhibition now is strange, for I am making use of discourses that were not available to me at the time. Work that has since emerged in sociology and cultural studies also offers useful ways to reconsider the critical reponse to the exhibitions, for it reveals a 'subtext'.

The 'celebratory/destabilising' framework helps to explain some of the assumptions implicit in Germaine Greer and Dilys Dowsell's reviews. For if textiles are usually seen in terms of beauty and decoration, textile exhibitions usually operate on the premise of affirmation and celebration.[27] Like most exhibitions of craft, they tend towards materials-based surveys emphasising technique and process, but avoiding critical content. In this context, as an entry in the visitor's book at Cornerhouse admonished, 'Women and Textiles Today' could be accused of not showing 'real textiles'.

The expression 'real textiles' is premised on a fixed idea of what textiles are. And although some of those exhibiting at Cornerhouse may have positioned themselves within fine art practices, for many this binary thinking – art/craft – is unsatisfactory, for their work 'fits' neither one category nor the other. It is 'on the edge'; in some buffer zone; a hybrid form, grappling to find a space and a name . . . Textile Art, Fibre Art . . .

As Sarat Maharaj suggests, 'edginess' is an appropriate term for 'avant-garde textiles practice' because it 'cites established genres and their edges even as it cuts across and beyond them'.[28] He talks of

> An 'undecidable' – as Derrida puts it, something that seems to belong to one genre but overshoots its borders and seems no less at home in another . . . Belongs to both, we might say, but not belonging to either. Should we comprehend 'Textile Art' under the chameleon figure of the 'undecidable'?[29]

Here too links can be made with the idea of the 'unstable subject', for just as woman and 'femininity' are not fixed categories, so ideas about textiles vary across time, place and culture.

Stuart Hall's work on cultural identity, also informed by the ideas of Jacques Derrida, offers a similarly expansive way to 'think textiles'. He argues for a cultural identity which is in a constant state of 'production',[30] never complete. As with 'the question of "woman"', the idea of deferral prises open a gap. For if identity/meaning is always deferred, then the fixed binaries (either/or) which stabilise meaning are challenged.[31]

This may be helpful in conceiving of textiles as a transformative and enabling practice, always 'in process'; but is it too abstract and open-ended? Doesn't there need to be some consensus of meaning, a moment of 'stasis'? As Stuart Hall explains,

> Potentially discourse is endless . . . to say anything at all in particular, you do have to stop talking. Of course every full stop is provisional. The next sentence will take nearly all of it back. So what is this 'ending'? It's a kind of stake, a kind of wager. It says, 'I need to say something, something . . . just now.' It is not forever, not universally true. It is not underpinned by any infinite guarantees. But just now, this is what I mean; this is who I am. At a certain point, in a certain discourse, we call these unfinished closures, 'the self', 'society', 'politics', etc. Full stop. OK.[32]

Textile Art and Fibre Art are 'unfinished closures', provisional categories. They don't sound 'right'. The difficulty of finding suitable vocabulary suggests uncertainty, a deferral. 'Real textiles', in contrast, is sure of its identity and history. It implies purity and authenticity, a Golden Age. It allows no space for the possibility of textiles as a critical practice. But 'real textiles' suffers from amnesia. It forgets that when Jessie Newbery started teaching embroidery at Glasgow School of Art in 1894, she too transgressed borders. For the first time in Britain, embroidery officially entered male-dominated art schools and was promoted as an expressive form in its own right. This opened the way for later experiments with the formal qualities of fibre as an end in itself, and for excursions into film, photography, performance, dance. More recently a range of cultural theories and practices have also had an impact on textiles, including feminism, modernism and postmodernism. Thus *contemporary* textiles practice has a history (and traditions) which we can *already* view in perspective.[33]

Women, textiles and exhibitions

At any point and at any time we can argue about what Textiles is. But our naming will be provisional. Exhibitions, too, are provisional and, inevitably, partial. So what is their role? Do exhibitions simply reflect received ideas, present what already exists? Or can they operate as dynamic and *reflexive* cultural forms, at the very heart of the construction of identity, culture and meaning?

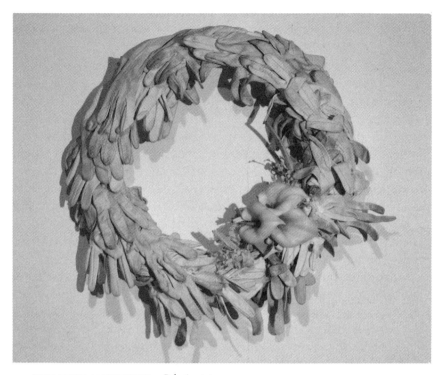

23 ROZANNE HAWKSLEY *Pale Armistice.*
Found gloves, artificial flowers, bone, 1985–86, remade 1988

24 BERYL GRAHAM *Diptych* (detail). Eighteenth-century sampler verse stitched
in red cotton on black and white photo of the artist's grandmother, 1984

'Women and Textiles Today' attempted to actively intervene in dominant discourses, but it did not appear in a critical void. It was indebted to the work of Rozsika Parker, as well as to a number of thematic textile exhibitions of the 1970s and 1980s which engaged in the discourses of feminism and the new art history.[34]

Despite its remit – to pose questions about the relationship between women, textiles and femininity – many of the reviewers could not get beyond issues of categorisation. Perhaps because, as Sarat Maharaj has suggested, avant-garde textiles itself marks out 'the site of dispute and disagreement'.[35] It's 'edginess' provokes argument. Yet even 'avant-garde textiles' doesn't sound right. It infers the march of progress; the promise of a future better than the present. Textiles as 'edgy' and incomplete takes us instead back to 'process' and 'production'. Process conveys 'becoming' as well as 'being' and in that sense belongs to the future as much as to the past.[36]

'Women and Textiles Today' presented textiles as a critical and discursive practice, yet when it opened in 1988 it was already, in a sense, 'retrospective', for it was based on arguments about craft, art and women that were already established. So some of the hostility to the exhibition surprised me. I had forgotten that it takes time for mainstream institutions to assimilate and articulate ideas and developments and even longer for them to be widely accepted. Similarly, I remember wondering why three books on feminism and art published in 1987 hadn't appeared earlier, since their contents seemed so familiar.[37] Unlike newspapers and magazines, exhibitions and books are slow and complicated to produce.

To some extent, 'The Subversive Stitch' exhibitions replicated feminist strategies of earlier exhibitions, which sought to valorise women's craft work. The contemporary exhibition at Cornerhouse was not intended to be definitive, an 'ending'. It marked, to use Stuart Hall's term, a moment of 'unfinished closure'. 'Women and Textiles Today' may not have been the 'right' subtitle for this exhibition, but neither the work nor its contexualisation was intended to present 'women' or 'textiles' as discrete categories. If we think, instead, of 'women' and 'textiles' – like theory – as provisional, then we have a more expansive framework: one which enables other voices to be heard; diverse practices to be seen; and new discourses to be released.

Notes

1 'Embroidery in Women's Lives 1300–1900' was researched and organised by Dr Jennifer Harris of The Whitworth Art Gallery, Manchester. 'Women and Textiles Today' was researched and selected by Pennina Barnett with Bev Bytheway of Cornerhouse, who organised the exhibition.

2 R. Parker, *The Subversive Stitch; Embroidery and the making of the feminine* (London, The Women's Press, 1984).

3 R. Parker, *The Subversive Stitch*, text on book jacket.

4 R. Parker, Foreword to *The Subversive Stitch*, (the exhibition catalogue), (Manchester, Cornerhouse and The Whitworth Art Gallery, 1988), p. 5.

5 'Women and Textiles Today' was shown at: Cornerhouse, Manchester; Shipley Art Gallery; Tyne and Wear Museums Service (1988); Watermans Arts Centre, Brentford; Cooper Art Gallery, Barnsley; City Museum and Art Gallery, Plymouth; Wolverhampton Art Gallery (1989).

6 *City Life* (Manchester, June 1988).

7 M. Currah, *City Limits* (London, 16 January–2 February 1989).

8 G. Greer, 'A Stitch in Time', *The Independent* (3 October 1988), p. 12.

9 G. Greer, 'A Stitch in Time', p. 12.

10 G. Greer, 'A Stitch in Time', p. 12.

11 T. Beck, *The Embroiderer's Garden*, (Newton Abbot, David and Charles, 1989).

12 D. Dowsell, 'The Subversive Stitch', *Women Artists Slide Library Journal*, 24, 1988, p. 25.

13 D. Dowell, *WASL Journal*, 24, p. 25.

14 V. Walsh, 'The Subversive Stitch', *WASL Journal*, 26, 1988, pp. 20–1.

15 V. Walsh, 'The Subversive Stitch', *WASL Journal*, 28, 1989, p. 31.

16 V. Walsh, *WASL Journal*, 26, pp. 20–1.

17 D. Dowsell, 'The Subversive Stitch', *WASL Journal*, 27, 1989, p. 29.

18 J. Wolff, *Feminine Sentences; Essays on Women and Culture*, (Cambridge, Polity Press, 1990), p. 8.

19 J. Wolff, *Feminine Sentences*, pp. 6–7.

20 J. Wolff, *Feminine Sentences*, p. 6–7.

21 J. Wolff, *Feminine Sentences*, pp. 81–2, J. Wolff on S. Harding, *The Science Question in Feminism*, (Ithaca, Cornell University Press, 1986).

22 J. Wolff, *Feminine Sentences*, p. 9.

23 J. Wolff, *Feminine Sentences*, p. 9, J. Wolff citing D. Riley, *'Am I That Name?' Feminism and the Category of 'Women' in History*, (Minneapolis, University of Minnesota Press, 1988).

24 J. Wolff, *Feminine Sentences*, p. 9, J. Wolff citing M. Poovey, 'Feminism and Deconstruction', *Feminist Studies*, 14, 1 (spring 1988), p. 53.

25 R. Parker, *The Subversive Stitch*, p. 11.

26 R. Parker, *The Subversive Stitch* (the exhibition catalogue), p. 5.

27 N. Corwin, in S. Rowley, 'Mind over Matter, reading the art/craft debate', *West magazine*, 1, 1, 1989.

28 S. Maharaj, 'Arachne's Genre: Towards Inter-Cultural Studies in Textiles', *Journal of Design History*, 4, 2, 1991, p. 93.

29 S. Maharaj, 'Textile Art – who are you?', *Distant Lives/Shared Voices*, (Łodz, unpublished essay commissioned for an International Art Project, 1992).

30 S. Hall, 'Cultural Identity and Diaspora', in Jonathan Rutherford (ed.), *Identity: Community, Culture, Difference*, (London, Lawrence and Wishart, 1990), p. 222.

31 S. Hall, 'Cultural Identity and Diaspora', p. 229.

32 S. Hall, 'Minimal Selves', *ICA Documents 6: Identity the Real Me*, (London, Institute of Contemporary Arts, 1987), p. 45.

33 E. Billeter, 'A Few Remarks on the History of Modern Textile Art', *Lausanne Biennial* (exhibition catalogue), (Lausanne, 1983).

34 For example: 'Feministo' (ICA, 1977); 'The Dinner Party', (San Francisco Art Musuem, 1979); 'Women and Textiles: Their Lives and Their Work' (Battersea Arts Centre, 1983); 'Quilting, Patchwork and Appliqué 1700–1982: Sewing in Women's Lives' (The Minories,

Colchester and Aberystwyth Art Centre, 1982); 'Knitting: a Common Art' (The Minories, Colchester and Aberystwyth Art Centre, 1986).

35 S. Maharaj, 'Textile Art – who are you?'.

36 S. Hall, 'Cultural Identity and Diaspora'. These are phrases used by Hall in his discussion of cultural identity.

37 R. Betterton (ed.), *Looking On, Images of Femininity in the Visual Arts and Media* (London, Pandora 1987); H. Robinson (ed.), *Visibly Female, Feminism and Art Today: An anthology* (London, Camden Press 1987); R. Parker and G. Pollock (eds), *Framing Feminism: Art and the Women's Movement 1970–1985* (London, Pandora 1987).

The cult of the individual

Artists do not work in a void; the idea perpetuated by the art market that individual geniuses arrive out of nowhere to make their mark is convenient but untrue. Artists invariably arrive at artistic solutions as a result of various social influences as well as for intellectual reasons. It is said that when Picasso and Braque 'discovered cubism' a thousand artists were working on similar ideas in Paris at the time, and they represented the peak of a pyramid, not an island. Artistic developments are usually being explored simultaneously by a number of artists. In collaborating with other artists you exchange ideas and acquire new skills; it is a public acknowledgement of what happens anyway between groups of people.

The art world, with its recent history of making artworks in studios for galleries, often fails when it tries to create works which have any real presence in a public context, whether a piece of sculpture, billboard or performance art. Collaborations can be particularly useful when they are with people experienced in creating a visual impact within a wider environment and who have the appropriate technical skills.

As an undergraduate student I worked within the space that I was given (approximately eight foot square). I stretched canvases on to the floor, completely covering the area; moving across the surface I dripped paint, printed marks off wet rolls of paper and stuck down newspaper, all the time scratching through the surfaces to reveal buried marks, and in the process integrating the different layers. The finished paintings revealed remnants of newspaper stories vying with traces of paint and charcoal drawing. The whole process was recorded photographically.

On leaving college I acquired my first studio at Butlers Wharf (1977–80). Canvases were torn up and worked on, sometimes in different parts of the room, before being reassembled. The small space of the canvas was being used as a concentrated metaphor for the much wider space we inhabit. Nothing was taken for granted as canvases were deconstructed and reconstructed; so were stretchers, the wooden frames being bound and knotted together and displayed as part of the work. The final shapes of the paintings responded to the dimensions of the rooms in which they were made. Having one of these paintings accepted for the Eleventh John Moores exhibition in 1979 in Liverpool underlined a dilemma; I felt that the painting (not unlike the other works in the exhibition) was 90 per cent history of art and 10 per cent mine; feeling alienated from the former because I felt it was patriarchal, I decided to concentrate on the latter, and there followed a number of years floundering in uncharted areas.

An MA (1979–81) did not help to clarify my position. Lecturers conceded that there was something 'going on' amongst artists like myself, Di Livey and Stephanie Bergman, all working somewhere between the traditionally defined Fine Art and Craft areas, but they didn't know what it was and there didn't seem any appropriate language to deal with it. Prominent feminist teachers and women artists looked at my work and continued to define it within recognised categories. On previous visits to the Women's Arts Alliance to look for supportive material, I discovered an article in an American feminist arts magazine from the 1970s on abstraction as a feminist art form. Everything else seemed to be concentrated around the development of ideas using figuration. Partly to expose the lack of publicity being given to women working with abstraction (the show 'Women's Images of Men' was in preparation at the time), Ingrid Kerma organised a show for six women artists at the Waterloo Gallery in 1980, in which I participated.

A confused period followed where three-dimensional objects, costume and clothing shapes (i.e. non-'Fine Art' cultural objects) were squashed and turned into two-dimensional wall pieces and art by continuing to impose a formal language on to the surface and referring to the work of other artists. Throughout this time I organised as well as participated in exhibitions in gallery and non-gallery spaces. Feedback from an audience was always important and the exhibitions often necessitated invigilation and consequent discussion with the visiting public.

A turning point and liberation was a meeting with Marian Schoettle, an American artist working with clothing. The fact that Marian was unfamiliar with the British art scene and its manifest inhibitions and was so enthusiastic about the artwork was very encouraging. As a development of Marian's written work we devised and researched the exhibition 'Conceptual Clothing' together.[1]

'Conceptual Clothing' (Figures 25, 26) grew out of a need to place our own work in the wider context of the art world amongst other art which used clothing as subject-matter or as a vehicle through which to express ideas. We approached the Arts Council, who expressed doubts about placing this 'popular' subject matter within the mainstream of the arts debate, in particular as it crossed the boundaries between textiles, craft and the Fine Arts. Anything associated with textiles or the functional was traditionally perceived as ranking below painting and sculpture and seen not to belong to a creative history of image-making. Clothing was frequently used by the exhibiting artists as a stand-in for the human figure. There is a marked difference between displaying a dressed figure as part of an artwork and clothing forms shown independently. The former is perceived as being total image and therefore objectified, the latter is seen as incomplete, the viewer being invited to mentally 'try on' the work to complete it. In the first type of work the initial interest lies with the image that the artist is presenting; with the second approach you are drawn more immediately into the artist's experience.

Influenced by research into the exhibition my studio activity focused on the use of clothing. The work started to evolve through the development of ideas rather than continuing to employ an increasingly meaningless formal language. Garments were taken apart, dipped into dyes and printed on paper; sometimes this involved

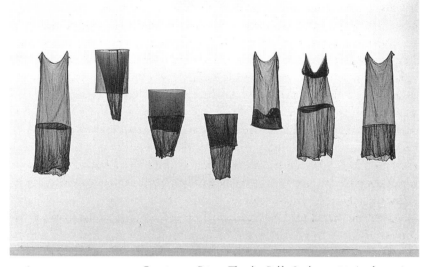

25, 26 FRAN COTTELL *Containment: Private Thoughts, Public Speaking*, 1986. As shown in the exhibition 'Conceptual Clothing', 1986–88. Figure 26, Battersea Arts Centre, 1986

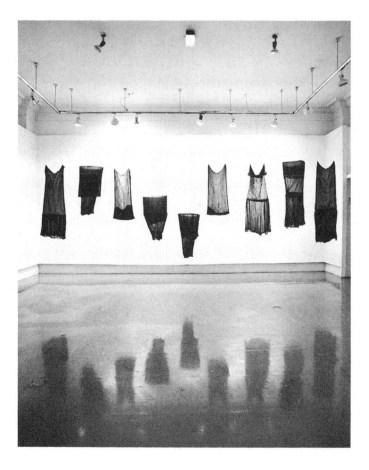

superimposing multiple prints from each layer of clothing. When printed directly on to perspex, the sheets would be shattered and riveted back together again. I began to make sculptural installations which used semi-transparent clothing shapes, the body space being established by a hoop. These empty still shapes invited animation and a series of performance collaborations followed with dancer/gymnast Mary Prestidge.

In the first performance collaboration with Mary (*Tents* at the Battersea Arts Centre, in 1986, assisted by Stefan Szczelkun), the hoop was extended so that large-scale clothing doubled up as a living or 'tent' space. Fine material was used so that large forms could be tied up into small packages extending outwards from the person carrying them. Mary felt uncomfortable working with fabric so in the second performance (*On the ground floor* at the Chisenhale Gallery, 1986) the body/clothing space was integrated into the space of the room. The extension of the body into the space was seen as a metaphor for confidence and the claiming of territory.

Back in the studio the installation *Double Interior* (Figure 27) was devised to combine the two forms of the body and the room. In this installation, the doors became synonymous with armholes. Ultra-violet stitching, not unlike road markings,

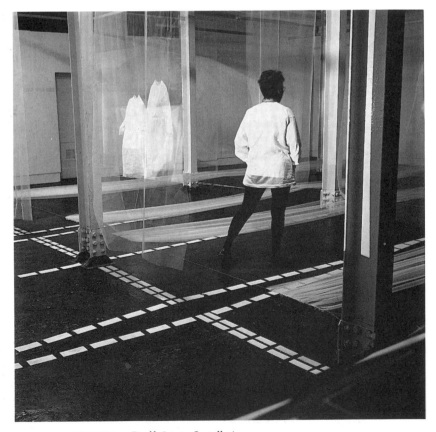

27 FRAN COTTELL *Double Interior.* Installation, Cambridge Darkroom, May 1991

was used to delineate the room as a massive garment. The dress shape that was used would expand or contract to follow the contours of the space that the work was being 'sited in'. In a number of installations during 1989–91[2] the work became more ambitious with the addition of darts and stitching details. A basic pattern shape was used when outlining the space and to make up clothes which would be suspended within the room. Slides of a model wearing a more stylised garment were projected on to the empty clothes, blank walls and through nets which were used as divides within the space. The static, passive and voyeuristic nature of this installation was underlined and reversed when the group of women helpers at the last gallery where it was shown took to the floor and photographed each other taking photographs of the installation. In parallel with *Double Interior* I devised the performance *Undercover* with Caroline Broadhead,[3] which using clothing as a metaphor to look at the construction of identity. This was followed by the performance *Portable Images*, in which we tried to break down the division between the audience and the event by mixing the performers with the audience.[4] Caroline had previously worked with jewellery before developing her work through clothing images and photography. Her approach, always very direct, concentrates on the clarity and presentation of ideas.

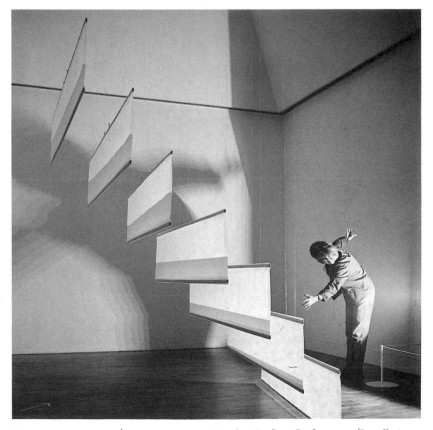

28 FRAN COTTELL/TERRY WATTS *Boundary Condition.* Performance/Installation, Whitechapel Art Gallery, June 1992

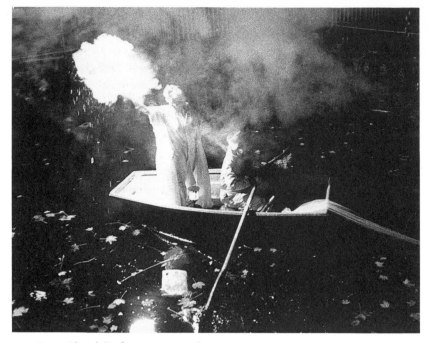

29 *Passing Through.* Performance, 1987. See note 5.

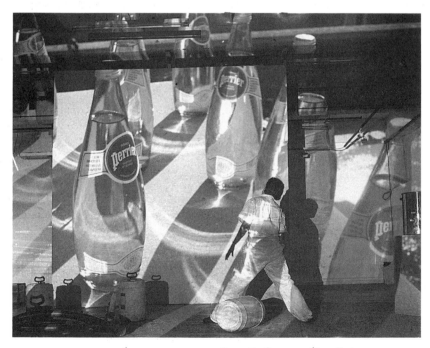

30 FRAN COTTELL/JAN HOWARTH *Source.* Performance/Installation,
Chisenhale Gallery, 1989

Following *Double Interior* other ways of combining the body with a building space were tried. Part of this new work continued to centre around the alienation and the incompatability of the two forms, i.e. the dehumanised nature of contemporary architecture with its emphasis on angular forms which inhabitants continually try to round off with 'soft furnishings', and seeing this as a metaphor for a general sense of alienation within the world. In *Boundary Condition*, a collaborative installation with artist/inventor Terry Watts, shown at the Whitechapel Art Gallery in 1992, a lighting rig was constructed which threw multiple contoured shadows of viewers/participants on to screens echoing the entrances/exits to the gallery as they passed through the space (Figure 28). This piece relied totally on activation by the audience.

Throughout the gallery-based works there has been a strong allusion to time and history. My paintings have often looked like archaeological finds, sculptures like shrouds, and people found the performances 'pagan'. Time as a literal idea was first used in *Passing Through*, a collaborative performance involving a hundred women on a canal in the East End of London (Figure 29).[5] This was a development of the earlier performances with Mary Prestidge, but in this case territory was sequentially claimed and given up. The central idea was that women lead productive lives but 'pass through' largely without trace, leaving very few markers. Rather than viewing this negatively we presented this approach as being 'environmentally sound'. Using very few props, groups of women on boats and alongside the canal performed actions and retreated. The water in this context represented history. The audience (of necessity) took part in the journey along the tow-path, finally being transferred across the canal by barge. In the *Blue Line*, a collaboration with students from Humberside College of Higher Education, as part of an Arts Council's performance placement scheme in 1988, history was again referred to; in this case the short span of human activity was set against the constant movement of the tide. The audience again participated in a journey over twelve hours of events, by double-decker bus. This was followed by a *Meeting Outside Time* (part of Projects UK's 'New Work Newcastle 1988'), a performance in which groups of women walked from different directions to meet on a piece of Northumberland National Park (traditionally border country), untouched by the twentieth century; in this instance using the landscape to represent time. The use of time was an attempt to counter the sense of importance ascribed to the individual, to try to place human activity within a larger perspective. In *A Meeting Outside Time* this sense of history was also to be seen as a form of empowerment, a way of stepping outside contemporary government-imposed restrictions. These same issues have been addressed by creating fusions with and within the environment.

In *Source*, a collaboration with Jan Howarth (Posterngate Gallery, Hull, 1988 and Chisenhale Gallery 1989), the idea that the body is 90 per cent water was explored in a tape – slide – performance – installation (Figure 30). In two recent site-specific outdoor installations, *Skylight* (a Common Ground tree-dressing project, Merton, 1992) and *Projected Landscapes* (Merton Arts Festival, 1993), both collaborations with Terry Watts, we used mirrors and projected light. The aim of these pieces was again to break down categories, but here the perception of landscape itself was disturbed. In *Skylight* mirrors which were attached to the tree and placed on the ground broke up

31 FRAN COTTELL/TERRY WATTS *Skylight.* Tree Dressing for Common Ground
with the London Borough of Merton, December 1992

the total image of the tree, integrating it into the sky and the surrounding landscape
(Figure 31). In *Projected Landscapes* the usual experience of seeing trees reflected in water
was reversed, with water reflected on trees.

Some of the projects which have previously been outlined did not have an
audience, but only participants, as in *A Meeting Outside Time* and *Boundary Condition*.
Participation can mean greater empathy as well as input into the work and the
experience breaks down the categories of audience and artwork. Where the col-
laborators on events have been all women this has allowed for a more exploratory
approach in devising pieces. Audiences have been particularly large where we have
produced accessible publicity which has been hand-delivered door to door, or
where we have made personal visits to local schools, shops and pubs to explain a
project. Galleries and theatres have their place amongst audiences and in the areas
that can sustain them, but where this is not the case it seems appropriate to find
alternative ways of accessing and experiencing artworks. In *River Crossings*, which was
the last project I researched and co-curated for Camerawork in 1993, transport and
commuter routes were chosen as sites, places where there is a 'natural' as well as
an art audience.

In the London Borough of Merton we are now (1994) developing a green arts policy where the artworks often involve devising concepts for parks and school playgrounds; tree planting, water features and landscape where appropriate can be drawn into plans for primarily sculptural seating and wall-painting artworks. The aim of this new work is to develop art pieces which can simultaneously communicate with art and non-art audiences, which maintain high standards and are well thought out as artworks, as well as being relevant to the communities and locations for which they are made.

Notes

1 The research took place between 1984 and 1986. The exhibition, hosted by the Ikon Gallery, Birmingham, toured eight venues around Britain between 1986 and 1988, finishing at Camden Art Centre. Twenty-three artists working with a cross-section of media, including performance art, took part.

2 Painted Bride Arts Centre, Philadelphia; Chisenhale Studios; Greenwich Citizens Gallery and the Cambridge Darkroom.

3 Performed at the ICA, the Painted Bride, Philadelphia and the Crafts Council Gallery during 1989–90.

4 Herbert Read Gallery, Canterbury and Wimbledon School of Art, 1992.

5 Organised with Mary Prestidge, Jan Howarth, Sam Moreton and Chisenhale Dance Space for the Arts Council's performance art promoters scheme in 1987.

On women dealers in the art world

I set up Interim Art in 1984 as a project space. It was a kind of 'hybrid' from the start, with a 'public-spiritedness' in terms of what I wanted to show in the gallery while at the same time creating a model that could work within the commercial sector. I built up my relationship to public grant funding by turning the gallery into an innovative place where artists could experiment. What I received was contingent upon the success of what I showed in a relatively modest space in the East End of London. Public funding enabled me to strengthen the gallery when a very high proportion of what I was doing was curation, promotion and risk-taking rather than selling.

I didn't come from the position of having worked for anyone in the business. From 1984 to about 1987 were my years of apprenticeship at Interim Art, learning from show to show with enthusiasm, creativity and energy. A lot of ground was covered in a fairly short period of time through group shows which had specific themes. The numerous artists who were then showing in the gallery were not actually being 'represented' by it.

By 1987/88 I was starting to put emphasis upon the idea of selling work by presenting it abroad. I began taking the work outside the gallery by travelling more outside the country and by employing staff who began to take an active role in the presentation of work in the gallery. In 1988/89 Glenn Scott Wright started to work with me and there was a sense that I was going to build the gallery into a business: I was edging more towards the idea that I could be taken up as a dealer. Interim was not fully commercial until 1989, when I moved to Dering Street in London's West End for a year.

I have always maintained that I am more an entrepeneur than a business-woman. My approach was more intuitive, based on a passion for the art and a vision that one could create a situation which provides possibilities for artists. It is this entre-preneurial zeal which keeps me going.

One of the things which I felt uncomfortable with in public spaces was the 'revolving door' policy, where artists showed work, but the same artist didn't tend to show there ever again or only after a long period of time. I wanted to build up more continuity in the gallery and a close relationship with some artists that I cared a great deal about and who I wanted to go into depth with. I made a commitment to Angela Bulloch (Figure 32), Helen Chadwick and Langlands and Bell and Hannah Collins very early on. I felt that I could learn as much from the artists as they could from me. I felt that one was marrying interest with interest. The artists I support are enor-mously independent people and it is a symbiotic relationship.

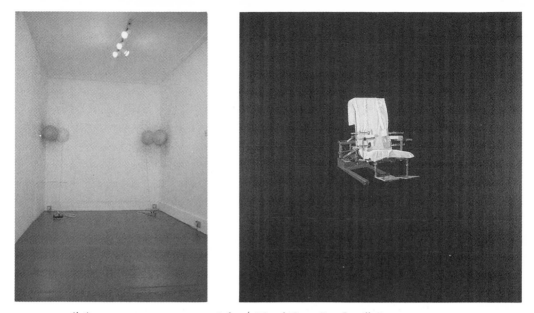

32 (*left*) ANGELA BULLOCH *Red on/off Switch Corner Piece.* Installation.
Polycarbonate spheres, wires, bulbs, electronic switching mechanism, 1990
33 (*right*) JULIE ROBERTS *Assessment Chair.* Oil on canvas, 1993, 60 × 60 in

In the first instance, I wasn't working with many British artists. I was build-
ing my reputation in the eighties by importing work from abroad. The gallery was
being shaped by bringing to Britain artists like Tim Rollins and K.O.S., Sarah
Charlesworth, Charles Ray, Jessica Diamond, Mike Kelly, Barbara Ess, Michelangelo
Pistoletto, Georg Herold, Thomas Grunfeld, Thomas Locher, Rosemarie Trockel
and Gunther Forg. I collaborated with the Institute of Contemporary Arts in
London, showing Jenny Holzer and Fischli/Weiss. These were artists who hadn't
been shown in Britain. I thought a lot of young (and mature) artists, as well as the
general public, would benefit from having the opportunity of seeing their work. In
the late eighties this was an important strategy, as it contextualised the work of the
British artists I showed.

There is a lot of very good British work of the early nineties that I am keen to
show. I am rebuilding the gallery in the East End and reshaping the programme. Having
imported from abroad in the 1980s it is appropriate now (1994), given the climate, to
show young British artists and export them. These include Julie Roberts (Figure 33),
Karen Knorr (Figure 34), Paul Winstanley, Gillian Wearing and Mark Francis.

I am now looking at a kind of self-sufficiency that I feel is increasingly
important. I've been deliberately dividing my time between curation, the gallery, some
lecturing and broadcasting. When you're constantly trying to break new ground and
to renegotiate your position it's quite good to lecture and curate; to take up ideas in
different settings. Curation in a large public space allows me to amplify the vision
which drives the gallery. It's been a very important part of my creativity.

I had always believed that women made incredibly strong work and that

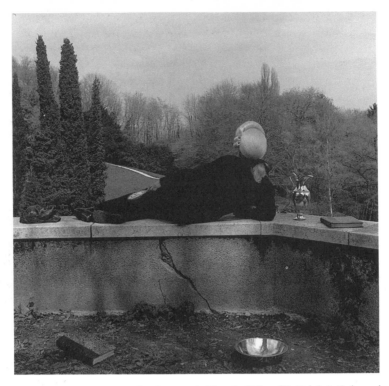

34 KAREN KNORR *The Mistress of the Place: Les Délices (The Delights)*. Colour photo, 1992

women should be taken up in exhibition programmes. This wasn't because I had a gender-blindness or because I was a woman. I soon found out that many of the other dealers in London, my contemporaries in the private sector, certainly didn't think that that was the case, and it was in no way reflected in their programmes. Although we can talk about problems in the public sector, for the most part it has a better track record at showing work by women artists. It's still an area that's very problematic, but it is considered worth while and it is taken up. In the commercial sector this is not an issue that is seen to be important.

If you look at the auction-based dealer galleries that operate commercially in the centre of London, not peripheral galleries that are working in, say, either Portobello Road or the East End, they have a terrible track record in terms of showing the work of women artists. All of these dealers are part of the system in which we are working, whether we like it or not (and the system we might aspire to be within). These are not people who see women's work as being either strong enough or important to them *or* something they have actually seen protected in auction. This is because the most important thing in the art market is that the work of an artist establishes its market value and then consistently keeps that value. These dealers have the world at their feet and have the money and opportunity to show artists like Cindy Sherman, Jenny Holzer or Barbara Kruger, but they don't. This is surprising, as these artists are far from risky in business terms.

If one looks at the Lisson Gallery (prior to 1992), they represented two

women, Shirazeh Houshiary and Avis Newman. They are just now (1994) showing younger artists like Hermione Wiltshire, Rachel Evans and Jane and Louise Wilson. This is a good development, but in general they haven't shown a consistent approach to women. As the Fanny Adams piece in *Art Monthly* in May 1992 pointed out, women artists are often marginalised within the programme. Less than 15 per cent of shows at Lisson, Anthony D'Offay, Nigel Greenwood, Edward Totah, Bernard Jacobsen, the Albermarle Gallery, Grob Gallery, Raab Gallery, the Mayor Gallery and Waddington included women, and in some cases they had shown no women at all throughout the year 1991. There could be years where a gallery is operating and women are not shown at all.

All the battles that were fought in the 1970s and the early 1980s led many people to feel that there is no longer a barrier to women being shown. Angela Bulloch and Rachel Whiteread do not approach the world as if they face a barrier as artists. Some of the younger dealers like Karsten Schubert and Laure Genilliard are including women in their programme, being fairly gender-blind and understanding that there is good work being done by younger and established women artists. There is still an enormous amount of ground to cover. What we are really experiencing is the first stage of tokenism. If you look at the programming and gallery structure, there is, sadly, not a lot of space to display all the deserving talented artists.

From my experience in setting myself up as a dealer, I was always very aware that there was not only a closed shop for women artists but also for women as dealers. London is a 'boy's town', and the old boy network that we are aware of, in terms of the way people are helped when they leave education and are preparing themselves to be in the world, is very much at work in the art world. I know that all the time I've been working, had I been a man doing exactly the same work that I'd been doing, I would have progressed much further than I have. I am not complaining, as I have been very successful.

Coming from North America I was rather shocked when I arrived in Britain and realised this, because when you consider Germany, France and New York it is understood that women are very capable of running commercial galleries, and a great deal of power resides with them. When I look at London, I realise that there are only four or five women running galleries. However, although there are many dealers in the world who are women, they are not necessarily feminists. Traditionally you could say that women dealers have not always favoured women; the assumption is not to be made that just because they are women they will show women. Nor am I arguing that simply by having more women running galleries we will provide better opportunities for women making art.

It was very important for me to have role models in the business who were women dealers of note, Paula Cooper and Barbara Gladstone, for example, in New York; Monika Spruth, Tania Grunert and Esther Schipper in Germany. I was able to find women who ran their business and galleries in a way which inspired me and made me feel part of a group or a network. I don't think that it was all fully conscious but it was something that intrigued me – finding out about their lives and how they began their galleries gave me a lot of encouragement about how to get on.

The gallery in the commercial sector cannot do everything. I think that I recognise the limitation of what I do and what I can offer. Even if an artist has a dealer, they can't sit back and think 'I've got it made'. Artists are not just collected, they are also seen by a broader public. If I place work in collections or exhibitions, that's great, but it is essential for artists to understand that that should not be the only outlet for their work. I support the idea that artists should set up their own gallery spaces. Artists make their own reality. This means not necessarily waiting for the public or commercial spaces to show one's work, but actually seeing that the whole process of organisation and curation of exhibitions is something that can rest with the artist as a possibility for power. Certainly for women artists it's a strong possibility for power, because if you want visibility you can't wait for the institutions that exist to do something about it; they have clearly shown over the years that they are not, even in the nineties, making the kind of strides that they should have made to open up the situation.

In the 1990s, because of the difficulties of the late 1980s, artists are taking matters into their own hands, and understanding the need to be self-organised and more and more co-operative in their efforts. This needs total commitment and the belief that it is an end in itself which is essential and important. Visibility and confidence is what we must work to maintain. Sometimes women are not even aware that they are not even seen to be fighting the battle or getting to the first rung, because they are not in the discussion. I've always believed that the 'squeaky wheel gets the grease', so it's very important to realise that no one can know what to give you if you don't ask for it.

On the question
of censorship

Where do we draw the line?
An investigation into the censorship of art

Introduction

Does art have the right to 'offend' its public? Is it legitimate for art and artists to be exempt from legislation governing 'ordinary citizens'? What kind of responsibility should artists have in producing and disseminating their art? Where do we draw the line? Despite talk of democracy, defenders of artist's rights under the free speech principle have failed to recognise a glaringly obvious issue: that dearly-held beliefs about art are not unquestionable truths, self-evident principles unequivocally for the best. That these are ideological constructs enshrined in artistic practice goes almost unacknowledged. This is characteristic of a problem not only with the moral absolutist terms of the 'freedom of speech' criteria, but a failure of the art community to face up to some of the more contentious sides of the art world: its cultural and social isolation, its own elitism, inequalities, differences and use of regulatory practices.

Censorship: new models for investigation

Since Britain is not experiencing a 'war against art',[1] is the issue of censorship at all relevant to us? I will argue that it is, further proposing that our apathy is due to the limiting ways in which the social function of both censorship and art are conceptualised. It is true that we do not live in a totalitarian regime where political expression is restricted and state bodies vet all material shown publicly. In Britain art does not play a clandestine, subversive role as in the former Eastern Block countries or present-day Indonesia, where artists have been banned or imprisoned. But while art is generally not restricted by overt censorship to ensure its consonance with government values, we do nevertheless live in a country where regulatory practices define our 'civic milieu',[2] and that includes art. The art community has grown accustomed to what it perceives is an unregulated and therefore privileged existence. There are no institutions devoted to the regulation of visual art practice in this country, as for example with the British Board of Film Classification, nor is there legislation aimed solely at art. When visual art is censored it is usually through existing legislation such as the Obscene Publications Act (1967).[3]

Annette Kuhn's study of film censorship, however, argues against this mis-conception, claiming that traditional definitions of censorship limit our under-standing of the processes involved in social regulation and control:

> Historical and sociological studies of film censorship have invariably emphasised its institutional and prohibitive aspects, constructing it as an activity on the part of specific organisations — organisations whose avowed objective is to impose controls on films, usually by excluding from them themes, topics and images deemed for one reason or another unacceptable.[4]

However, despite the absence of such prohibitive organisations in art, various 'incidents' (see below, p. 104) would suggest that art is regulated, but in other ways. For even when censorship does operate through identifiable institutions, not necessarily with the sole function of censorship, e.g. local authorities or galleries (even curators themselves), there is always more to censorship than merely the effect of 'cuts, bans and censor boards'.[5]

Kuhn proposes an alternative investigative strategy for comprehending censorship, which in moving beyond the 'prohibition/institutions' model releases censorship from its limited negative function within organisations, concomitantly liberating the censored artwork from its previous inertia. The art text, no longer a passive object and 'subordinate to the structure and organisation of censor boards and other institutions'[6] is accorded a productive role in a process of regulation.[7] Borrowing from Foucault's theories of power, Kuhn redefines censorship not as a one-way traffic of repression, but as a far more fluid and potentially productive process which emerges through and participates in 'an apparatus or set of practices whose interrelations are imbued . . . with the "play" of power'.[8] This approach permits censorship to be understood not as an agent of (state) repression, but as a process of regulation which is uneven, contradictory, possibly productive,[9] open to conflict as well as resistance and ever changing.

Employing this new approach transforms our understanding of censorship. The question is no longer *what* is this thing called art censorship, so much as *how, when* and *with what consequences* does it emerge? Censorship in Kuhn's 'causational model' is not 'reducible to a circumscribed and predefined set of institutions and institutional activities',[10] knowable through marked instances such as exhibition closures or the excision of pictures from exhibitions, becoming instead something which emerges through 'an array of constantly shifting discourses, practices and apparatuses. It cannot therefore be regarded as either fixed or monolithic';[11] nor is it necessarily immediately observable.

The value of this expanded approach is that it permits censorship to be understood as part of the contradictory practices that contribute to the management of our social order. It opens up the possibility of seeing regulation functioning in 'everyday' ways, both positively and negatively: as self-censorship, in what we allow ourselves to do or even imagine, as a means to circumvent confrontation or the 'principled' exclusion of representation deemed unfit for public consumption;[12] as economic censorship via the provision or withholding of funding, and importantly as something we are all necessarily involved in through processes of selection.

Considered in this way censorship cannot be all 'bad', for essentially it is a process we are all subjectively engaged in. If censorship is 'all around us', how can we ever come to recognise and analyse its operations? It is a point of fact that censorship often goes unrecognised, for its operations are only made knowable through the investigation of social practices. But history does reveal patterns of regulation which appear to emanate from a social or political context. How then do we respond to these 'compounded' or overt incidents of regulation?

Annette Kuhn suggests that these occurrences are recontextualised in a broader investigative framework: 'censorship becomes an activity embedded within an ensemble of power relations, whose operation can be unpicked through attention to particular events and instances.'[13] While the event itself is observable, its extended context only becomes knowable through investigation. In this causational model, the historical, 'real' event or set of practices acts as a 'trigger' for a process of analysis which aims to uncover and 'scrutinise' the operation of social forces through which the event came about.

Britain has not experienced a mounted attack on art, but over the course of the last five years we have witnessed more 'incidents' restricting the viewing of art in the public sphere: e.g. the removal of two nude self-portraits from Pendle Photography Gallery; the prosecution of the Young Unknowns Gallery for conspiracy to corrupt public morals; the cancellation of exhibitions such as 'Ecstatic Antibodies' in Manchester, or Southwark Council's last minute refusal to fund an Irish arts festival; sponsors reversing commitments to fund exhibitions such as 'Egon Schiele' at the Royal Academy; and the continued involvement of the police in exhibitions which involve images depicting naked bodies. Varied as these instances are, they must all be understood as expressions of an anxiety concerning art's cultural role. They raise questions concerning what is appropriate subject-matter, where it should be shown and what its audience should be. And more critically, given recent struggles over definitions of the public sector, what can be shown in publicly funded places, what can public monies support, and who has the right to decide these things.

To move towards a precise understanding of the way in which art censorship is currently functioning, we must recognise that neither art nor 'cases' of regulation can be treated uniformly. There has been a tendency to view the above incidents, amongst many others,[14] as arbitrary indications of artistic philistinism, legal 'contradictions/absurdities/archaisms'[15] or, even more inaccurately, as the crude reawakening of outmoded moral principles. It is essential that we develop a more sophisticated and accurate analysis of why certain and particular artworks are caught up in a grid of regulation, sometimes legal, usually less formal, often 'top down', but just as capable of being 'bottom up'. Failure to do so is to misunderstand the nature of society with its complex and conflicting value systems. The art community gets nowhere by burying its head in the sand or refusing to accept the 'values' of others (even others in its own community) while defending its own rights. How is it possible for the same art text to be 'censored' at one historic moment and not another; for one photograph to be removed from an exhibition in one town, but be 'unproblematical' elsewhere?

What allows sexually 'explicit' advertisements national circulation while the showing of sexually explicit art may be restricted? In short, what may variously cause 'readings' (and feelings) of 'offence'? It is tempting to look for the answer in the art itself. But the very fact that the same work can be viewed as either offensive or not, no matter how justifiable such judgements may be, suggests that the 'problem' *ipso facto* can not lie wholly in the artwork. This signals much greater uncertainties within our social and political fabric.

Deanna Petherbridge/Rochdale Art Gallery: liberalism, cultural difference and the public sector

> It is actually easy to grasp the main thrust of the free speech arguments. What is difficult is to be sure that we understand the dispute to which we bring those arguments.[16]

In 1990 Rochdale Art Gallery rehung 'Themata,' an exhibition of drawings by Deanna Petherbridge first shown in London at Fischer Fine Art, a private commercial gallery. Collectively the curators, without consulting the artist, decided not to hang one of the drawings, *The Judgement against Rushdie* (1989; Figure 35), despite its unproblematic showing in London. That the drawing was considered 'problematic' in one gallery and not in the other, even in a show which addressed a wide range of controversial and political subjects, can only be understood through a broad investigation into the specific social and political forces that affected its interpretation. The differences between the public and the private gallery with their particular audiences and systems of accountability frame our investigation.

Rochdale Art Gallery is publicly funded through the (Labour) local authority of a provincial Lancashire town. As a municipal gallery, Rochdale Art Gallery is expected to 'reflect' the interests (variously interpreted) of the 'public' (which includes a large Muslim constituency) as represented in the form of the elected Council. The gallery's cultural role and artistic policy is negotiated between local authority officials (curators and relevant department officers), elected councillors and funding bodies, such as the Arts Council of Great Britain. Over the years Rochdale has built up a reputation for programming radical and politically committed work from feminists, Black artists and Irish artists. With the management of, and provision for, cultural difference becoming a pressing reality in multi-ethnic towns such as Rochdale, the role of public amenities such as galleries can be crucial in the practical implementation of the Council's commitment to multi-culturalism. By contrast private galleries, like Fischer Fine Art, cannot operate outside the law, but its mechanism for accountability rests with the financial and cultural interests of its directors. By identifying an exclusive art market and appealing to a particular audience, culturally and economically elite, mainly European in origin, Fischer's exhibition policy is framed by economic, not 'public', interests. Indeed one might argue that curatorial decisions simply boil down to the question, will the work sell?

In *Art Monthly* (September 1990) Deanna Petherbridge voiced her concern over the 'censorship' incident: 'If one cannot even name the name Rushdie,

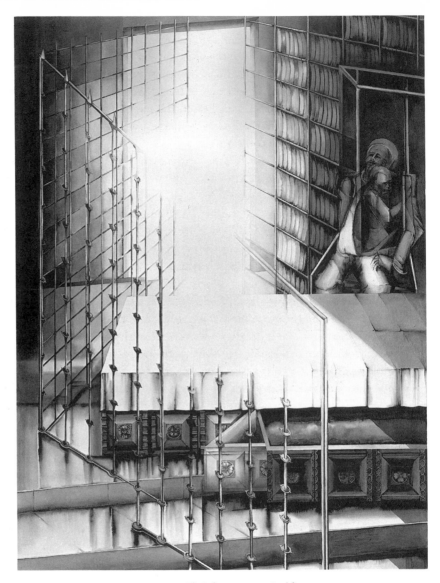

35 DEANNA PETHERBRIDGE *The Judgement against Rushdie.*
Ink and wash on paper, 1989, 150 × 110 cm

irrespective of context and width of debate, then cultural freedoms have already been jeopardised in Rochdale. Rushdie is right: freedom of speech is not divisible.'

In suggesting that the context in which the overdetermined signifier 'Rushdie' circulated was irrelevant, Deanna Petherbridge overlooked the particular political circumstances in which Rochdale Art Gallery was operating. Britain was experiencing a violent debate following the publishing in 1988 of Salman Rushdie's *Satanic Verses*, and community relations in multi-ethnic towns such as Rochdale were extremely volatile. The book had been interpreted by many Muslims as blasphemous and it became a symbol of the injustices perceived by some British Muslims. The

polarised interpretation of the 'Rushdie Affair' between liberal and fundamentalist Muslim communities, coupled with the increased regulation of the public sector and the complex relationship between representation, audience and meaning had determined how her work could be read in Rochdale and triggered the pre-emptive action of the curators. The Rochdale incident has been regarded as an infringement of an artist's rights at the hands of censors. But to discuss this incident through the discourse of artistic freedom (as Petherbridge herself does in her *Art Monthly* article) obscures why and how regulation came about.

Space restricts a comprehensive analysis of the social factors which made various readings of the (censored) text possible: as a drawing of great skill and form (by a feminist artist); as having something valuable to say about artistic isolation and power; as either a potentially culturally offensive or a politically problematic work. But this brief introduction has highlighted certain key elements. At the height of the 'Rushdie Affair' the private gallery context, socially and geographically isolated, publicly unaccountable and with its elite audience, minimised the possibilities of Petherbridge's drawing being read as pro-Rushdie/racially provocative and politically problematic for its curators. Yet the complex racial politics and issues of accountability in Rochdale at the time made these readings probable, heightening the anxiety felt by and acted upon by the Rochdale curators. Although it might seem that Deanna Petherbridge's drawing was totally subordinate to the political situation in Rochdale, the art object is never totally passive in the regulatory process. In writing about 'Themata' Katy Deepwell states that Petherbridge's art resisted 'being contained by a single reading', presenting 'a range of positions from which a specific political issue can be viewed' ('Themata' catalogue, 1990). In considering why this drawing was not exhibited in Rochdale, its textual openness must be 'accorded a productive role'.

The curators' interpretation of the drawing was entirely dependent upon the signification of its title, *Judgement Against Rushdie* – indeed the imagery of the drawing was not directly at issue. Without the title, the formal content of the work could variously connote human alienation, isolation, imprisonment and so on. The work itself contained nothing that anyone might find ideologically 'offensive'. Once the picture was read with its title this openness to meaning was constrained. But the title that Petherbridge selected, while referring to Rushdie, thus framing the audiences' interpretation of the content (the figure in the drawing 'becoming' Rushdie), was nevertheless still suitably ambiguous. Do the title and the picture refer to a Muslim judgement against the writer Salman Rushdie or the artist's own judgement that the author's actions were questionable? Even if the drawing was intended to question artistic responsibility – as provoked by the Salman Rushdie incident – this symbolic reading was still wide open to the ideological 'stance of the viewer'.

Petherbridge's comments in *Art Monthly* are indicative of an absolutist position that assumes that freedom of speech/artistic activity is a self-evident principle unequivocally for the 'best'. Her espousal of freedom rests on the understanding that free speech fundamentally protects the rights of the 'weak' against the 'strong'; censorship restrains the 'powerless' from 'speaking'. Her commentary implies that given open 'debate', 'reason' and 'truth' will triumph over social difference of values. But her

statement does not acknowledge that our society's unequal distribution of power limits access to freedom. This is a reality which most ethnic groups in Britain are daily reminded of. Nor does she seem aware that the line drawn between 'oppressor' and 'oppressed' is not fixed or clear cut, and indeed an artist's personal freedom may limit that of another individual. The absolutist criterion of free speech tends to ignore the fact that we willingly accept many regulations of our freedom and do not call these 'censorship'. There is little sense that freedom is not an overriding neutral principle, but is a value inextricably linked with other values, and cannot exist by itself. What is missing from the moral absolutist appeals to freedom of speech is the recognition that what is at stake should not be an abstract principle, but the issue of values. Without further clarification Petherbridge's abstract appeal to freedom ironically protected the rights of the curators to impose a ban as much as her right to show her work.

If we are not explicit about the values we wish to uphold, it may well be that liberal principles like freedom of speech help to maintain social inequalities we would otherwise seek to eradicate. Ultimately, society comes to terms with social and cultural difference and conflict by 'preferring' and regulating certain values over others. This is not an activity undertaken exclusively by state regulatory bodies, but, as Annette Kuhn makes clear, it is a process we all participate in. The Rochdale incident reveals the difficulty of resolving, evaluating and giving preference to competing values, particularly when the conflict arises between liberals. The action of the curators was not a blanket ban on references to 'Rushdie', but a questioning of the appropriateness of an ambiguous text, given the political context in which it was selected to be shown. Characteristic of a particular postmodern conception of art, as anti-polemical and open to meaning, is the artist's expectation that audiences' plural interpretations will mirror her own cultural liberalism. It seems ironic that Deanna Petherbridge (a 'politicised' artist) should produce an artwork circumscribed by multi-cultural debate but which ultimately is reliant upon a narrow liberal intellectual reading. In effect the exhibition context at Fischer Fine Art closed down the multi-cultural pluralism of the work. The drawing was not 'culturally provocative' *per se*; its exhibition in London and a feature in *Eastern Art Report*, an Asian arts magazine, had been interpreted very differently, as a contribution to the debate; rather it was the particular social context of Rochdale which was 'problematic'. Undoubtedly a public forum (which the artist offered to lead) or publicity material could have closed down the meaning of the text, but could this realistically have succeeded, given the 'explosive' social circumstances of the time? For at the height of the 'Rushdie Affair' it was impossible for the signifier 'Rushdie' – however it was used and in whatever circumstances – not to provoke an intensified response. The curators recognised that the conditions of reception and the ambiguity of the text made for too unstable a meaning. 'In good faith' they judged that the 'value', that the provocation of the text posed, was not 'worth' the price of damaging community relations in Rochdale, which would have repercussions for the Council's own political standing. The curators recognised that though Petherbridge's drawing was in no way intentionally anti-Muslim, in this context it had the capacity to be read as culturally offensive.

It would be wrong to ask Deanna Petherbridge to shoulder the whole responsibility for the regulation of her work, for the chain of causality that the drawing was caught up in was far beyond her immediate control, and the curators should in any case have been mindful of the potential problems when selecting the show. Neither am I suggesting that Deanna Petherbridge or other artists should stop producing culturally provocative work. But it seems vital that artists (and curators) accept that in a fundamentally unequal society, with different cultural values and access to power, artistic values could well conflict with those of social groups. To rally behind a defence of artistic freedom *misses* an opportunity for artists *and* curators to challenge this system of inequality. Might it not be reasonable to expect socially aware artists in particular to be prepared sometimes to sacrifice their artistic values in favour of social ones? The thought that Deanna Petherbridge and many other artists seem unable to acknowledge is that their art *might* at times unintentionally reinforce or provoke a group's sense of alienation.

I have been arguing for an expanded interpretation of censorship. This is not to undermine its significance, but to understand what lies behind systems of regulation, in order that we might pre-empt, confront or change those relations of power; significantly this process restores art to its social context. In defending the principle of artistic freedom, artists defend their own right of exclusion and elitism, protecting art as a privileged domain. To be truly effective in bringing about social change, artists must understand that art is not isolated from other struggles in society and that these are not necessarily antithetical to artistic interests. The art community needs to come out from behind its aesthetic barricades and make connections between the symbolic and the real. Failure to do so ensures the survival of artistic privilege but at the price of foregoing the cultural relevance of art.

Notes

1 For an introduction to the Congressional attacks on art in the USA, see Vance, C., 'The War on Culture', *Art in America*, September 1989, pp. 38–9. It has been widely noted that this censorship crisis served to 'politicise' an otherwise politically apathetic community.

2 Brown, B., 'Troubled Vision', *New Formations Journal*, 19 (1993), p. 29.

3 Brown, 'Troubled Vision', p. 30.

4 Kuhn, A., *Cinema, Censorship and Sexuality, 1909–25* (London, Routledge, 1988), p. 3.

5 Kuhn, *Cinema, Censorship*, p. 127.

6 Kuhn, *Cinema, Censorship*, p. 4.

7 Kuhn, *Cinema, Censorship*, p. 5.

8 Kuhn, *Cinema, Censorship*, p. 7.

9 A number of artists from former Communist countries have lamented that without official state censorship art seems to have lost its purpose and direction.

10 Kuhn, *Cinema, Censorship*, p. 127.

11 Kuhn, *Cinema, Censorship*, p. 127.

12 Even amongst liberals there is profound disagreement regarding the relationship between
 representation and 'reality'. This debate is tirelessly reworked, particularly in regard to images
 of sex and race – do images effect attitudes to sex and race? Even if this causational model
 is not endorsed by liberals, the fundamental question still remains. How should we regulate
 images?

13 Kuhn, *Cinema, Censorship*, p. 9.

14 Brown, 'Troubled Vision', p. 44.

15 Brown, 'Troubled Vision', p. 44.

16 Lee, S., *The Cost of Free Speech*, (London, Faber, 1990), p. 69.

Women's movements: feminism, censorship and performance art

Censorship is a significant issue for women in general and has a resonance for feminist cultural workers in particular. The development of censorship as a concept is, I believe, a key to the critical analysis of a range of work currently being produced by women artists – particularly in the area of Performance Art.

I believe we need to understand further why and how it is that censorship affects our lives and how our particular situation as women is affected by censorship. Here I will look especially at two forms of censorship (although there are many): self-censorship and covert censorship.

When censorship is discussed in relation to the arts, and in particular in relation to women as cultural producers, it is often presented as an oppositional debate between those against censorship, who supposedly argue for 'free expression' (which to me denies the complexity of discrimination), and those who want certain images which they perceive as perpetuating an imbalance of power not to be produced and distributed. While it is important to continue these debates, I believe this confrontation can perpetuate insidious divisions where there is a tendency to consider work as necessarily progressive if it has been banned and where there are simplistic readings of what culture is and what artists do.

Censorship exists. Censorships exist. It is/they are a part of this culture. Censorship serves significant power relations that maintain a system of discrimination which affects women in different ways. Discrimination does not separate women into discrete (equal opportunities) groups or lists, but affects our real lives in individually different ways. As cultural workers many women address issues related to discrimination in rich and diverse ways, involving the complexities and contradictions that are our lives.

There has, however, been a recurrent difficulty, in the women's movement in general and the women's art movement in particular, with the cross-analysis of the discrimations we face as women. Women are still often considered (at conferences and in magazines and exhibitions) as separate homogeneous groups – Black women or disabled women, for example. While I fully support the need for women to organise in autonomous groupings with which they identify, I think it is crucial that there is more space to make the connections and develop the dialogue that acknowledges the diversity of feminist cultural politics. I believe that censorship is a concept that can be used as a way of traversing these differences in a constructive and progressive way.

We operate within the collective knowledge of our culture – that is to say, we live our lives according to ideas and beliefs that maintain the values that exist in this culture, values that (amongst other things) picture women as subordinate, as objects, as things to control.

As such we, as artists, as cultural workers, have an important role to play, namely to 'look' at this culture; to 'see' it, to 'describe' it in our own ways and in our own terms.

Censorship plays a key role in women's lives. Issues of power, control, invisibility, opportunity and access are bound up with the term 'censorship' and need careful consideration. These are issues that women have campaigned around for years, and yet still have a relevance for feminist cultural workers today.

As a practising artist I use Performance Art as the medium for communicating my ideas. As a performer and a woman I have been considering and questioning the medium of Performance Art for many years – in particular the role of women within it. I am also struck by the lack of critical debate and analysis that is applied to Performance Art generally, a medium that has been somewhat overwhelmed by the avant-garde and yet, as I show here, is an area that women continue to work in.

My interest in censorship goes back to a concern with what I, as a feminist artist, have identified as a 'double-bind': *self-censorship*. On the one hand artists have the desire to be responsible for their work; they are conscious of the process of interpretation and the power of the images with which they work. They question over and over again the ideas, the issues, and analyse the implications of the work. On the other hand, they want to produce exciting, challenging work that takes risks, to create images that let ideas run on to generate new and creative possibilities. This is a permanent, creative battle that informs feminist creativity, yet too often silences us or stops us working.

My concerns about the 'double-bind' of self-censorship found some release when I co-edited an issue of *Feminist Arts News* on 'Censorship and Freedom of Speech' with Sarah Edge.[1]

We set out to deal with the complexities of the issue, to make links between the ideas and work of women from different backgrounds. But when inviting contributions we met with some confusion as to how the work could fit into the 'censorship' debate as described earlier. However, considering feminist work within a broad concept of censorship produced a range of articles which opened up the debate in an interesting and challenging way. The issues tackled included personal accounts of lack of access to opportunity (grants; employment, etc.); details of how state censorship effects creativity (section 28); making activities visible (strip-searching); and an analysis of assumptions made about Lesbian creativity.

I have since continued to develop my research on feminism and Performance Art – it is from this research, shared ideas and lived experience that this essay evolves.[2]

For several years I have met women working in and around Performance Art whose work I feel inspired by – work that consolidates some ideas related to issues of censorship defined in relation to discrimination, work that challenges expectations of what Performance Art can be about and pulls us further along.

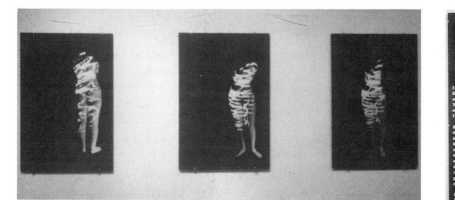

36 MARY DUFFY (A) *Stories of a Body.* Installation
and (B, *right*) text from installation, Rochdale Art Gallery, 1990

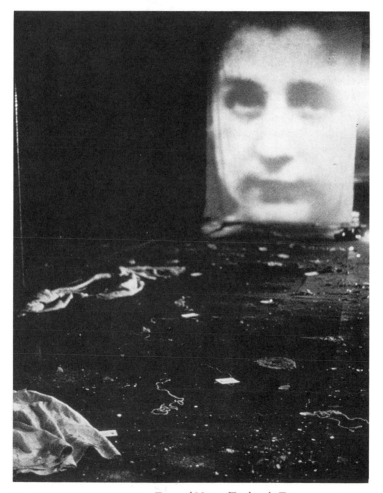

37 ALISON MARCHANT *Time and Motion (Treading the Traces
of Discarded History).* Barchant Mill, Rochdale, 1990

When considering feminist Performance Art it has also been useful to analyse work in relation to a second idea about censorship that I refer to as *covert censorship*. That is, the analysis of ideas which are hard to define, to 'see', especially when you live with them or they are subsumed into the 'his'-story and practice of British culture.

These notions of covert censorship and self-censorship inform my research. They provide a framework for the critical analysis of feminist cultural politics found in a range of women's work being produced in England, Scotland, Wales and Ireland which subverts 'histories' into 'herstories'.

The herstories of the female performer are crucial to the debate on feminisms and censorships. She has stories that are long and varied, which concern how she is placed as the objectified source of visual and physical pleasure for the dominant (male/white/middle-class/heterosexual) viewer: as prostitute; model; singer; actress; dancer; or cabaret artiste . . .

As Sally Potter asked: 'Can women 'use' their own bodies in performance in a progressive way in a culture in which women are consistently objectified?'[3]

These stories cannot be ignored but are necessarily addressed by the feminist Performance Artist before she even starts. I have selected four examples of women's Performance Art to highlight how concepts of censorships can be a useful tool in the critical analysis and comparison of work. The issues which these and many other artists address are complex and difficult to list in neat rows, but can be considered as: versions of history; analysis of body politics; representation of nationality and identity; redefining and renaming; accessing power.

Mary Duffy's performance *Stories of a Body* (Figure 36) challenges notions of normality in relation to body politics. Mary recites a poem standing in front of the audience, naked. She is lit by one light. As a disabled woman artist she confronts her audience's expectations of what a body looks like and relates her story. She controls the space in a stark yet poetic way. Mary writes:

> I made a performance that challenged the traditional depiction of the disabled body as being incomplete, less than functional and pitiful. It was about the many subtle and varied ways my life was mapped out for me at the age of ten according to rules which reveal the value and level of expectations society places on disabled people, especially women.[4]

This piece has been performed widely in a variety of contexts (art and non-art venues), and while it is confrontational in its approach, it is Mary who is spotlit, while the audience is left dealing with the issues raised and their different responses to her. The performance has been accompanied by a photo-text form (Figure 36).

Alison Marchant excavates working-class women's herstory from the perspective of a working-class background. She uses site-specific installation/performances to explore her ideas. In *Time and Motion: Treading the Traces of Discarded History* Alison subverts the cultural stereotype of the rosy-cheeked Lancashire 'lass' (Figure 37). She highlights the strikes, the power, the victories and the noise through a tape of conversations with a weaver interrupted by the sound of thundering looms in motion. She chalks strike dates on to the factory floor, an action which echoes the chalking of

political information on street pavements. The work was performed at the Barchant cotton mill in Rochdale and the Lewis Textile Museum in Blackburn in 1991.

Alison Marchant is not involved in a romantic, nostalgic retrieval but instead she questions as well as acknowledges the past in terms of the present as a way to move forward. In describing her work Alison writes:

> Much of working-class history is defined within the context of middle-class acade-mic conventions subject to misappropriation, stereotypical definition and ideolog-ical freezing. Working through site-specific installation and live art, both inside and outside the gallery context, it is my aim to counter these debilitating notions by making a contemporary art practice available to a broad-based audience that may otherwise perceive artwork as elitist and exclusory.[5]

Many art historians and critics of contemporary women's art have suggested that women turned to Performance Art in the 1960s and 1970s as it was not bound with restrictive traditions but was new and experimental. In *Framing Feminism*, for example, Rozsika Parker and Griselda Pollock state 'Performance offers the possibil-ity for women to make new meanings because it is more open, without an over-whelming history, without prescribed materials, or matters of content.'[6]

Significantly, analysis of the medium of Performance Art is considered within the context of contemporary art *or* the Women's Movement, but the female performer is not considered within the social, historical and cultural contexts she explores or the herstories she tells. This absence in the analysis serves to locate women Performance artists as part of the general avant-garde, but it does not acknowledge that difference, in terms of gender, cultural diversity, sexuality, class, etc. has *as* sig-nificant a role to play in Performance Art as it does in all art forms. It is these lived differences that are part of the 'tool-kit' that feminist Performance artists use when creating their work.

So to perform as a woman is to operate within a series of meanings and ideas that are historically, culturally and socially defined – these shift and evolve, but pow-erful ideas of woman as object are maintained. Women artists today face these various definitions head on and present us with visual strategies, visual conversations which empower and encourage us to continue to live as women in a culture that does not represent us as we wish to be. Significantly, many of the creative strategies used are based on activity – they are about movement and change. Redefining; reclaiming; naming; quizzing; shifting; redressing; mapping; taking control. Challenging cre-atively in many different ways the self-censorships and covert-censorships that dis-crimination against women imposes.

Anne Tallentire's installation/performance *Altered Tracks* (Figure 38) takes on the idea of control and explores the question of a fixed historical destiny.[7] Large sec-tions of maps of Ireland hang near the ground of the performing/installation space. Anne works carefully and methodically to plot a journey through the performance space which relates to the 'life' lines on her hands. She places stones on the charcoal lines which mark out the floor – sometimes treading on the lines, sometimes not. The marks become blurred, altered. Female voices echo the motivation to gain the power to change the future, not to accept a situation as inevitable. She can put the stones

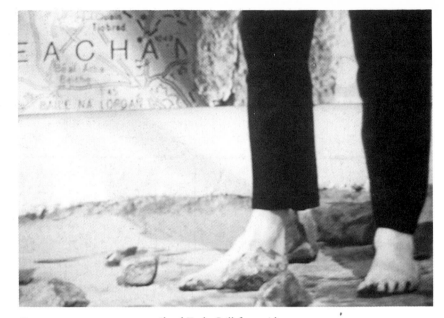

38 ANNE TALLENTIRE *Altered Tracks.* Still from video, 1990

anywhere and change her mind. We can make changes and have influence on our futures – they are not predetermined by some greater force. Anne's work is minimal in its visual impact but leaves space to consider the personal implications of the ideas; she actively engages the audience in her journey.

Delta Streete's work *Quizzing Glass* (Figure 39) uses discrete visual elements to produce (in the words of the artist) 'an invigorating performance tackling some historical roots of contemporary tensions within women-to-women relationships'. The piece was a collaborative performance by Delta Streete and dancer Angela Kennedy, produced as part of their college work and later performed in art gallery settings. Writing about her experience of art school Delta says:

> I started researching into ideas that suggested there was more involved in the consumption, production and analysis of art than the ideologies to which I was being exposed. I looked at the development of a feminist discourse on the arts, not only with a view to the issues brought into consideration by that discourse but also those re-marginalised by it. Specifically the creativity of the blackwomanartist . . . This was a process that led to my realising ways of making artwork that challenged and traversed these conventions, both traditional and otherwise.[8]

Quizzing Glass engages the viewer in observing a series of movements and actions that are systematically developed. Music and slides dissect the space. Costumes and wigs disconnect the piece from the present. The women, one Black, one white, take turns in the leading and echoing of repeated movements. The piece is poetic yet powerful – abstract images of shape and form contrast with real women performing strong and powerful movements.

These works are not, therefore, efforts to reveal the essence of womanhood

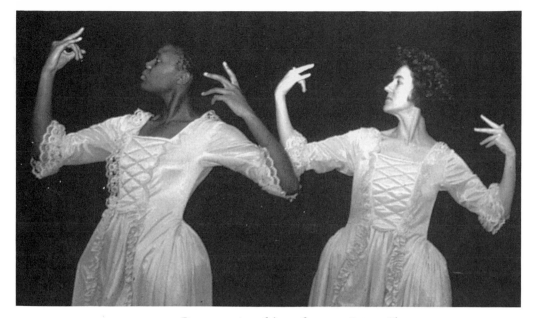

39 DELTA STREETE Documentation of the performance *Quizzing Glass*
by Delta Streete with Angela Kennedy

– to find some inner depths of pure femaleness, as women's performance is often con-
sidered. No; they are complex struggles to gain control of how we are represented in
the world and how we choose to represent ourselves – as performers – as women –
as ourselves. The subjects and ideas tackled concern ways in which women are
marginalised, ignored, written out, written off. Importantly, these works involve iden-
tifying and challenging the sophisticated methods and means through which ideas and
beliefs become accepted as 'truths' and 'facts'.

They, and many many more, raise an awareness of ourselves and others,
through identifying the well-hidden and camouflaged hierarchies of power that criss-
cross our lives. For it is only through this process of understanding that we can
provide a barrage of cohesive progressive ideas from our different perspectives to chal-
lenge discrimination and influence change.

It is my concern that if we do not acknowledge the power and complexity of
censorship in its many guises (including self-censorship and covert censorship), and
just argue against all forms of censorship as opposing free expression, we are not
addressing significant discriminatory processes that exist in our culture.

By considering this (and other) work in the context of the censorship/s
which I have defined, we can continue to dismantle the various structures (political,
social, economic and cultural) that persistently deny equality of opportunity and
access to power – for it is these structures that inform these works. These and other
pieces can then be productively compared and contrasted, with similarities and differ-
ences being addressed in the context of censorships. By grouping work in this way we
can also usefully begin to locate feminist Performance Art critically within the arenas
of art, Performance Art and feminist politics.

Notes

1 *Feminist Arts News*, 3, 8 (August 1991).

2 I am currently (1993/94) undertaking research into feminist Performance in Scotland, England, Wales and Ireland. The research looks at a number of issues in relation to contemporary artists's work, including censorship.

3 Catalogue essay from the exhibition 'About Time' (ICA, 1980).

4 'Redressing the balance' by Mary Duffy in *Censorship and Freedom of Speech* (eds Sally Dawson, Sarah Edge), *Feminist Arts News*, 3, 8 (1991).

5 *Time and Motion (Treading the Traces of Discarded History)*, performed at Barchant Mill, Rochdale as part of the Gracie Fields Live Art Commissions, Rochdale Art Gallery, August 1990. Artist's statement.

6 *Framing Feminism: Art and the women's movement 1970–1985*, eds Roszika Parker and Griselda Pollock, Pandora Press, 1987.

7 *Altered Tracks* was performed widely (for example, in 'Along the Lines of Resistance – an exhibition of contemporary feminist art' curated by Sutapa Biswas, Sarah Edge and Claire Slattery, 1988–89).

8 Delta Streete, cited in 'Women and Modernism' (eds Maud Sulter, Deborah Cherry, Jane Beckett and Lubaina Himid), *Feminist Arts News*, 3, 4 (1989).

Why have there been no great women pornographers?

The aim of an exhibition that I have organised, called 'What She Wants', is to present an experimental reversal of erotic traditions by women artists. The idea is to platform women artists whose work is, in theme or in visual content, about the erotics of looking at men. This includes the process of actually taking the pictures as well as the fears and taboos of showing explicit images of the male body (Figure 40). While there has been a considerable amount of interesting work done in feminist theory and art

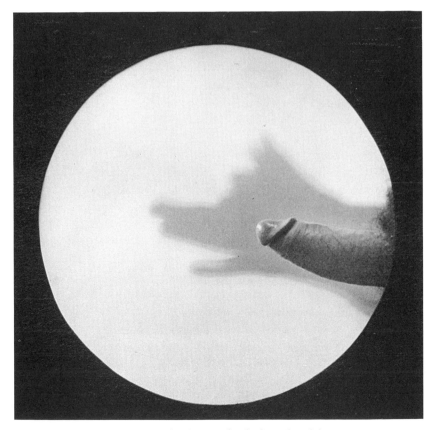

40 DIANE BAYLIS *Who's Afraid of the Big Bad Wolf?* from the exhibition 'What She Wants' held at the Impressions Gallery, York, 18 September–31 October 1993

practice concerning the construction of femininity, the representation of women and the 'male' gaze, there has been much less on female spectatorship and representations of masculinity and hardly anything on visual pleasure, female spectatorship and images of men. If the feminist art critiques have developed from the question, 'why have there been no great women artists?,'[1] then the 'What She Wants' project begins with the question, 'why have there been no great women pornographers?'

I will consider here some of the public, cultural and personal aspects of exhibiting or publishing explicit images of men and masculinity. In my own opinion, it is not so much the legal restrictions which have stopped women from enjoying a visual erotica of the male body,[2] or inhibited the practice of women looking at pornography, but factors more ideological and more unconscious.

There are three cases of what could loosely be called censorship that I want to consider. They all involve women artists and representations of masculinity that have been removed from public display. These examples do not represent a survey on the matter but are situations I know quite well. I think they are useful to discuss briefly in three ways. Firstly from a practical point of view; what was the 'problem', why was the work removed? Secondly, what are the cultural repercussions? Thirdly, what is it about the content/context of these images which may have disturbed audiences/authorities on a deeper level?

The first situation I want to discuss was in 1987, when the 'Invisible Man' show, curated by Kate Love and Kate Smith at Goldsmiths' College, London, was taken down because of Rebecca Scott's large painting, *Porsche Cabriolet*, of a man fondling his erect penis in front of a red car. The Rector considered this one image to be unsuitable as Princess Anne was scheduled to visit the University (Figure 41). In the end the College removed the whole show, and hung their collection of English watercolours in its place.

The second situation was in 1991 when Della Grace's book *Love Bites* came out. This book of dyke photographs was aimed at a lesbian audience, published by the Gay Men's Press, but was refused shelf space at some feminist, left and gay bookshops. The 'problem' images were a series called *Rough Sex*, which showed an orgy in process with a woman being penetrated by a butch type wearing a black dildo, while being held down by another.[3] Thirdly, in 1992, Robin Shaw's photographs were withdrawn from the Brighton Festival. Her series *An Exchange of Views* was included in 'Addressing the Forbidden', an exhibition curated by Alasdair Foster about art and pornography. Shaw's pictures were of a woman looking and arousing herself at the sight of magazines showing men masturbating. These same images had already been exhibited in a London gallery, and indeed have been since.

These three instances do not involve actual censorship by the legal authorities. Rather they illustrate a plethora of smaller committees and organisations acting as if they are the law, or acting in fear of the law. None of the work mentioned above is against the letter of the law, although the police do have the right to raid and remove any of it to a magistrate's court if they so wish. In the case of *Love Bites*, the independent book shops were worried that the images of penetration might provoke a police raid and outrage some of their customers.[4] Gay Men's Press had meanwhile arranged

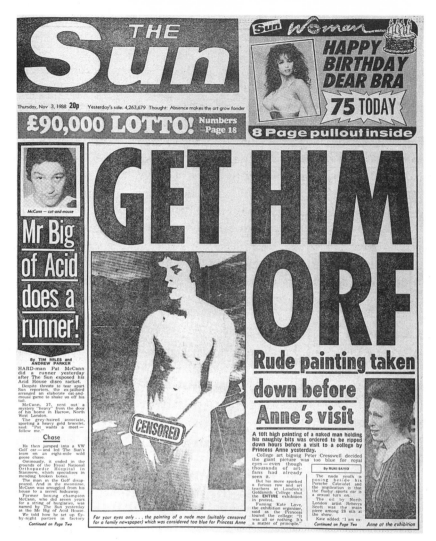

41 Front page of *The Sun*, 3 November 1988. The lead story concerns the removal of Rebecca Scott's *Porsche Cabriolet* (reproduced) from an exhibition at Goldsmiths' College, London, because of a visit by Princess Anne

national distribution and retail with Waterstones, a subsidiary of W. H. Smith. Waterstones were happy to stock it, and give it window space. The book seemed to change its legal status and its political hue depending on where it was sold. Waterstones would not stock a book they considered to infringe the Obscene Publications Act.

In the case of *Porsche Cabriolet*, we have less a concern about the police and more a worry about one particular viewer, a member of the Royal Family. This is not a worry about whether the image will harm the viewer, but a realisation that the picture will be part of how the College will represent itself to a higher power and symbol of the Nation. With regard to *An Exchange of Views*, the Brighton Festival

committee was swayed by fear and apprehension. From what I can make out it was a mixture of fears; that they might lose sponsorship on which they depended; that they might get adverse publicity and give the Festival a bad name. A similar situation to the one above, but including a fear of what the 'public' might think. The organising bodies acted to remove images to safeguard their own self-image. The naked masturbating man was in both cases the unacceptable and undignified other of their authority.

Those in authority in these cases were men. But not so with *Love Bites* which was also treated in this way, as a potential liability. Sisterwrite in North London was the first feminist/lesbian bookshop to decline stocks of *Love Bites*. Their argument was that the book contained scenes of violence against women, which they could not support. They refused to stock *Quim*, the first British-produced lesbian porn magazine for similar reasons. Compendium in Camden took a neutral line, stocked the book below the counter, and would sell it to women customers only. Meanwhile, across the capital in branches of Waterstones, *Love Bites* was visible and available to all. Visibility for marginal groups has nevertheless been the key argument for the continued existence of these alternative bookshops. Some of course did support the book, like Central Books, but many did not, like Sisterwrite, Gay's the Word and Silvermoon. *Rough Sex* presented unacceptable scenarios for some lesbians, feminists and alternative men, whose response was to remove it from visibility, from circulation. The effect of this was to highlight a split within the left concerning representation and fantasy.

I want to consider these 'unacceptable' images at a level of personal response. While we can describe the cultural repercussions of these acts of censorship and develop strategies to fight them, I think it is also important to look at the personal or psychic activities that may have contributed. How is the political censorship of *Love Bites* related to more intimate forms of self-censorship? In psychoanalytic writing about the scopic drive, vision has been described as in between touching and knowing. A crude reading might suggest that the wish to look is always a wish to look at the genitals. For Freud, the wish to look is a component of our sexuality comprising both the wish to identify with the object of the gaze and radically to incorporate the object, to penetrate it and be penetrated by it. Our gaze is not confined to our gender, rather it seeks pleasure in multiple identifications; part of the pleasure is the fantasy of the other's pleasure. The structure of these identifications plays a part in primal fantasies that form the basis of our sexuality. Fantasies of seduction are, for Freud, always reworking the primal scene and in this sense there are no new fantasies, only new formulations of old fantasies. It can be argued that from this perspective the unacceptable representations of sex so far discussed in this paper remind us of fantasies that we already know, but which we resist, and cause us great anxiety.

In the case of *An Exchange of Views* and *Porsche Cabriolet*, the authorities concerned may have been terrified not only by the prospect of scandal, but also by the fantasies that these images invoked for them. The image of the aroused, erect man may have brought up repressed memories of the wish to be penetrated, as well as the desire to penetrate. Anal penetration of a man is considered a sign of weakness or punishment by discourses which authorise men in society.[5] That our society is

founded on a severe repression of male homosexuality is a familiar notion. What is less rehearsed and more interesting for the discussion here and for the project 'What She Wants' is that as representations of aroused, erect penises are often confiscated by the authorities there is little chance for women spectators to respond to these images. The issues that, for instance, *An Exchange of Views* may raise for different women spectators/observers[6] cannot begin to be articulated if the reaction to such images is censorship and if the agenda in debating censorship concentrates only on the authority of those who censor. This is a shame, because amongst the hysteria surrounding explicit images of men are some interesting, if troubling, questions for women, which have been persistently marginalised. If these images bring back homosexual fantasies in male observers what do they do for female observers? Do they involve us in heterosexual fantasies? And what exactly are these? For the woman observer of *An Exchange of Views*, part of the visual pleasure will be in imagining what his pleasures is like. That is identifying with the man in the frame, the fantasy of being a man, of having an erection and penetrating and ejaculating. Other fantasies revolve around ideas of incorporation; taking him inside.

The woman's desire to have an erection and to penetrate is highly charged, and rarely openly discussed. This leads us on to Freud's lamentably misrepresented notion of 'penis envy'. Of all Freudian terms this is perhaps the most offensive to many women. Many women will insist that they have never wanted a penis, as if the very mention of the term is in itself a put-down. In a similar way some men will insist that they have never fancied another man.

The point is that what is being discussed in penis envy is the unconscious, and women's problematic relationship with their masculinity. For Freud, the infant girl, on seeing a boy's penis, recognises it as similar to her own clitoris, and assumes that it has the same erotic function. She immediately judges hers in relation to his, and realises that what he has to represent his phallic sexuality is bigger and better than what she has to represent her phallic sexuality. This is traumatic for the girl, and she resolves it by repressing the sight and the moment of envy, and substitutes for it a constitutive part of her identity as female and different from him. That is not to say that she resolves the problem. Meanwhile no one wants to be accused of wanting something they cannot ever have, and women will never have willies. But they can of course have dildos. Enter *Rough Sex*. What identifications circulate here that are unacceptable to certain feminist ideologies?

Feminism's important advances over the last century have come about through campaigns for material power for women. The fight has been against ideologies of femininity which proclaim women as naturally passive, naturally maternal or naturally inferior to men. As a political movement it has a history of struggle; to change consciousness and statute. But what of the struggle to change unconsciousness? Some bookshops and organisations that are politically committed along the lines of materialist struggle cannot accept *Rough Sex* within their framework, because it could be read as evidence that women enjoy being brutalised, enjoy submission.

On an unconscious level the decision not to stock the book might temporarily assuage the anxiety caused by the scenarios of *Rough Sex*. But if you follow this

line of argument you will have to concur that *Rough Sex* does not in itself cause this anxiety – rather it reminds us of fantasies which we have but which we don't want to have. In *Rough Sex* we have an ambiguous scene. We can see a woman being taken violently by an anonymous and polyvalent assailant. He? She? We don't know. Is she being accosted? Does she want to be accosted? Are the surrounding figures aiding and abetting or taking a part in the staging of her fantasy? Is the one who is penetrating simulating it for her benefit, or acting out her own aggression, her own fantasies of taking? *Rough Sex* confronts us with many possibilities and many difficulties as it opens up viewing as amoral. The women here want to be aggressively masculine and passively feminine. But surely these women can't be feminists as well? And how can anyone who enjoys these images call herself feminist? What is a feminist imagination? Why would it stop short of fantasies of dominance and submission?

I think we need to move the debate on from censorship to start a discussion about self-censorship in terms of our own political ideas. Certainly pressure needs to be put on the networks of media and cultural distribution to include and allow discussion and production of exploratory/celebratory sexual expression. But how can that pressure be applied when issues of our own pleasure cause us so much anxiety?

Della Grace's book can sell in Waterstones, but its meaning there is largely titillation for straight men. I am not against titillation for straight men, but I do think there is an abundance of it available. Women who are producing visual erotica for women are still developing new repertoires, production bases, distribution and audiences for their work. This work is not at odds with feminist aims, but it will not shackle its thoughts to a feminist line on what can be thought about or imagined.

Women currently producing work for the 'What She Wants' exhibition have to confront their own internal censors just as much as the external ones. If we consider the opening question, 'why have there been no great women pornographers?' from this starting-point, then our discussions will not simply cover the very real history of exclusion and marginalisation from the technologies of representation that women have been subjected to but our conversations will also point to the troubling questions of our visual pleasure and the anxiety and trauma that attend it.

Notes

This chapter was written in June 1992.

1 Linda Nochlin, 'Why have there been no Great Women Artists' in Linda Nochlin, *Women, Art and Power* (London, Thames and Hudson, 1989).

2 'What She Wants' is an experimental reversal of the dominant traditions of erotica in which man looks at woman, or male artists eroticise the body of the woman. 'What She Wants' does not assume that the artists in the show are necessarily heterosexual.

3 The 'problem' about these images was the act of penetration. I know, from talking to Della Grace, that all those involved in this shoot were consenting dykes. However, the one wearing the dildo, doing the 'fucking', could be read as male, or certainly masculine. Aggressive

penetration has been considered an essentially masculine activity by various anti-pornography theorists and essentialist feminists.

4 Gay book shops were worried that police homophobia might be visited on them again as in 1984, when Gay's the Word bookshop in London was raided and had to close.

5 See Mandy Merck, *Sex Exposed* (Virago, 1992).

6 Linda Williams '*Corporealised Observers*', 1992 (in which she discusses the problem with the term 'spectator' in film and photographic theory). She invents the term spectator/observer with reference to J. Crary, *The Techniques of the Observer* (MIT Press, 1990) in order to bring in the physical sensation of perception to the debate about vision. For the spectator the image is produced for the audience, whereas the observer is trained to interpret and look out for certain codes or certain phenomena.

The engagement
with psychoanalysis

Just jamming: Irigaray, painting and psychoanalysis

Within English-language cultures, one influential strand of feminist art practice appeals to the psychoanalytic theories of Jacques Lacan to privilege the 'scripto-visual' over painting as a medium for articulating that which falls outside the horizons of patriarchal language. How ironic, therefore, to note that one of the best known – but still least understood – of the French feminist theorists argues almost the opposite. Luce Irigaray wants psychoanalysis radicalised by attention to painting:

> The point about painting is to *spatialise perception* and *make time simultaneous*, to quote Klee. This is also the point about dreaming. The analyst should direct his or her attention not only to the repetition of former images and their possible interpretation, but also to the subject's ability to paint, to make time simultaneous, to build bridges, establish perspectives between present–past–future. In psychoanalytic therapy it is in my opinion necessarily a question of painting, in this sense. . . . *interpretation* can be defined as the ability to compose along with the patient and to help the patient to paint: to represent his or her perceptions and form them into a perspective in space-time.[1]

Like much of late Irigaray, this essay is overly concerned with 'psychological balance' and with reforming the symbolic codes of Western culture by attention to the heterosexual couple. However, the concern to topple a culture that takes the male body and mind as ideal and norm was a constant in Irigaray's work from the beginning. Also from the start there was an insistence that vision is gendered. Irigaray takes seriously Jacques Lacan's claim in *Seminar I* about the importance of optics to his psychoanalytic theory: 'I cannot urge you too strongly to meditate on the science of optics . . . peculiar in that it attempts by means of instruments to produce that strange phenomenon known as *images*'.[2] But Irigaray opposes Lacan, opening up his psychoanalytic system in ways that permit a specifically female relationship with images.

Lacan himself would have deemed this impossible. And as Lacan's view has been more influential in feminist art theory, I wish to make Irigaray's challenge to Lacanian orthodoxy more widely accessible, as it seems to me to have important consequences for women artists and critics. Although Irigaray's own comments on painting are deeply flawed, she nevertheless provides the resources for seeing a way out of the Lacanian impasse. In order to recognise the merits and demerits of Irigaray's analysis, I will first give an account of the relationship between language, image and the unconscious in the Lacanian system.

For Lacan any structured network can be read as a language, including the unconscious. The latter is not a psychic depth, nor a hidden place of the soul resonant with psychic energies or forces: it is rather all that has been excluded from the self-conscious 'I' in order for identity to be constructed. And since that construction has gone on *through* language, the unconscious itself is a kind of echo of refused signifiers that seem to threaten the identity of that 'I'. Some of these refusals are visual. For Lacan language determines images; but images provide the resource (the imaginary) which makes language possible. To see oneself as a unitary subject involves a form of visual *repression*.[3] What is blanked out is everything that would disturb the illusion of the 'I' as controlling and autonomous. Because we cannot bear to view our body as non-unique, as no more than a collection of limbs and organs, the gaze narrows.

To give us a sense of power, we construct an image of the body as *owned* by the seeing/conscious/speaking subject. This image is not chosen or constructed by the subject himself; it precedes subject formation and is, indeed, what makes it possible to say 'I' when we eventually enter the domain of language (the symbolic). The body-image is the result of a dialectical interplay between the subject and the Other/the Mother which occurs during early infancy. This 'Mirror Stage', as Lacan most famously terms it, involves a dialectics that is initiated by desire and by the infantile experience of absence or lack.[4] Thus, within vision there is always a kind of shadow – the optical unconscious – which threatens to destabilise the subject's sense of visual control and his optico-geometrical mastery of space.

In this last paragraph I have used masculine pronouns to indicate the viewing position adopted by both men and women on the Lacanian model. This is because, for Lacan, there is no speaking or viewing position that is that of woman. Indeed, in so far as women speak or gaze – or, rather, can linguistically (and hence conceptually) register vision – they are positioned as masculinised. *Women* can speak; but they cannot speak (consciously) from the position of *woman*. This is because self-identity is first prefigured in relation to a 'cut' from the Other: that which eventually gets characterised as not-self, but which is only thrust into Otherness as the infant experiences non-completion or lack in the absence of the mother. Indeed, the gaze of the M/other serves as a kind of mirror against which identity is constructed and boundaries determined. What is prefigured in that mirror is established more firmly later as the child is inducted into language. At that stage it is the father who comes to symbolise the break between the child and the mother.

For Lacan images themselves function as a network of signifiers, with meaning determined by substitutions and differences. The child forms an image of the mother as incomplete – castrated – in reference to the father, and thus comes to symbolise complete power (the phallus) in masculine terms. The transcendental signifier around which the whole symbolic axis turns is the transcendental phallus, and at an early stage the child comes to dissociate the phallus from the mother and, instead, to associate it with the penis (as the outward sign of sexual difference). The boy images the possibility of castration; the girl images herself as already lacking/mutilated/castrated. Via one of these two doors – possession, threatened with loss, or that which is already lacking – all selves have to enter into the symbolic.

If we are going to disturb this symbolic system that takes the male body and mind as both ideal and norm, then it is the repressed images that provide one of the resources. In the Lacanian model of the mind, the images that do not fit with the construction of the ego persist at the fringes of vision. 'Sanity' involves visual repression. But Lacan is not straightforwardly on the side of sanity. He shows his surrealist ancestry when he indicates that in psychosis, hysteria, ecstasy (*jouissance*), the artificial boundaries constructed around the self to divide the self from Otherness break open. There are intrusions and protrusions into the symbolic from other levels.

In English-language reception of French feminist thought, there has been a tendency to look to the pre-symbolic for a way of opening up the Lacanian system in such a way as to make space for the repressed feminine. Via Julia Kristeva, an appeal is often made to the psychic raw material – component drives and pleasures zones focused on the Phallic Mother – that arises during the pre-Oedipal stage, and that persists in both men and women in adult life. There is, however, nothing profoundly radical about such a move. Thus, for example, although Kristeva allows that males and females relate differently to this material, this is only because of their differing relationships to the absent phallus. The Lacanian symbolic is retained, with its one transcendental signifier (the phallus), although Kristeva values 'feminine' painters and writers whose bond with the Phallic Mother remains traced on the symbolic order.[5]

Very few of these 'feminine' artists are also female, however.[6] Indeed, Kristeva indicates that creative women are disabled by adopting a fetishistic attitude towards their work: treating it as a phallus, in order to compensate for the lack of identity that they experience during *jouissance*.[7] Since Kristeva aims to get rid of the binary opposition man/woman in her psychoanalytic practice and theory, there is nothing specifically *feminist* about her approach.[8] The maternal that she valorises in her semiotic practice is a subject-less corporeal space, more accessible to males than to real-life mothers. Furthermore, self-identity is only firmly established in language (in men and women) *against* Otherness.

Against such strategies, it is necessary to bear in mind Luce Irigaray's basic point. She insists that there has not yet been a psychoanalytic theory that makes *female* identity the developmental norm or ideal. Since the Oedipal relationship describes first and foremost the relationship between a father and his son (with the mother as the third term), the notion of a *pre*-Oedipal psychic moment prior to the construction of sexual difference remains deeply androcentric.[9] Although Luce Irigaray's opposition to Freud and Lacan is often read as the reinsertion of woman's body into cultural discourse, she has quite sharply distanced herself from such a self-description.[10] Her objection to Lacan is more philosophical: that psychoanalytic theory inherits from Western metaphysics a profound inability to think identity in *female* terms.[11] For this heresy Irigaray was expelled from the institutions of Lacanian psychoanalysis.

Irigaray queries the symbolic substitutions (and hence meaning) as construed by Lacan. She also suggests that feminine desire not only falls outside the language–reality system, but possesses an anarchic force that is capable of disrupting the symbolic order. However, her most profound argument against Lacan is that there are

two symbolic axes, not one, around which identity can be constructed. In rejecting the model of the phallus as sole transcendental signifier, Irigaray indicates that there is not just one optical and linguistic repression in the construction of the ego. The second, more profound cultural repression involves a refusal to envisage an alternative model for identity construction; one that would take mother/daughter relations as primary, and hence entail a paradigmatically female dialectic of relation to Otherness.[12]

Within the Lacanian schema woman is merely a part of that *Otherness* against which male identity and Western 'civilisation' are secured. There can be no 'female' or 'feminine' reversal of perspective; *no Other of the Other*. In her early work, Irigaray's solution to the paradoxical position of attempting to speak as a woman within a hostile theoretical space is to 'mimic' that theory in ways that 'jam' the analyses of both psychoanalysis and philosophy.[13] And since both rely on metaphors of sight and mapping to explain the relationship between 'image' and the 'real', she also seeks to 'jam' the sciences of optics and topography. She uses that jamming operation to open up the possibility of another way of mapping reality – a female optics and topography that involves a different relationship to space and time. Irigaray opposes an optics that privileges straight lines, particles and clean-cut identities. Instead, she proffers a morphology of the female body, structured by gradation, shadows, flows and intensive magnitudes.

Irigaray's early position is (deliberately) unstable. But by associating the female with the resistant gaze she opens up possibilities closed to feminist artists who look merely to the pre-Oedipal for models of 'feminine' expression. I do not want to pretend, however, that Irigaray herself has any very profound understanding of painting. In 'The Culture of Difference' she gives a series of practical tips for reforming the female imaginary, cashing out her thesis that the mother–daughter relationship is unsymbolised in art, in the crudest possible terms.

> In all homes and all public places, attractive images (not involving advertising) of the mother–daughter couple should be displayed. It's very damaging for girls always to be faced with representations of mother and son, especially in the religious dimension. I'd suggest to all Christian women, for example, that they place an image depicting Mary and her mother Anne in their living-room, in their daughters' rooms, and in their own room.[14]

Even bearing in mind that Irigaray is writing in a Catholic culture, this treatment of art as mere propaganda cannot be excused. In these oversimplifications (not atypical of her late work), she seems to have forgotten the sustained analysis of the science of optics that was contained in *Speculum of the Other Woman* (1974). There she asserted that, in order to develop a female optics and understand what is not representable in the history of philosophy and by Freud and Lacan: 'It would be necessary to knock down the field of optics whilst at the same time keeping it the same.'[15] Only by this double move would it be possible to see/represent as a woman, given that *woman* is the blind spot of man's gaze. She is the Other/the Mother who acts as the silver at the back of the mirror, flattening reality out and firming it into sharply delineated individualities.

Patriarchal culture freezes fluidity into fixity in the mirror of the (M)other's eyes; but only because it has no perspectival space in which it can mimetically represent the original bond of the infant and the mother. For Lacan, in order to look, women have to adopt an Oedipalised viewing position and become *like men*. For Lacan there is no *Other of the Other*. This is the move that Irigaray refuses. She argues that in patriarchy there is

> *Also an optical chiasmus*. The father denies the condition of specularisation/speculation. He ignores, one would say, the physical, mathematical and even dialectical coordinates of representation 'in the mirror'. He would know nothing of the irreducible inversion which is produced in the identification of the other, as other.[16]

For Irigaray, women's 'look' cannot be a gaze that flattens reality out into a single clear 'truth'. Using the metaphor of a speculum – a curved mirror that represents a rounded reality in ways that make points merge and blur – Irigaray seeks to problematise our understanding of space/time. For her, to be is not to exist first in a specularisable portion of space; but to be extruded from time by a process of becoming or negative entropy.

Such a fluid bond demands a different space/time: one in which wholeness is not a result of adding together individual entities clearly distinguishable in a space/time framework, but in which an undifferentiated chora precedes fixity and ego-boundaries.[17] To rethink identity (so that self is not constructed *against* Otherness), Irigaray will later appeal to 'the placental economy' – the 'neither one nor the other' – that regulates exchanges of fluids between foetus and mother.[18] She also suggests that we rethink our relationship with mucous.[19] Irigaray asks us to consider this ambiguous boundary between the body and Otherness not with horror or disgust (pushing Otherness away as in Julia Kristeva's description of abjection in *Powers of Horror*), but as providing a glorious opening on to a new form of identity-construction – a female divine.[20]

In *Speculum*, using a methodology consistent with her theory, Irigaray has attempted two irreconcilable tasks simultaneously. On the one hand, she sought to jam the established theoretical machinery for speculation and specularisation. On the other hand, she worked to allow a diffuse and fluid identity – identity as a woman – to emerge from the shattered mirror of the specularising gaze of Western philosophy and psychoanalysis. In her early work, at least, Luce Irigaray did not have to be read as a biological essentialist. She was not claiming that being born into a woman's body guarantees seeing *as a woman*. We are reared in a patriarchal culture which does not allow us to explore the revolutionary dimensions of mother/daughter and other female/female relationships. The gaze of the absent male intrudes even into our most intimate relationships: between mothers and daughters . . . and even onto our selves. However, for Irigaray – unlike Lacan – the female symbolic was not closed.

Later, in 'A Lacuna of Birth', Irigaray meditates on the drawings of Unica Zürn (1916–70), and in so doing indicates that woman – and hence also a female art – 'is yet to come (or come again?) in its own forms'.[21] Irigaray reads Zürn's graphics as opening on emptiness, absence, space – and hence Otherness and identity – in ways different from the flattened, fetishised and mutilated female bodies in

contemporaneous art by Hans Bellmer. Zürn, it seems, reaches out to – but fails to touch – 'the mucous' (i.e. the boundary between self and Otherness) 'in its subtlety, its grace, its intimacy'.[22] Zürn fails, because she lives in a culture which is threatened by fusion with the M/other. The male gaze thrusts away Otherness; freezes woman into stasis – producing artistic ugliness and failure of female creativity. For Irigaray, the birth/rebirth of women artists is yet to come. This will come about by representing women's bodies not as passive matter, but as 'the place where the universe was generated'.[23] 'We have volume, meet volume, procreate and create volume. We cannot remain an indefinite enumeration of images.'[24]

In 1953 Unica Zürn became Hans Bellmer's mistress and model. She is there in his surrealist photographs and drawings: naked, trussed, her body publicly fragmented and on display, with a vulva where her right eye should be. Later she would go mad, producing prose recounting trips in and out of insanity; eventually killing herself. What is disturbing about 'A Lacuna of Birth' is the way Irigaray treats Zürn and Bellmer as representative of all women and men within the artistic past. Irigaray's aesthetic model tends to make women artists tragic failures; both consenting and resisting victims. There is a suggestion that things might once have been different; but this eventuality is pushed on to other non-Western, pre-patriarchal ('goddess') cultures.[25] Although Irigaray does not treat the symbolic in the straightforwardly synchronic way that Lacan does, she also cannot register change in the history of the West since Plato. Irigaray wants to open a space for painting or speaking the female; but she first closes down the history of Western philosophy and art to a history of sameness.

If we followed the hints supplied in this 1983 essay, a feminist aesthetics would have to be despairing, utopian or nostalgic. But there were successful women surrealists, as well as tragic failures.[26] We don't have to be trapped into looking for the female imaginary only *beyond* the monolith of the Lacanian symbolic. We can use Irigaray's own comments on 'jamming' in *Speculum* and *This Sex which is not One* (1977) to see that a female optics exists already if we know how to look. If seeing as a woman involves a resistant gaze, then painting has long been a privileged medium in which women have both respected the laws of optics and reversed them, in ways that have employed a gendered dialectics of negation.

Women surrealists frequently represented reality from a 'male' perspective, while simultaneously undoing that perspective. Take, for example, the paintings of Kay Sage (1898–1963). This American surrealist was much influenced by de Chirico; but the latter had claimed that only males were capable of 'metaphysical painting', or of the transcendent melancholy that enabled them to confront the terribleness of lines and angles. Sage insistently and with great melancholy paints lines and angles in ways highly evocative of de Chirico. Yet these spaces are also corrosively feminised; fragile eggs scattered amongst the harsh lines and angles, or with swirls of empty drapery that suggest an absent female poised over and against de Chirico's harsh linear world. In *I saw Three Cities* (oil, 1944; Figure 42) or *The Secret Voyage of a Spark* (oil, 1947), the flame-like movement of the hallowed-out female draperies has more dynamism and potentiality than the cold lines and angles of the metaphysical landscape that her

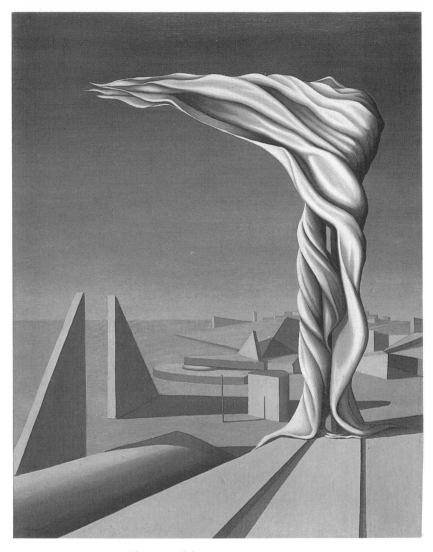

42 KAY SAGE *I Saw Three Cities.* Oil on canvas, 1944

paintings mimic. In her universe, space and time are dialectically structured: negation is not simple emptiness.

A British example would be the surrealist painter and writer Ithell Colquhoun (1906–88). In her *Scylla* (oil, 1938; Figure 43) she reworks the Greek myth of the beautiful maiden, made monstrous and covered in seaweed from the waist down as a punishment for attracting – and refusing – the sea-god Glaucus. The jealous Circe caused Scylla to be solidified into a rock, on which Ulysses' companions and subsequent mariners were wrecked. She is the counter-pole to Charybdis, a whirlpool which sucks other heroes down to the depths. Male identity can only be maintained by preserving a linear path that steers away from the threat that is woman. Colquhoun paints this monstrosity that rises from the sea to wreck the male self. Her divided

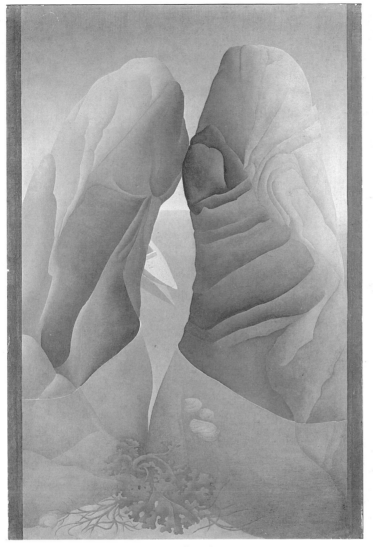

43 ITHELL COLQUHOUN *Scylla.* Oil on canvas, 1938

image simultaneously registers the allure and horror of women's bodies as seen from a male perspective, while also constructing a counter-view in which the monstrous retains its own beauty and integrity. The organic undersea blur of the female genitals pulls the eye down past jellyfish and seaweed, away from the sharply-defined lines of the penile boat and the mass of women's legs/rocks as seen from the upper (male) viewpoint (which emphasises and re-emphasises the phallus). Colquhoun paints with a double perspective which exemplifies the female resistant gaze.

In claiming that a female optics has already 'been born' if we know how to look, I'm making a radical departure from the Irigarayan model. Like Irigaray I would claim that being female is not just a biological 'fact', it is to be assigned a place in a network of symbolic codes, practices and power relations based on the way that one's

body is perceived. However, these codes are neither universal, necessary, static, constant or unchanging. The notion of identity as constructed *against* Otherness is not a necessary feature of the psyche of the Western male, but became dominant in its present form towards the end of the eighteenth century. Even during the so-called 'modern' period, the conceptual frame was by no means monolithic, but contained tensions within it that came from treating the male as both ideal and norm while adopting competing models for masculinity.

We don't have to look only to the future to open up the potentials for a female imaginary. Women in the past and present have already managed 'to be born' as women by – consciously or unconsciously – using those tensions to open up a different (gendered) space. What is needed is not a closing down of the past along Lacanian lines, nor postmodernism – which would assert the end of history – but a different (female) relationship to time. We need to dynamise the history of philosophy, culture and art.

Notes

1 L. Irigaray, *Sexes and Genealogies*, trans. G. C. Gill (New York, Columbia University Press, [1987] 1993), p. 155.

2 J. Lacan *Le Séminaire I* (Paris, Seuil, [1953–1954] 1975), trans. J. Forrester; *Freud's Writing on Technique* (Cambridge, Cambridge University Press, 1987), p. 90; J. Rose, *Sexuality in the Field of Vision* (London, Verso, 1986), p. 167.

3 J. Lacan, *Le Séminaire XI* (Paris, Seuil, [1964] 1973), trans. A. Sheridan; *The Four Fundamental Concepts of Psychoanalysis* (Harmondsworth, Penguin, 1979); R. Krauss, *The Optical Unconscious* (Cambridge, Mass. and London, MIT Press, 1993).

4 J. Lacan, 'The Mirror Stage', *Écrits*, trans. A. Sheridan, (London, Tavistock, [1936] 1977).

5 J. Kristeva, *Desire in Language*, ed. L. S. Roudiez (Oxford, Blackwell, [1977] 1981), p. 191; E. Grosz, *Sexual Subversions* (Sydney, Allen and Unwin, 1989), pp. 63–9.

6 J. Kristeva, *Black Sun*, trans. L. S. Roudiez (New York, Columbia University Press, [1987] 1989).

7 J. Kristeva, *Desire in Language*, ed. L. S. Roudiez (Oxford, Blackwell, [1977] 1981), p. 164.

8 J. Kristeva, 'Women's Time', in Toril Moi *The Kristeva Reader* (Oxford, Blackwell, [1979] 1986), p. 209.

9 L. Irigaray, *This Sex which is not One*, trans. C. Porter (Ithaca, Cornell University Press, [1977] 1985), p. 142; Irigaray, *Sexes and Genealogies*, p. 13.

10 L. Irigaray, *Je, Tu, Nous*, trans. A. Martin (New York and London, Routledge, [1990] 1993), pp. 51–9.

11 L. Irigaray, *Speculum of the Other Woman*, trans. G. C. Gill, (Ithaca, Cornell University Press, [1974] 1985); Irigaray, *This Sex which is not One*, pp. 159–60.

12 Irigaray, *Sexes and Genealogies*, pp. 9–21.

13 Irigaray, *This Sex which is not One*, p. 78.

14 Irigaray, *Je, Tu, Nous*, p. 47.

15 Irigaray, *Speculum of the Other Woman*, p. 337 (my revised translation).

16 Irigaray, *Speculum of the Other Woman*, p. 301 (my revised translation).

17 Irigaray, *Speculum of the Other Woman*, p. 301; *This Sex which is not One*.

18 Irigaray, *Je, Tu, Nous*, pp. 37–44.

19 M. Whitford, *Luce Irigaray* (London and New York, Routledge, 1991), p. 163.

20 J. Kristeva, *Powers of Horror*, trans. L. S. Roudiez (New York, Columbia University Press, [1980] 1982; E. Grosz, *Sexual Subversions* (Sydney, Allen and Unwin, 1989), pp. 71–8.

21 L. Irigaray, 'Une Lacune natale', *Le Nouveau-commerce* 62/63 (1985), pp. 41–7 (my translation, p. 47). For my knowledge of this article, I am indebted to Margaret Whitford who first brought it to my attention and gave me access to her own translation, now published in *Women's Art Magazine*, No. 58, May/June 1994, pp. 11–13.

22 Irigaray, 'Une Lacune natale', p. 45.

23 Irigaray, 'Une Lacune natale', p. 46.

24 Irigaray, 'Une Lacune natale', p. 43.

25 Irigaray, 'Une Lacune natale', p. 43; *Je, Tu, Nous* pp. 15–22.

26 W. Chadwick, *Women Artists and the Surrealist Movement* (London, Thames and Hudson, 1985).

Border crossings: womanliness, body, representation

'She' is indefinitely other in herself.[1]

So, immediately and unmediated, Luce Irigaray presents us in this phrase with three problematic pleasures: 'she', 'other', and 'self'. Or rather, maybe three pleasurable problems: who is she? what is other? where is self? The phrase and the questions raised by it resonate from a significant amount of recent work by women artists — work which is visually disparate, unconnected by media, by formal interests, or by group-ings of artists, but where the central concern is the locating of the female and the fem-inine in the body and through bodily experience. What the work does have in common is an insistence upon the specificity of gendered bodily experience while denying that there is an essential, or core, femininity; instead, the specifics of female bodily experience are seen as cultural and social in origin. Therefore while the expe-riencing of the feminine is the experiencing of the body, at the same time the femi-nine is not essentially of the body: it is mediated through the body and through representation. With artworks, this can be suggested by at least four different bodies: by the body of the artist, whether through its presence or through the trace of its gesture; by the body of the viewer or audience and its experience as it encounters the artwork; by the body of the artwork itself, its materiality; or by the representation of the body within the artwork — its overt subject-matter, or possibly (though more superficially) its proffered content.

The body is gendered. Our understanding of the body, our reading of it, is only possible with a concurrent reading and understanding of gender. The human body is rendered intelligible to a significant extent through the intelligibility of its gender. It is not possible simply to be a person who happens to be female (or male) within our systematics of representation: we do not recognise 'a person', we recognise 'a female person' or 'a male person'. Ambiguity breeds anxiety or transgressive fantasy; the androgyne is the object of voyeuristic fascination, investigation of the extent of its masculinity, its femininity, the search for the marks of similarity or difference, confirmation of otherness and similarity. The body is not a *tabula rasa* upon which gender is projected, but rather gender is one of the aspects through which the body is produced and thus represented, through which it represents itself, produces and is given its meaning.[2]

At the same time, gender — masculinity, femininity — is utterly codified

according to the power structures of a particular society at a particular time. Freud's belief that biology is destiny, neatly and completely body-swerves the extent to which gendered biology is shaped, rendered intelligible, and thus understood, according to those same structures. Women's biology is thus not a pre-given, but is constructed and compromised by contemporary, traditional and local codifications of gender. It is constructed according to contemporary fashion in clothing; access to and beliefs about different foods; etiquette and anxieties about eating; medical practice and assumptions; laws governing family relations; contraception; peer-group pressure; self-censorship and so on. Menstrual cycles, for instance, their regularity, the men-arche and menopause, are affected by diet, stress, exercise and even the proximity of women to each other. These in turn are affected by the cultural and political environment.

> Biology provides a *bedrock* for social inscription but is not a fixed or static substratum: it interacts with and is overlaid by psychic, social and signifying relations. The body can thus be seen not as a blank, passive page, a neutral ground of meaning, but as an active, productive 'whiteness' that constitutes the writing surface as resistant to the imposition of any or all patterned arrangements. It has a texture, a tonus, a materiality that is an active ingredient in the messages produced. It is less like a blank, smooth, frictionless surface, a page, and more like a copperplate to be etched. Body morphologies are the results of the *social meaning* of the body.[3]

But if 'she' (to return to Luce Irigaray's phrase) is essentially compromised – if her 'feminine essence' is shown to be in fact a construct, and not a semi-mystical nugget buried deep within women's souls – then 'she' – she-woman, she-artist, she-image – has room to manoeuvre, to work with the construction. And if 'she' is a construct, rendered intelligible through codification, then 'she' is intelligible only through the languages that make representation, be they visual or verbal. It is here, in representation, that the manoeuvring can take place; in languages that are nothing but representation, subject to codification for their intelligibility. On the borders of those languages and that intelligibility – at the point where either language and understanding reach their limits and end, or new understandings and new meanings have to be developed – we find the women beyond the law/s of the father/s;[4] we find the sorceress and the hysteric; we find the disproportionate number of women who become 'mentally ill'; we find women in political and personal struggle.

We find also she-artist. The classification 'artist', carrying masculine codings of placing work before all, of the overvaluing of the creator and the undervaluing of procreation, and of the codification 'genius' which is always manoeuvred to exclude the female, in her case needs the qualification 'woman'.[5] The codes of femininity imply suppression of desires in favour of others, particularly the family. According to these codings, the definition 'artist' cancels out the 'feminine': the words 'feminine' and 'woman' by definition exclude what it is to be an 'artist'. The woman artist thus transgresses both what it is to be an artist and what it is to be a woman. She-artist is bodily, professionally, of the margins; the (gendered) visuals of her (gendered) body and of her (gendered) work are by their existence transgressive; they are on edge, marginalised; they cross borders.

The body of woman is pervasive in the lexicon and poetics of Western visual language. Woman becomes the aesthetic object of contemplation, a sight, an object, a vision: the body of woman connotes to-be-looked-at-ness.[6] Muse, model, madonna, moll: from religious icon to pornographic photo, the desire for novelty, the desire to possess the woman/image, the desire for power over the object – and ultimately the desire to fantasise desire – all disguise the repetitive similarities of the codes. The bare breast of the lactating Virgin and the bare breast of the 'page 3' pin-up gain their meanings – and provoke appropriate responses – through repetition and occasional modification of the codes of representation. It is a process of banalisation. With the addition of the codes of aesthetics, rarity and the discourse surrounding the artist-as-genius it becomes high art. Inserted into the market-place and given the gloss to stimulate envious desire, it becomes advertising. Lynda Nead has spoken of how the body of woman becomes the major site of policing the border between the obscene and the beautiful.[7] Kenneth Clark (talking about Boucher's *Miss O'Murphy*) unwittingly demonstrates how this happens within the traditions of fine art – who is to be looked at and who is to do the looking, the exactness of the codifications and their policing effect on the experiences, representations and self-representations of the actual bodies of actual women:

> By art Boucher has allowed us to enjoy her with as little shame as she is enjoying herself. One false note and we should be embarrassingly back in the world of sin. . . . To this day a style derived from Boucher is considered appropriate for predominantly feminine establishments, coiffeurs and beauty parlours. He created the image which Venus Naturalis would like to see in the mirror, a magic reflection in which she ceases to be natural without ceasing to be desirable.[8]

The woman artist, working in and with representation, is in an almost sublime position. From the first time that she is given something pink-for-a-girl she is persuaded into a working knowledge of the codes of femininity. From the first time she is scolded for breaking those codes she learns their limits and the rewards for keeping within them. Almost by definition, if the two words are to retain wide intelligibility, the woman–artist is on the margins of her profession and has to negotiate the conflicting codes of 'woman' and 'artist', in her life, in her work, in her concept and representation of self. Working with/in representation, traces of her (gendered) body and (gendered) self are always left in her (therefore gendered) work. The work is thus always a representation of the artist's gender, an embodiment of her embodiment of gender, a gendered self-representation, no matter what its medium or overt context. Furthermore, it will occupy a space where it will be encountered by other gendered bodies, and will attempt to produce meaning for them. That meaning will be mediated through the (gendered) audience's bodily encounter with (the gendered) artwork: it will initially be a bodily, and thus gendered, experience.

The possibilities for exploring the limits of intelligibility through the four bodies evoked at the start of this essay (artist, artwork, audience, image), for stretching and recoding what it is that constitutes 'womanliness', is dizzying in prospect. This is indeed the border known by the sorceress and the hysteric.[9] In the present paradox that is their name, 'woman artists' can consciously become border runners

operating within the no man's land of their developing visual languages. To describe them as occupying similar territory to the sorceress and the hysteric is not to hystericise them, place them as the hysterical 'other' to masculine rationality in the present pejorative use of the word; it is rather to acknowledge the seriousness of their intent, the nature of their risk, and the origins of the modern discourse of hysteria.

The word 'hysteria' is itself redolent with gendered codification and representation, developed as it has been from the Greek *hystera*, meaning womb, and with a current dictionary definition stating 'general features being an extreme degree of emotional instability and an intense craving for affection: an outbreak of wild emotionalism'[10] all of which can be located on a continuum from present codifications of the feminine. And it was Charcot's photographs of his mainly female 'hysteric' patients that were crucial to the developing interests of the young Freud. Inscribed on their faces and bodies with appalling clarity is the impossibility of living in the Western patriarchy. The women were turned through Charcot's photographic gaze into objects to be offered up to the scrutiny and surveillance, the recodification and (mis)representation of the male gaze, in the form of the medical profession. In Charcot's hands (literally) the women and his representations of them became body-as-symptom. And it is upon Freud's interpretation (representation) of the words of his mainly female 'hysteric' patients that psychoanalysis is predicated. What does woman want? he asks, and then in an aside, representing his prejudice and position of power in the guise of polite banter, he suggests that women themselves should not concern themselves with the question as they themselves are the problem.[11] Lacan then follows suit in seeing woman as the proper subject for psychoanalytic investigation.[12] Notably, these are attempts by men to make intelligible through representation the demonstration by women of the limits of intelligibility. As representations of the self-representations of women, the discourse of hysteria has its uses – if often at the point where it is seen to fail by its (gendered male) instigators.

> It is far from certain that woman is more narcissistic than man, as Freud maintained. But for a woman to be able to redirect the insatiable craving for a fine distinctive image toward her inner bosom or, in more psychological terms, her inner solitude, in the exquisite pain of contemplation, daydreaming, or even hallucination – that amounts to a true resolution of narcissism that is not at all erotic (in the Greek sense of the word) but is, quietly or fanatically, wholly amorous. Dissipation of the glance within itself, fusion and permutation of the one and the other, neither seeing nor seen, neither subject nor object; love in the feminine, against which mystical experiences stumble, coils up around the mother–child's tight embrace, the blur of images prior to the 'mirror stage'. A swallowing up of the imagination by the real, the emergence of the imagination under the aegis of the symbolic, the beginning and absolute of the ideal – this feminine facet of love is perhaps the most subtle sublimation of the secret, psychotic ground of hysteria.[13]

For the woman/artist today, Charcot's chosen medium of the camera is often seen as an appropriate tool for aiding border-running, for self-representation, for representing the inscription of gender on the body, for testing the intelligibility of deconstructions and reconstructions of gender. The linguistic codes and representations of women developed by Charcot, Freud and Lacan can be questioned by the

traces of the gendered body of the woman/artist left in her work. For a woman/artist to turn her attention towards the body of woman, attending directly to the borders within representation, can provoke charges of hystericism – that she is narcissistically hysterical, or is hystericising the representation of the body through her narcissism – and it can also run a very real risk of repeating the codes of representation that construct femininity/woman as the object of the controlling gaze of the male subject. However, as Kristeva implies above, narcissism and the masochistic wish to be the object of the male gaze are not automatically the motives for attending to the self. This activity and self-representation may rather connote the primary blissful relationship with the mother. Before the acquiring of language, before the development of subjecthood and the recognition of the other as object; before, even, the infant's recognition of her own boundaries, her relationship with the body of the mother is the bringer of all pleasure; the body of the mother, with which she has to identify into her maturity, rather than differentiate herself from it, as does her brother. Kristeva goes on to chart the differences between narcissism as suggested by Ovid's rendering of the myth, and the attention to self as spiritual exercise, which she exemplifies with Plotinus' belief that the attainable ideal of self reflects the One (i.e. God), and she draws out resonances between the relationship of the self to the One and the relationship of the girl child to the all-powerful mother.

Several women/artists have come to produce work using one or more of the four bodies charted earlier to transgress the limits of intelligibility, to shift the location and construction of the feminine, to produce meaning which is mediated through the construction of the female body and its experiences. Geneviève Cadieux's absolutely vast photos of body-parts – a closed eye, a relaxed hand, a mouth, a woman's blurred face, possibly in pain, possibly in pleasure – insist on an intimate reading, one that is potentially physically overawed. Her equally vast images of ambiguous and unplaceable areas of skin (sometimes bisected by two mouths in an intimate embrace; sometimes puckered by a scar; sometimes bruised) exert a particularly seductive and bodily appeal to the viewer, suggesting transgression of bodily and gendered borders, the possibility of losing the self in the other, or the primary, blissful feminine space in which the desire for the mother is not yet subject to taboo (Figure 44).

In Helen Chadwick's *Viral landscapes* (Figure 45), cells from different fluids of the female body are placed over sections of rocky coastline which in turn recall body-parts. The merging of scale and the use of coastline, with its associations of tides, fluidity, erosion and deposit, immediately raises questions about the location of the interiors and the exteriors of the body and the locations of self and of gender. Another recent installation placed the viewer between two back-lit photographs of meat, cut and laid open, the symmetry of the resultant muscle-patterns disturbingly resonant of female genitals or interior body cavities.

Pauline Cummins and Louise Walsh's photographic and video installation *Sounding the depths* (Figure 46) is nothing if not bodily work. The darkness, the laughter and other noises evoke the interior spaces of the body; the body moving around the exhibition is subject to sensations not often associated with the white, hushed environment of a modern art museum. The body of work is a cohesive whole, with

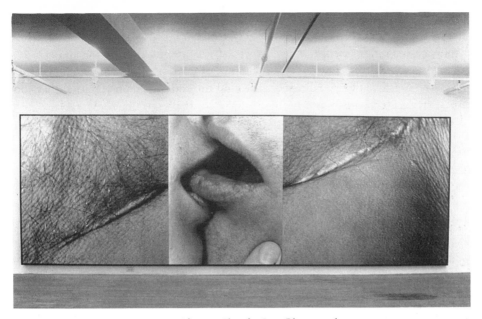

44 GENEVIEVE CADIEUX *La Fêlure, au Choer des Corps.* Photography.
Exhibited at the ICA, 30 July–30 August 1992, 228 × 662 cm

its own integrity and boundaries, yet is also constituted of clear 'body parts'. And central, visually, is the female body represented.

Laura Godfrey Isaacs's paintings (Figure 47) have developed in recent years from being pink canvases with overtly sexualised surfaces (dotted with nipple-like nodules of paint or vulva-like openings) against whose large scale the viewer could lose herself. Now they are more likely to be smaller in scale, relating more to the body of the viewer in terms of size, heavier and intensely visceral. Layers of paint and varnish build up to produce not so much a surface, but more an insistent physical presence, evoking mucous, unnameable interior tissues.

Annette Messager's sometimes witty fragmentations of the body, inscriptions (literal drawings) on to skin, and fragments of sometimes unintelligible writing, all obsessively, fetishistically framed, speak not only of desire, but of desire to rediscover in the loved one (the body of the other) that first, consuming, undifferentiated love (Figure 48).

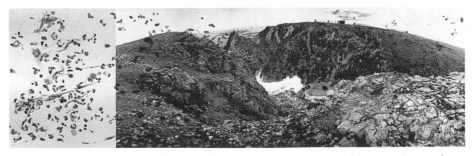

45 HELEN CHADWICK *Viral Landscape #5.* Computer edited montage from cromalin proof, 1984

46 (*left*) PAULINE CUMMINS AND LOUISE WALSH *Sounding the Depths*.
Collaborative photographic and video installation, Irish Museum of Modern Art, Dublin,
1992
47 (*right*) LAURA GODFREY ISAACS *Curtain* (detail), 1990, 274.5 × 305 cm

Lorna Simpson places the black female body at one and the same time at the
centre of, and beyond the reach of, a nexus of representational systems. Hair braid-
ings, combing and tying; items of clothing and shoes; and words with their multiple
significations combined in various configurations demonstrate the limits of present
representations of the black female body. With face turned from the camera or placed
beyond the frame, the presence of the body with its specific histories is asserted, while
the penetrating and possessive aspects of the viewer's gaze are denied.

Sue Williams's paintings are placed on the border between reinforcing and
breaking apart representations of the female body. In her work it is the representa-
tion of woman as victim that is to the fore; women abused, raped, killed, shat upon
– subject matter with which we are all too familiar in popular and high culture. Where
Williams takes her representations up to the border and across is in her refusal of the
aesthetics normally reserved for such representations. Instead of a seamless joining of
femininity, victimisation, glamour, seductive mastery of technical skills, we are pre-
sented with the aesthetics of street protest, of obscene graffiti, scrawled statements
and challenges, a blank surface on to which paint is dragged with evident urgency and
lack of irony. But the border of the aesthetically acceptable, and therefore politically

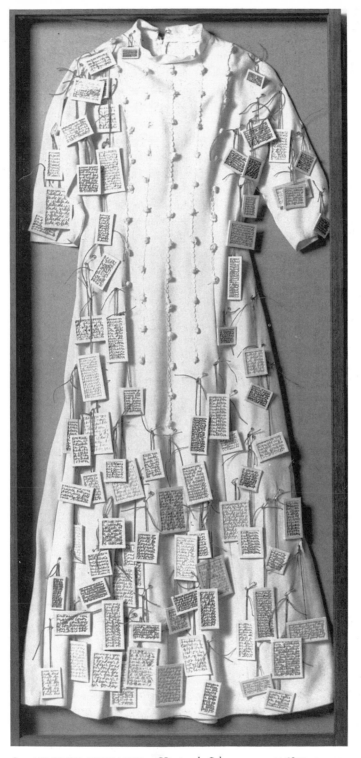

ANNETTE MESSAGER *Histoires des Robes*, 1990, 150 × 68 × 7.5 cm

containable, and Williams's success in the art world will bring new sets of questions about the body of the artist, the body of the artwork, the body of the audience, and the body of the woman represented.

Notes

1 L. Irigaray, 'This sex which is not one', in Luce Irigaray, *This sex which is not one* (Ithaca, New York, Cornell University Press), 1985, p. 28.

2 A similar argument could be constructed against biological essentialism for other experiences of the body in respect of, say, race, age, ability and illness. For the sake of focus in this essay I shall explore only gender, and within that, the female body. The mark of illness as represented through the body will be mentioned, but again with regard to the specific experiences and representations of the female body.

3 E. Grosz, 'Inscriptions and body-maps, representations and the corporeal' in T. Threadgold and A. Cranny-Frances (eds), *Feminine, masculine and representation* (London, Allen and Unwin, 1990, pp. 72–3).

4 The phrase 'the law/s of the father/s' is used to incorporate Lacan's phrase 'the Law of the Father' (the laws to which we all have to submit in entering into language and intelligibility) with those less abstract fathers within families, churches, and by extension within governmental and legal systems.

5 For a full discussion of these points see R. Parker and G. Pollock, *Old mistresses: women, art and ideology* (London, Routledge and Kegan Paul, 1981), particularly chapter 3 and the opening of chapter 4, and C. Battersby, *Gender and genius* (Women's Press, 1989).

6 See amongst others Irigaray, *This sex which is not one*, and Laura Mulvey, 'Visual pleasure and narrative cinema', *Screen*, 16, 3 (1975).

7 L. Nead, *The female nude: art, obscenity and sexuality* (London, Routledge, 1992), pp. 25–6.

8 K. Clark, *The nude* (London, John Murray, 1956), p. 140.

9 For discussion of the concepts of the sorceress and the hysteric see H. Cixous and C. Clément, *The newly born woman* (Manchester, Manchester University Press, 1986).

10 *Chambers twentieth century dictionary* (Edinburgh, W. R. Chambers Ltd, 1983).

11 S. Freud, 'Femininity' in S. Freud, *New introductory lectures on psychoanalysis* (Harmondsworth, Penguin Books 1991), p. 146.

12 E. Grosz, *Jacques Lacan: a feminist introduction* (London, Routledge, 1990), p. 6.

13 J. Kristeva, 'Narcissus: the new insanity' in J. Kristeva, *Tales of Love* (Columbia University Press, 1987), pp. 112–13.

(P)age 49: on the *subject* of history

Page 49 is referred to in the *Historia* section of the exhibition 'Interim' (Figure 49, A–E). It is central to the visual exegesis of the installation and to the argument I am about to make here, but it does not, in fact, exist.[1] Let me explain. *Historia* takes the form of minimal sculptures that resemble four large books. Stainless-steel pages unfold to display a montage of image/text screened on to oxide panels. Mimicking the galleys of a generic newspaper or magazine layout, they imply, not the finished work of a heroic narrative, but the metaphor of *making* history. On the left, the upper register repeats the fragmented image of an unknown suffragette. Part cliché, part *memento mori*, she replaces Charcot's hysteric with the spectacle of women in the political theatre of the 1990s. Below, the metonym VIVA traverses the pages, prompting the viewer to complete a phrase, remember a moment, an event or incident of the 1960s. On the right, in the first column, the narrative begins with an emotive reference to 1968, but the meaning of this reference changes for the different speakers who describe themselves respectively as twenty-seven, twenty, fourteen and three in that historic year. The second column appears as a quote insert, but does not refer to the original story. Instead it elaborates the subjective reflection of the first speaker throughout. In the third column, a slapstick send-up of the older generation breaks abruptly with the nostalgia of the quote sequence. Furthermore, it is presented without a beginning or an end, simply continued from or on the next (p)age, (the page numbers, 40–49, are the approximate ages, in 1990, of the women who were active in 1968), and 49, of course, never comes. So, in effect, the absent page projects the narrative into the imaginary space of the spectator. The space of reading, not literally but figuratively in a field of associations, always *to be continued* in the present. What interests me above all is that I, too, am included in that space and it is from there, on page 49 where I am situated as another reader rather than a privileged interpreter of the text, that I have asked myself the most important questions concerning the implications of the piece.

First, what view of history is proposed here? From the perspective of page 49, I see two distinct concepts of history being negotiated in 'Interim'. One is genealogical, that is, constructive in the sense of description and analysis which applies specifically to Part III, *Historia*, where the past is constituted as a narrative with definitive inclusions and exclusions. The other, archaeological in the sense of layered discontinuities, is viewed across the work as a whole – its separate sections, different themes, diverse media – and posits a history without chronology, positions or answers. This is not a linear history, not, for example, Fredric Jameson's periodisation

49 (A–D *above and facing*) MARY KELLY *Interim, Part III: Historia.* Silkscreen, oxidised steel and stainless steel on a wood base, 1989, each unit 150.5 × 91.5 × 74 cm

of the sixties where 'the new social and political categories – (the colonized, race, marginality, gender and the like)' appear bracketed in an infinite and indecipherable series, one eclipsing the other without consolidation until the classic Marxist paradigm of class can re-establish a *totality*.[2] My inclination is more towards Julia Kristeva's non-linear schema (she calls it monumental time), in which the different moments of feminism – legal (discourse of equality), cultural (representations of sexuality/identity), ethical (potentialities of difference) – would be seen as parallel discourses rather than transitional phases.[3] There would not be a continual displacement of marginal discourses *and the like* by a master narrative, but an accumulation of knowledges about the social. This is also why I would maintain that there is no such thing as feminist art, only an art informed by different feminisms. If the work subscribes to a particular ideology uncritically, then it risks reinventing a social totality that once more does not allow the *others* to emerge from their bracketed identities as the new subjects of history.

This leads to my second question: what is meant by *identity* in 'Interim'? Reading between the lines of the fictitious page, I find a distinction unfolding in the work between identification as a psychically determined process on the one hand, and identity as a social and political voice on the other. For instance, Part I, *Corpus*, focuses on the woman's narcissistic identification with an image, a psychic process that underlines the difficulty of femininity and points to the hysteric's dilemma. Identity is never fixed, yet it is, in a sense, framed, as the work suggests by posing or repositioning the garments, which act as surrogates for the mimetic body, within discursive systems such as medicine, fashion or romantic fiction. By alluding to the look of familiar greeting cards, Part II, *Pecunia*, presents the woman, her things and the artwork itself as commodity, fetish, gift. In fantasy there would seem to be as many forms of identification as there are objects of desire. Nevertheless, because the family is the privileged term of this *mise-en-scène*, desire is, in a way, circumscribed for the woman by the social agency she fulfils (or does not) as mother, daughter, sister, wife. Similarly, in Part IV, *Potestas*, there is a diagrammatic representation of the woman's social status, her statistical identity so to speak, in the form of a bar graph; but there is also the

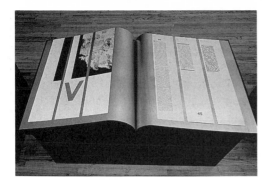
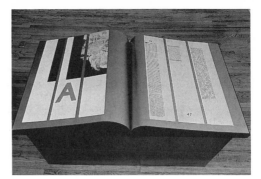

II

I was twenty in 1968.
I'd gone to university, having read the *Feminine Mystique* because my father picked it up at an airport. Perhaps I also had some sense of a feminist tradition from my mother. I knew that she and her friends had struggled to get some kind of education. At Oxford, the term feminism was in use, but bracketed off...as a term of abuse.

I have a vague recollection of the women's conference at Ruskin in 1970, but I was preoccupied with the student occupation then, which was becoming quite militant. I remember people from Ruskin coming to support us, but I didn't get involved in a women's group until I left university and went to London.

In 1971, maybe it was January 1972, some of us formed The Women's Lobby. Our reference point was the traditional suffrage movement. We wanted to do something that would have an immediate political impact, so we decided to try to get the Equal Opportunities Legislation out of the doldrums...one of the Labor MPs had presented it four or five times to the House of Commons and it had been laughed out. So we mobilized a whole range of women's support groups...to write letters, to speak at meetings, to give the issue a public identity and keep it from continuing as an in-joke in Parliament. Out of this came the *Women's Report*. We thought that unless we could provide women with regular information on current affairs and how this affected them, then we wouldn't be making much progress. Eventually we got into a kind of workshop production of the *Report*. It covered legal, parliamentary and social issues, as well as the arts. Some of us were interested in the question of culture, so we started a section called "Images." We used this wonderful typeface...where women's bodies were shaped into letters and we made these lovely banner headlines. I was involved in that until 1974.

Then came the Women's Art History Collective. The very first meeting took place around that time, and we met regularly for almost three years. We were aware of the women's workshop of the Artist's Union, but we weren't directly involved in it. We wanted to explore new ways of doing historical research about women artists, so we did projects...like self-portraits...exploring the historical and political implications of looking at ourselves. We read Nochlin, Berger and that kind of thing...finally, after we had been meeting for quite awhile, we decided to try teaching *collectively* We advertised ourselves and were asked by a number of polytechnics to give presentations. The plan was to make sure that everyone had a chance to speak, that no one dominated, and then, to avoid becoming a collective authority as well, so that the audience could feel involved...but, in fact, the whole project was never resolved. I remember it was really amazing going to art schools...you would present your material and you would see the women in the audience gasp, eyes popping at the possibility of someone daring to come out with this, and then back it up with these astounding statistics. It was a horrendous picture...one that you could see there and then, sitting in front of you...here there were these massed ranks of silent women controlled by these, you know, macho, or at least anxious men at the back.

Our efforts to understand those kinds of stereotypes kept bringing up the question of sexuality and, in our group, there was some interest in psychoanalysis. But I remember my first encounter with the Lacanian lot at The Edinburgh Film Festival in 1976, it absolutely enraged me...made me feel so disabled, so ignorant, sort of castrated by my inability to place myself within that discourse. Yet, it really intrigued me...I wanted to translate our material into this other language. But none of the Collective would follow me down that road...everyone went off to develop her own work and it became defunct as a meeting group.

By then, I was committed to writing the history of our projects and some of the other feminist activities of the seventies, because it seemed to me that there was a process of amnesia in the eighties which was so rapid and widespread that the immense revolution initiated earlier was already disappearing. People felt, or were ideologically pressured to feel, they had to erase it. So, I made myself its immediate archivist...feeling that the documents we had collected had to be made available in a certain form, within some kind of framework, that underlined their significance.

"Each article had to be discussed in detail, then corrected and okayed by the entire group. Most of us had never written anything before. So, one by one, frogs in the throat, knees shaking and all that, we read our contributions. I remember Lorna's. She was hesitant, apologizing first for all the faults we would encounter, and then, finally, after we had coaxed her to continue, she began. The clarity, yes, that's the way it was, we thought. But more, her turn of phrase transported us into a realm of...well, collective ecstasy, I guess, since when she finished no one said a word."

(continued from page 41)

They are interrupted by a man, presumably a friend, in a black silk shirt (presumably washable), but no grey hair (probably dyed). "How old are you?" One Earring asks immediately. The Shirt is taken aback. "Ah...same as you, I guess. What difference does it make?" "No, no, you're younger," she persists. "Never mind," No Lipstick, coming to his rescue, "I think he qualifies. So tell us, what about your students then?" "Mine? ...Well, they're too young to remember or perhaps don't want to... take the concept of repression, Freud's, that is... One of them said to me, 'You mean you want to do something, nobody stops you and you still don't do it? That sucks, sir.'" "Amazing," says No Lipstick. "Tragic," adds One Earring. Then, exchanging The Look of Utter (and Tragic) Amazement, they proceed with their complaints. Meanwhile..

(continued on page 45)

43

49 (E) MARY KELLY *Interim, Part III: Historia.* Detail of text, 1989

description of a more ambivalent relation to power in the elliptical narratives that cut across it.

In writing the stories for *Corpus*, *Pecunia* and *Potestas* I used the first or the third person singular. But in Part III, *Historia*, when the characters give their accounts of the different phases of feminism, they often slip into the first person plural. Here something is evidenced at the level of primary identification which is already constitutive of a collective or political rather than a personal identity; what I might call the function of the *nous* or *we*, playing on Jacques Lacan's reference to the *je* or *I*. In his exposition of the mirror stage, the infant's jubilant assumption of an image precipitates the formation of the *moi*, or me, an ideal ego which in turn gives way to the social function of the *I*. The subject emerges as an effect of language. And the ego, no longer replete in itself, embarks on the Imaginary's course of setting up Ideals elsewhere.[4] Significantly, this fictive but necessary structure is the basis for all secondary identifications and perhaps it also underpins the uncertain destiny of *we*. If a collective identity is formed by replaying the initial moment of *Gestalt* as an image of political empowerment or totalization, then at the same time it produces the alienating effect of a fundamental misrecognition (the feeling of imperfect fit we experience even at the height of our most passionate support for a campaign). So, following the imaginary trajectory of page 49, what does this communal enunciation signify within the specific context of emerging feminism in the 1960s? And, how do *we* represent *our* history now?

The political identity of the early movement was founded on the notion that women were radically *other*; excluded from language, barred access to pleasure; Lacan summed it up with the notorious proposition: '~~The~~ woman does not exist.' In order to come into being, to exist, as it were, a transcendental expression of association was required: 'We are all alike.' But it was the unconscious dimension of this assertion, that is, the desire to identify with someone who was like us, which more fully explained the powerful emotive force of slogans such as 'Women of the world unite.' Unbarring, appropriating *the* universal term for *woman* was the precondition for the existence of a *movement*; its moment of imaginary capture. In the arena of political organisation the effect was to disavow hierarchy, deny conflict and assume mastery in the guise of our collective bodies, our symbiotic selves.

One of the quotation inserts in *Historia* describes the ecstasy of a collaborative writing project. In a mode suggestive of hysterical identification, the group, seized by the discourse of the other – the woman who writes well – claim her work as their own. Another insert, in which a young woman organiser is referring to working-class women at a union meeting, begins, 'They looked indescribably tired, in a way anonymous, perhaps middle-aged or appeared to be even if they weren't.' First, the other is projected as a figure of abjection; that is, not like us. Yet when one of the women starts to move in time with the music in the background, the narrator is overwhelmed by feelings of empathy. Interjecting the other as an image of herself, the quote ends, 'And like us she loved to dance.'

Again, the account of a meeting in 1970 between representatives of the women's movement and an official delegation of women from Vietnam initially

revolves around terms signifying separation and distance: 'The room was cold, they looked at us, it seemed, without expression.' Only when the Vietnamese women begin to talk about their personal experiences of the war is it possible for the group of feminists to identify with them. The other is constructed as victim and, through a vicarious relation to their suffering, incorporated as the same. Narcissistic *over-identification* is central, in my view, to both the pleasure and the problem of identity formation. For instance, by erasing difference in the field of the racial or ethnic other, on the basis of gender the *white* feminists have avoided the objectification of the Vietnamese women, but at the same time, they have obliterated their autonomy and, effectively, their power.

Symptomatically, however, we would insist on separation from the other's *Other*, that is, white men. I say symptomatically, not only because what is repressed, that is, differences amongst women, will return in another form, but also, because in the unconscious, unity, that is, the Real (community of women), must be endlessly reconstituted by desire as a lost object. In the final quote insert, the narrator reflects nostalgically on the significance of the last issue of a magazine which has represented her particular tendency and generation within the women's movement. 'I remember thinking that it marked the end of an important era. There was a sense of loss; loss of collective voice, of body politic, and in a way, of pleasure – I mean, the pleasure of identity formed in the company of other women.'

In this respect the formation of political identity reveals something similar to the psychic structuring of nationality. Slavoj Žižek has observed that our enjoyment as a nation, our *thing* as he calls it, is conceived as inaccessible to the other and at the same time threatened.[5] In fact, the unity of feminism is threatened not by men, but by a different generation of women who 'don't understand'; *post-feminists* and *others*. Our enjoyment as a movement is stolen, displaced by the new social, racial, ethnic and sexual politics of the present. The mythology of feminism, *our* history, comes into being at the moment it is left behind. But this is not the same thing as writing/thinking the histories of feminisms, nor is the impossibility of unity a cause for strategic pessimism. And this returns me to the imperative of page 49.

The slapstick fiction of the series *Continued on the next page* cuts across the reality effect of the biographical narratives and the nostalgia of the quote inserts by sending up the way one generation of feminists denies the activism of another. Implicitly, then, the missing page would argue against a privileged or ideal moment of feminist politics; but it would not necessarily relegate feminist theory, the discourse of psychoanalysis for instance, to the realm of orthodoxy. Rather it would be seen to have continued relevance within the specific sites of struggle which *Historia* traces through the 1970s. Moreover, I think that the alienating effect of the absent ending might suggest that another kind of misrecognition reminiscent of the mirror phase structures not only the formation of political identity, but also its dissolution. The image of unity is always threatened by division and disarray. At the same time this instant of ambivalence is generative; creating the condition of possibility for questioning and repositioning and forming not simply new, but instrumental subjects of a certain age.

Notes

1 Mary Kelly, 'Interim', exhibition and catalogue, New Museum of Contemporary Art, New York, 1990.

2 Fredric Jameson, 'Periodizing the 60s', from *The 60s Without Apology*, University of Minnesota Press, 1984, pp. 178–209.

3 Julia Kristeva, 'Women's Time', from *Feminist Theory: A Critique of Ideology*, trans. Alice Jardine and Henry Blake, University of Chicago Press, 1982, pp. 31–53.

4 Jacques Lacan, 'The mirror stage as formative of the function of the I', from *Ecrits*, trans. Alan Sheridan, Tavistock Publications, London, 1977, pp. 1–7.

5 Slavoj Žižek, 'Eastern Europe's Republic of Gilead', *New Left Review*, 1990, pp. 50–62, 189.

Models of painting practice: too much body?

... painting is privileged in modernist discourse as *the* most ambitious and signifi-
cant art form because of its combination of body and trace, which secure by
metonymy the presence of the artist. These inscribe a subjectivity whose value is, by
visual inference and cultural naming, masculinity.

Griselda Pollock.[1]

In this chapter I want to situate painting as a positive choice in the context of theor-
ised feminist practice and to point out that the basis for certain arguments against
that possibility are not without their own problems.

The project of adopting art forms that did not fit neatly into the 'Grand
Tradition' of Fine Art produced salient, exemplary work and remains an important
strategy. I do not intend to criticise the work of feminist artists engaging the inter-
ventionist intention inherent in this strategy. However, I do wish to point out that it
is nonsense for those feminists to fetishise painting to the point where it can have no
practical use for them, basically re-enforcing a long-standing prohibition.

Much feminist art history has gone into recouping the history of women
painters and there are probably more women painting now than ever before. To regard
making painting as an unavoidable continuation of a masculinist tradition is to place
those women in the invidious position of 'Uncle Toms' within the canon of feminist
art history and theory and that is a strangely negative project for feminist criticism to
undertake.

A body too much

In response to the invitation to write about the relation of psychoanalysis to my work
as a painter I felt an immediate dilemma; I am a painter and not an analyst and
although my reading of psychoanalytic texts informs the reverie that surrounds the
making of my work, they do not structure my work literally. Nevertheless the paint-
ings, prints and drawings have always been intended to fit my own feminist project of
ongoing definition, and this is where psychoanalysis offers authoritative commentary
on both sexuality and subjectivity.

I have been seen as a figurative painter and it is true that figures do appear
in my paintings, although how they appear and with what degree of clarity is an
important consideration. For as much as I am a figurative painter I am also a colour

painter and colour makes its own demands on representation; so figures are rarely given strong outlines or solidly tangible surfaces, nor have they any kind of volumetric core. The considerations of colour lead to a degree of abstraction where the figure has to be felt for rather than seen. What they are doing is more important than what they look like, so I prefer to say I work with narratives of the body rather than figures. Psychoanalysis is based on the word and the text, but in so far as the major theme of its discourse is a betrayal of the impossible demands of the physical body through narration it would seem to be an important study in relation to my work.

Representation of the body in the feminist canon is a fraught subject and there has been great concern to establish 'conditions of hygiene' under which such representations may be viewed. There are times when feminist writings on painting seem to be obsessed with seduction and with policing a puritanical enquiry into which women in iconography have been depicted as prostitutes and whether or not we should look at them. Griselda Pollock's description, in a recent essay, of Matisse's *The Painter and his Model* (1917) is an example of how this innuendo is employed. She points out that the man in the painting is '*the painter*', who is 'clothed', shown observing his female model who is 'naked', 'supine', 'paid', and 'probably working-class':

> [painting] presents to us the space of representation, that canvas, upon which is painted a fictive body which has been invented by the combination of the painter's look and gesture. A social and sexual hierarchy are pictured: the artist is canonically male . . . *his* material is female . . . By its formal disposition of man/artist: woman/model, the painting articulates the symbolic value and symbolic gender in Western modernism's discourse of the 'body of the painter'.[2]

In this account, painting itself seems to be inextricably linked with the 'voyeurism of the male gaze' and the gestures of the male body, and is consequently theorised as an impossible space for the purpose of any female voyeur.

Representation of the female body in painting has become politicised and problematised. The hysterical avoidance of shameful reference to what should be a basic resource of women means that mention of that body has to codified and handled with allusive scientific detachment, distanced, or displaced on to other images or part-objects which can be allowed to stand in for the feminine. Mary Kelly gives a standard position on this in an interview with Paul Smith in 1985:

> I feel that when the image of woman is used in a work of art, that is, when her body or person is given as signifier, it becomes extremely problematic. Most women artists who have presented themselves in some way, visibly, in the work have been unable to find the kind of distancing devices which would cut across the predominant representations of women as object of the look, or question the notion of femininity as a pre-given entity. I'm not exactly an iconoclast, but perhaps historically, just at the moment, a method needs to be employed which foregrounds the construction of femininity as a representation of difference within a specific discourse.[3]

I have two problems with this; first, that I cannot construct femininity, nor am I satisfied with any constructions that I have read; second, that underlying such thinking there is an assumption that visual seduction is necessarily complicitous with male fetishism and so is, necessarily, bad feminism. As a painter I have a special interest here;

painting is one of the most seductive of media and I am interested in its seductions. However, that is not to say that I regard representations of the female body as unproblematic.

Kristeva shows in her book *The Powers of Horror* how images of women seen without distance become the very image of horror. Her description of Celine's obsession with the work of obstetrician Ignaz Semelweiss, a man with intimate contact with perhaps the ultimately female image — the woman in childbirth, shows how that contact with the feminine presages death and decay. Celine devoted his doctoral dissertation to the infection that develops during childbirth, puerperal fever. Semelweiss discovered that this fever was caused by infection via doctors' hands from corpses they had touched prior to the delivery. Kristeva writes: 'puerperal fever is the result of the female genitalia being infected by a corpse; here then is a fever where what bears life passes over to the side of the dead body . . . a panic hallucination of the inside's destruction, of an interiorisation of death following the abolition of limits and differences'.[4] The remedy, says Kristeva, involves hygiene, not touching, separating, washing and purification: distancing devices.

Kristeva's description of the dangers of contact with the female body seems to echo the meaning of another story, Freud's account of his dream of Irma's injection.[5] Freud was attending a party and he looked into the mouth of a lady who was also a guest. He was disgusted and disturbed to find it ulcerated and horrible. In the second part of the dream he joined his medical colleagues, the prescription Triethylamine was found and everything was back under control, but for a moment he was sickened by the sight of 'the very origin of the world', the equivalent of the female genitals, a sickness that Kristeva calls the abjection of contact with the feminine. This 'hygiene' about the viewing of representations of female bodies is not essentially a feminist concern but the basic cultural exclusion on which society is founded. An instinctual exclusion through 'natural' disgust, clearly experienced by Freud himself, and by implication an underlying theme of Freud's construction of psychical reality.

The question that I would like to ask at this point is that if feminism is about progress, then how can that project be framed in relation to this exclusion? I must emphasise that I do not think that you can simply rectify exclusion by dint of inclusion. To put in place undesired representations of the female body as a form of counter-assertion may provoke only negative response, and this is not progress. Judy Chicago's *Dinner Party*, for example, is a brave attempt to employ this strategy by placing on display flamboyant and highly aestheticised versions of female genitalia, but in reality it offers no solution either to the pain of exclusion from images or the pain of inclusion in only highly circumscribed circumstances.

Nevertheless, maybe some vision of what is to be included would be a good starting-point, and Parveen Adams gives this vividly in her discussion of Mary Kelly's *Interim*. Adams recounts the story of Aeneas in Virgil's *Aeneid*, looking at a painting (I would stress that it is a painting he is looking at) of a scene from the Trojan War. Aeneas is deeply moved by what is depicted and says, 'Great valour has due honour; they weep here for how the world goes, and our life that passes touches their hearts.'

Adams comments here: 'His story is understood; he sees it as it is seen. Aeneas as subject of the signifier finds his past before him. There is a subject-supposed-to-know and there is interpretation. Aeneas says "throw off your fear, this fame ensures some kind of refuge".' Parveen Adams asks her readers, 'is it too far-fetched to say that this ordering of signifiers brings a certain peace of mind?'[6]

Aeneas had been 'at a loss', he had come through a storm, lost men and ships, and found himself in a strange land. But seeing that his history was understood enabled him to survive and make progress. Now this is all very well for Aeneas, to find his historic deeds recorded, but Parveen Adams has chosen an image of male heroism in order to mirror the strategy of Mary Kelly's *Interim*, a less than heroic account of the daily concerns of women's existence. I am not complaining here of a lack of heroism in Mary's work, but note that in the case of a subject-supposed-to-know in the context of feminine exploits we are offered narratives of a very different nature that would probably have compounded Aeneas' disorientation had he found them instead of the narratives that he did find.

Adams also proposes an analogy here between *analyst* and *analysand*, and how a work of art may work on the spectator. 'Perhaps', she says, 'what *Interim* does is to whet your appetite for a feminine ego ideal, for a point of view from which we can feel satisfactory and loved.' But the model here is still Aeneas. I, too, would like to use that model so that progress might be made towards a 'feminine ego-ideal', but I am having difficulty constructing that progress. To substitute a 'male ego-ideal' with documentation of a 'female–real' seems to be a reiteration of the status quo.

Freud himself solves the problem of dealing with less than heroic individual narratives by finding mythic structures that fit. In this way the stories can be interpreted within a larger context and progress made. I have no faith in mythology. It seems to lead directly to the abjection of contact with the feminine that creates the horror and confusion that Kristeva describes and which Freud felt so forcibly. Somehow that image of abjection has to be redeemed.

So the questions have to be asked: how am I using narratives, and, how am I representing the body, taking into account my assessment of the problems? Looking at my paintings, narrative might seem too strong a word to describe anything happening there, because the bodies are not caught in any particular sequence of events that can be recognised. I am interested in the simplest movements of the body, prior to gender and prior to speech. A slight turning of the head, a moment of instability where the figure falls or rolls towards the spectator, a movement of the arm across the body or the face, an attempt to lift the head against gravity, or just a feeling of pressing a weight to a prostrate form. The important thing about these gestures is that they are moments of animation that are felt, not described, and that they come as a surprise, something unexpected from the appearance of the painting, a moment of change in the image, an optical effect that could not be quantified in purely visual terms (Figure 50, A and B).

My paintings are often monumental in scale, and so even slight movements seem huge. In confronting these movements the onlooker feels aware of the body's presence in the painting even though its outlines are not firmly drawn. I want this

almost invisible but intensely heavy body to be not-there yet too-much-there simultaneously.

My second strategy, also optical, is about seduction. I want to create a tension between the figure and the ground so that when you look at the area of figure it assumes one kind of shape, pushing out expansively against the ground. When you look at the ground the opposite takes place, a shrinking as the ground expands. The edges of the figure and the ground merge, sometimes tonally, sometimes the ground seems to penetrate the figure, sometimes the figure spills over on to the ground, so the eye is always engaged in locating the figure but never quite satisfied that the description is complete.

The investigation of the figure motif leads subversively to an investigation of the surface of the painting and the painting's real seduction, paint itself, its substance, its tactile qualities: is it oily or dry, opaque or translucent, thick or thin? Paint contains the history of contact with the painting: soft, stroking movements, scraping, scratching rhythms of the hand; and phenomena – splashes, blots, dispersions of substance against the tension of the canvas. The surface of the depicted bodies is always the body of the painted surface, not a positive, moulded form, but a void in the wrong place.

The physical presence of the work is nevertheless about strength and interaction with the spectator. These voids do not retire. In a recent series I attempted to paint the gaze of the painting back at the onlooker, a series of yellow heads each of which had a distinct way of looking at you, or not looking on some occasions. The paintings were extremely simple shapes using the pigment *jaune de baryte* on white, and no eyes were present to say where the gaze was from. These pictures were to be installed in a long series, so that as the eyes of the spectator shifted, so did the painted shapes. The presence of the onlooker was always qualified. *Jaune de baryte* is a very cold pale lemon that almost disappears against the white but is as physically different from white as chalk is from cheese. The onlooker must continually relocate that yellow shape from one canvas to the next, at once retiring and confrontational.

This leads to my final strategy, colour. The physicality of pure pigment is an enormous seduction but it is colour in painting that creates the ambient light of the space one feels oneself to occupy and disrupts the order of content. Kristeva writes in her essay 'Giotto's Joy': 'The language/painting analogy, when faced with colour, becomes untenable.'[7] And this is precisely why I am interested in colour.

My paintings are highly colour-schemed, often monochrome, in order to maintain the strongest possible colour sensations. Such powerful, saturated colour is bound to create after-images and reflections and to flood adjacent surfaces with complementary hues, again directly involving the body and the visual physiology of the spectator as directly as possible, but also creating incident to question the assumption that the spectator can know where to look in order to consume the image.

50 (A, B, *overleaf*) JOAN KEY *Cobalt Violet Series.* Oil on canvas, 1993, 183 × 163 cm (×2)

In her essay Kristeva describes the powerfully subversive effect that Giotto's colour had on the ideological norm of Christian narratives of that period and sites the basis of its subversion on a 'triple register in the domain of visual perceptions . . . an instinctual pressure linked to external visible objects; the same pressure causing the eroticizing of the body proper via visual perception and gesture, and the insertion of this pressure under the impact of censorship as a sign in a system of representation.'[8] Colour has a diacritical function in painting; it both produces the visible object within the system of the painting and destroys it: consequently, as Kristeva states, 'the chromatic experience constitutes a menace to the *self* and to the contrary it cradles the self's attempted reconstitution'. Again she restates this theme: 'Colour is the shattering of unity. Thus it is through colour that the subject escapes its alienation within a code that it, as a conscious subject, accepts.'

Kristeva is clearly describing the revolutionary role that colour can have in painting, and here she quotes from Matisse:

> When the means of expression have become so refined, so attenuated that their power of expression wears thin, it is necessary to return to the essential principles which made human language. They are, after all, the principles which go back to the source, which relive, which give us life. Pictures which have become refinements, subtle graduations, dissolutions without energy, call for beautiful blues, reds and yellows, matter to stir the sensual depths in men.[9]

Kristeva notes the linking of colour with the maternal reference of 'going back to the source' and, in a fascinating annotation to this text, she addes that Marcelin Pleynet has shown, in the case of Matisse, the connection between chromatic experience, relation to the mother, and the oral phase of infant eroticism. This is the moment in individual history that is of specific interest to my work, the maternal metaphor of the painting itself. The perpetual movement between unity and disintegration that reminds us of our earlier history brings us into contact with our source, the 'very origin of the world'. But in this engagement we begin to dream, not necessarily according to the code of contact with the feminine that leads to degradation and death, but also to the opposite, of possible well-being in this situation; so: 'Throw off your fear, this fame ensures some kind of refuge.'

The subtitle of this chapter, 'too much body', is a quotation from Joan Copjec's essay 'Vampires, Breast-Feeding and Anxiety'.[10] Copjec is describing the anxiety felt when a part-object that we felt to be safely under control re-emerges, no longer a partial object, but on the contrary as a complete body. This is not only 'too much body, but a body too much'. This body stands in the way, suffocates, crowds out and, even though desired, must be rejected for the sake of survival and progress. This is the story of Aeneas standing before the great history painting, but also here, with this strong and animated body-in-paint, there is, I hope, a sense of place, of fears of the worst being overcome, a little peace of mind, even if the 'subject-supposed-to-know' can only give the slightest indications of what the narrative was that was so familiar, and why that almost abstracted memory should seem to guarantee survival.

Notes

1 G. Pollock, 'Painting, Feminism, History', in M. Barret and A. Phillips (eds), *Destabilising Theory, Contemporary Debates* (London, Polity, 1992), p. 142.

2 G. Pollock, 'Painting, Feminism, History', p. 138.

3 M. Kelly, 'No Essential Femininity' (a conversation between Mary Kelly and Paul Smith), *Camera Obscura*, 13–14 (1985), p. 152.

4 J. Kristeva, *The Powers of Horror, an Essay in Abjection*, trans. L. S. Roudiez (Columbia University Press, 1982), p. 159.

5 J. Lacan, *The Ego in Freud's Theory and in the Technique of Psychoanalysis, 1954–1955*, ed. J.-A. Miller (New York and London, Norton, 1988); discussion of Freud's dream, pp. 146–71.

6 P. Adams, 'The Art of Analysis: Mary Kelly's *Interim* and the Discourse of the Analyst', in *October*, 58, (MIT Press, 1991), p. 90.

7 J. Kristeva, *Desire in Language*, trans. T. Gora, A. Jardine and L. S. Roudiez, (Oxford, Blackwell, 1981), p. 216.

8 J. Kristeva, *Desire in Language*, p. 218.

9 J. Kristeva, *Desire in Language*, p. 221.

10 J. Copjec, 'Vampires, Breast-Feeding and Anxiety', in *October*, 58, (MIT Press, 1991) p. 36.

Textiles

Text and textiles: weaving across the borderlines

Meanings and perceptions: what's in a name?

In the public mind, at least within the West, traditional textiles are homogeneously described under one generic term: Textiles. This term commonly seems to signify certain ideas, values and traditions within communities identified with domesticity, women's creativity and shared endeavour. Textile work is perceived as labour-intensive, slow and painstaking and yet, in a double twist, rendered and devalued as invisible women's work, non-work or non-productive labour. Simultaneously textile manufacture is a multinational corporate activity in which the nimble fingers of 'Oriental' women produce endless garments for tourist consumption and the conspicuous economy. In sweatshop factories textiles operate as circuits of exchange between individualised subjects and conflicting historical interpretations, but are always ethnic, class and gender indexed.

Weaving, Donna Harraway suggests, is for 'oppositional cyborgs,'[1] whether across the computer-generated screen of satellite images that transcend national/geographical borders or through the electronics of the loom,[2] mindful of the politics of location in its mix of metaphors as an 'epic tapestry' and a 'bulletin board'. Yet cloth is also inscribed within a range of humanist and universalist discourses as a container for full human expression; rites of passage, 'primitive' and 'natural' activities which camouflage the industrialised West's obsession, and fantasies of lost innocence, rural idylls and safe havens. Closer to 'home', textiles have been mobilised as banners for Suffragette resistance, trade union rights, wrapping the Greenham Common fence and honouring those who have died of AIDS.

As intrinsic to the construction of the Eurocentric gaze,[3] textile–fashion–costume constructs an otherness of exotic/erotic swirls which, by the sleight of hand, can destabilise the very naming and fixing of textile itself. The mobilities of fabric can be traced through the echoes of another sign which can be loosened from its referent, i.e. the founding theory of 'femininity as masquerade',[4] which scrambles the codes of the singular to encompass a signifying chain of fractured, multiple and precarious identities.

Textiles can further be represented as unpretentious, simple, honest and limited to a set of technical procedures; pick up a knitting pattern, cross-stitch your Textile Heritage of bygone memories and release your longing for a romanticised and

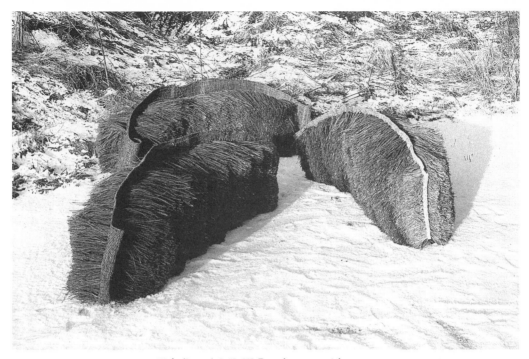

51 SOILI ARHA *Hede (Stamen) I, II, III.* Rug, bast material, 1991, 3 × 65 × 210 × 60 cm

mythical past when flags were waved in the Empire dramas of colonial rule. These leisurely pastimes evoke 'feminine' sensibilities within the patriarchal order. They contrive to silence the wounds inflicted by history as faded markings on sheets. But this, as I hope I have shown, is also an invented tradition.[5]

In short, these representations of textiles/femininity, worked across popular and high culture, are repetitiously articulated through advertising images and trade journals (have you bought your tapestry cushion to embroider from the Sunday supplement?), within filmic representations (have you seen '*Brief Encounter*' again?), and occupying (much to her indignation) Maggie Tulliver's childhood days (aged nine) in George Eliot's '*Mill on the Floss*'; but in another register enabling Alice Walker to remember in '*In Search of our Mother's Gardens*'[6] that the quilt was a major form of creative expression for black women in the USA.

As finished artefacts, textiles would appear on the one hand to guarantee a range of protective, comforting and homely values, whilst in their 'raw' state these scraps and fragments of cloth become synonymous with residues of 'Women's Time'.[7] At one and the same moment these pieces can rhythmically pattern and reassemble touch and texture, offer intricate and ingenious design to interrupt the masculine model. For example, in her recent article 'The Story of the Eye' Rosalind Krauss proposes a model of vision which is 'carnally constituted' and inseparable from the body and its relations to the unconscious.[8]

In the paradigm formulated by Showalter,[9] piecing equates with jouissance and is expressive of the pre-verbal semiotic phase with the aesthetic possibilities of

the pre-Oedipal primal scene. Semiotic eruptions as anarchic 'raw material' obliterate Freud's terminology of 'lack' (the example here is pubic hair, which comes to hide what is missing: the phallus). Disruptive excess, rebellious 'crazy fields' represent transgressive breaches of strict symbolic coherence and regulation. Multiple peaks of fluid stitches, rhythmical passes of woven lines and bodily movements counterpoint the single climactic moment of masculine gesture exhausted and depleted as the final mark invades the woman's body on the oily canvas. From within the discredited exclusions of Art History, gendered subjectivity, the metaphorics of femininity and the language of textiles, scratch through the painted sign of luxury and wealth as an obscene encounter between luscious folds, interior drapery and commodity spectacle. But for whose display? For whose orgasmic delight? (And somewhere in the corner of the room, the controlled 'displays of needlework have gone berserk like a madwoman's overgrown macrame project.'[10] The decorative extra rebels; the expunged detail insists on returning as the repressed signified.)

Hybrids: textiles in the expanded field

According to Kristeva, at certain historical moments 'madness, holiness and poetry' erupt into the social orders and the conscious, rational layers which control discourse.[11] During these 'abnormal' periods of rupture the dominant art discourse becomes saturated by a 'transgressive' moment in the avant-garde which, in my view, can be traced through the problematic genre of 'textile art', the category of which can be made almost infinitely elastic. The disruptive excesses of sensuous ropes, exuberant textures and overscaled patterns mark a decisive shift from dainty stitches and constraining corsets. Covering wall and floor, ceiling and corner, 'hysterical' combinations of process and weave are stretched across space and release the 'feminine' from its estranged location at the margins of the unconscious. In a constant slippage of identity, the 'boundaried boundarilessness'[12] measures a fraying hem; a postmodern practice of not belonging to one practice or another.

This 'genre débordé'[13] permits a way of thinking that transforms visual practice into the language of the hybrid form. Rosalind Krauss has argued that the production of hybrid forms overcomes and undermines gender inscriptions of existing cultural languages, particularly those enmeshed within the discourses of modernism.[14] In 'Sculpture in the Expanded Field', Krauss suggests that new critically coded meanings are set free within the free play of the signifier.[15] To encode critically is to force a dislocation with old forms in order to make explicit both old and new meanings. Consequently, hybrid forms eclectically appropriate or replace, quote and parody, contaminate and are contaminated by 'other' traditions, languages and gender inscriptions which are in an uneasy and playfully, wilful relationship to the situation of postmodernism. Therefore Krauss concludes 'practice is not defined in relation to a given medium but in the logical operation on a set of terms, *for which any medium might be used*'[16] (my italics).

How then do I/you 'read' Rosemarie Trockel's knitted patterns of simulated authorship? (Figure 52). Why are the framed *petit point* memorials of Narelle Jubelin

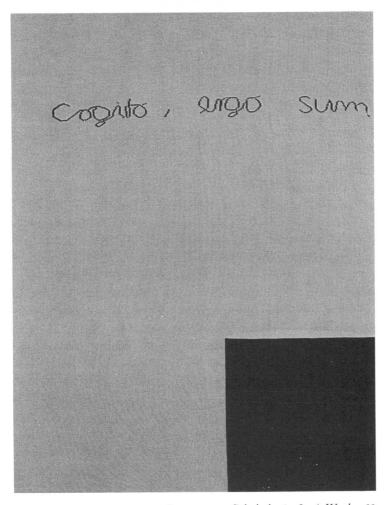

52 ROSEMARIE TROCKEL *Cogito, ergo sum (I think, therefore I am)*. Wool, 1988

so 'primly' disquieting?.[17] Why is Zizi Raymond's perforated bodice and taffeta dress with meat skewers so wonderfully outrageous?[18] (Emerging from these rhetorical configurations, I 'grope my way to the border',[19] and remember Andrea Nye's encouraging remarks on Cixous's writing, 'The important thing is to keep the writing going, not to stop the loom or the weaving, not to censor or to tidy or to edit the thought.'[20])

In 1980, when 'Textual Strategies and the Politics of Art Making'[21] was written, one type of women's art was seen as a glorification of inherent feminine artistic essence which would find full expression if allowed to be explored freely. Instead of patriarchal culture, female power would be elevated to primary status, thus writing a matriarchal heritage into history. This view of women's art was reclaimed and celebrated as a form of subcultural resistance in Judy Chicago's *Dinner Party*. As an attempt to bear witness to an alternative culture, the limitations of this untheorised strategy propelled vaginal imagery to the forefront of textile retrieval and accreditation. Paradoxically, this strategy served only to reinforce the notion of

separate spheres which had marginalised textiles as craft, outside the art mainstream, in the first place.

'Outside' culture, 'outside' language, 'outside' meaning, this construction of the personal as political took 'nature' for a feminine subculture. There could be no covert or tacit women's cultural traditions that could escape an essentialist ideology. Taking Janet Wolff's point,[22] there is no way that we can theorise either the 'wild zone'[23] outside the socialised realities of the dominant structure, or the untheorised unconscious.

When in 1977 Lucy Lippard described Michelle Stuart's work as having 'a calm rhythm akin to the gradual process of nature itself: the same kind of soothing "busyness" of spinning and weaving'[24] she too linked textiles to nature. In the same review Lippard comments that Stuart's employment of ritual-like processes recalls 'Pueblo women dancing the corn dance so as to stamp female energy back into the earth'. In the 1990s the symbol of mother earth returns with a vengeance in the environmentally-based work of the 'new' textiles. Textiles in this context signifies 'our' rediscovery of an ecologically based lifestyle; nomadic dwellings, hand-felted shelters and recycled fabrics rot back into the ground to remind 'us' of our natural beginnings and transient bodies. These 'textiles in nature' frequently propose a new aesthetic alignment between the natural and the cultural. Shall we respect the natural world or shall we exploit its resources? Shall we live in or against nature? The 'we' is not sexually neutral but, once again, gender indexed.

Is there a woman in this ~~textile~~?

Mary Jacobus asks, how does the female subject inscribe herself in writing? I ask, how can the female subject inscribe herself in avant-garde textile practice? In an emphasis from feminist producer to viewer/reader the double question is posed; 'reading woman (reading) or woman reading (woman)?'[25] If, according to Jacobus, the question should be rephrased to ask, is there a woman in this text/textile, why have I crossed out 'textile'? To write the words 'sous rature' ('under erasure'),[26] to cross it out but to print both the word and the deletion is to acknowledge Derrida's observation that a word may be inadequate but also necessary. Since the word is necessary it must partially remain legible; it is always 'not quite' there but also 'not quite' that. So perhaps I could say that my understanding of the name – 'textile' – is continually breaking apart. Sometimes it gets reattached in 'new' combinations and in different contexts where I wish to insist that echoing in the remnants of its interdisciplinarity is the other, 'not quite' there and 'not quite' that 'woman' in contradictory discourse with herself/myself in all her/my heterogeneous difference.

Sarat Maharaj's brilliantly persuasive essay 'Arachne's Genre: Towards Intercultural Studies in Textiles' argues that avant-garde textile practice 'maps out an inside/outside space – "edginess" – it cites established genres and their edges as it cuts across and beyond them' to throw out of joint 'handed-down notions of art practice/genre/gender'.[27] The mythical contest between Arachne and Athena is provocatively restaged with immaculate flourishes and running-stitch rhythm to play

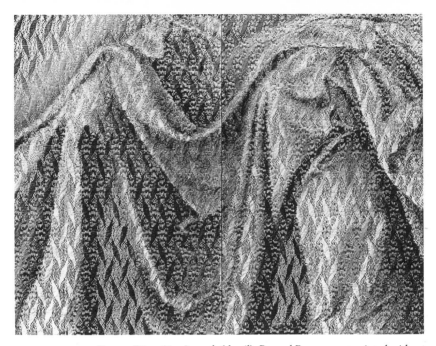

53 LIA COOK *Drapery Frieze: After Leonardo* (detail). Pressed Rayon warp painted with dyes, linen weft painted with acrylics (six panels woven on a 32 harness computer loom), 1992

with the 'ornamental, with its traditional connotations of effeminacy' and flirt with the metaphorics of femininity by privileging the detail. In 'Textile Art — Who are You?' 'manly swagger signs' switch into 'womanly sway signs' and back again fluently and effortlessly within the text.[28]

In 'Arachnologies: The Woman, The Text and the Critic', Nancy K. Miller outlines the ways in which text and textiles are inextricably stitched together in a complex network of language-games and femininity.[29] She suggests that the gendered subjectivity is concealed with a text. She proposes that the languages of textiles are similar to Freud's assertion that woman invented the art of weaving. This is woman's unique contribution to civilisation. In 'Femininity' Freud claims that through this symbolic invention women re-enact nature's art of concealing with pubic hair that which is women's great genital deficiency. Pubic hair comes to hide what is missing.[30]

In Freud's writings femininity is treated as supplementary, as parasitic to the masculine. What is at stake is the desire to repress that which negates or complicates the masculine position. Situated at the margin, the feminine is designated as a deviation, a chaotic, wild and messy 'other', while in another discourse it is also positioned as patient, prudent and nurturing, representing the area of immersion in life, the natural part of a human being, the sphere of passivity and natural necessity.

To disentangle this web of hair is to under-read (following Miller) the subject of this psychoanalytic history as a double displacement; women and nature,

femininity and textiles. The goal of over-reading is to stitch in the signature, to put one's finger – figuratively – on the place of production that names the woman as a speaking subject. The manifestation of the 'putting into discourse "woman"'[31] is to unpick that which has traditionally connoted femininity and by analogy, textiles.

To zoom in on the details, the minute and the partial is to unravel the entangled threads that make up the sign 'Textiles'. The analysis pursued by Naomi Schor in *Reading in Detail: Aesthetics and the Feminine* signals a complementary complication. She concludes that from within a historical perspective, suspicion and downright hostility to the valorisation of the detail coincides with the classical equation of the Ideal in aesthetics and literature, which Schor considers to be profoundly gendered. To focus on

> the detail and more particularly on the *detail as negativity* is to become aware of its participation in a larger semantic framework, bounded on the one side by the *ornamental*, with its traditional connotations of effeminacy and decadence, and on the other, by the *everyday*, whose 'prosiness' is rooted in the domestic sphere of social life presided over by women. . . . The detail does not occupy a conceptual place beyond the laws of sexual difference: the detail is gendered and doubly gendered as feminine.[32]

These two extraordinary paradigms established by Miller and Schor provide a way of shaping this double weave so that their interrogations into language systems can become the potential threshold for constructing a 'matrixal borderline'[33] of my/our own. Why, asks Miller, is the textual as textile so favoured by Barthes[34] so suspiciously enticing? Why, asks Schor, does the triumph of the detail in the writings of Barthes, Derrida and Foucault occur at the very moment when it ceases to be associated with the feminine? Does the appropriation of warp and weft, stitch and thread within the textual interplay of a degendered writer/reader deceptively dissolve the productive agency of the subject?

As I have indicated, during the 1970s and 1980s textiles appeared to rupture, renovate and enliven the worn-out binary opposition of fine art versus craft. But to move the masculine subject from its secure territories of practice is to run the risk of perpetual strangulation in the battleground of who controls the discourse, while to leave one's own desires unexpressed and unrealised is to be consigned to the footnotes of patriarchal culture.

To pursue Miller and Schor's lines of interrogation further, who is the more deviant and improper: the writer writing-like-a-woman or the woman-as-subject of the discourse? Can *'genre débordé' in practice and in analytical writing and warping* (my italics) attempt to neutralize the male/female opposition? What happens if the hybrid textile–text was open only to be recolonised by the male mimicking signs traditionally coded by the feminine? For Derrida, and in this context the implications of myself as the woman-as-reader of 'Arachne's Genre', the hierarchy of the binary opposition always reconstitutes itself. The signature that 'writes [in]difference'[35] asserts the primacy of the oppressed term (femininity) as strategically indispensable. Can I be so sure (in Schor's words) that 'degendering the text/textile' [through luxurious narrative and subtle repositioning] is not merely defeminizing, leaving the masculine and

54 CATHY DE MONCHAUX *Defying Death I ran away to the Fucking Circus.* Brass, velvet, leather, screws, buckles, rivets, 1991, 55 × 77 × 11 cm

its prerogatives intact?[36] Luce Irigaray puts it this way: 'the masculine is not prepared to share in the initiative of the discourse. It prefers to experiment with speaking, writing, enjoying "woman" rather than leaving that "other" any right to intervene, to act in her own interests'.[37] What is denied is that the potential of a utopian and political woman's discourse is incorporated into a 'metaphysical cannibalism', a reinscription of the primacy of the phallus.

What would be 'absent' is not the biological woman or an essential textile, but a non-transparent space of the unknown of patriarchal history, a 'space' over which the master narratives of Western thought have lost control but which paradoxically signifies disgust and repression, bearing the imprint of desire, masquerading as an 'uncanny stranger on display'.[38] Now here's a thread: 'Femininity as real otherness is uncanny in that it is not the opposite of masculinity but that which subverts the very opposite of masculinity and femininity', advises Shoshana Felman.[39]

I am transfixed by Cathy de Monchaux's *Defying Death I ran away to the Fucking Circus* (1991; Figure 54); luscious folds of red velvet, shot with leather, screwed and riveted with shiny brass clasps. Can I read this soft/hard hybrid as materially 'translating' the 'uncanny stranger on display'?[40] Defiant and uncensored, opulent and mocking, this 'fucking circus' seems to me to encompass one of the definitions of 'the uncanny'.[41] De Monchaux's practice has a double semantic capacity to mean its opposite, signifying both the homely, comfortable and intimate connotations of fabric—material–textile and the uncomfortable, alien and unknown. According to Elizabeth Grosz's reading of Freud, woman can disavow her own castration through narcissism, whereby the woman turns her own body into the phallus through a theft and rejection of the masculine perversion which is known by fetishism.[42] If fetishism (generally bound up with an inanimate or partial object like fur or velvet) functions to make part of the female body into a phallus, then can de Monchaux's work further parody the notion that woman is and is not castrated?

Can this interpretation of the uncanny operate as a potential for subverting the codes of masculinity? Can it restore the gendered subjectivity of sex to text to 'textile' and refurbish the 'putting into discourse "woman"'; the decadence of woman as speaking subject?

Notes

1 Donna J. Haraway, 'A Cyborg Manifesto: Science, Technology, and Socialist–Feminism in the Late Twentieth Century', from Donna J. Haraway, *Simians, Cyborgs and Women: The Reinvention of Nature* (Free Association Books, 1991), p. 170.

2 Trisha Ziff, 'Taking New Ideas back to the Old World: Talking to Esther Parada, Hector Méndez Caratini and Pedro Meyer', in *PhotoVideo: Photography in the age of the Computer*, ed. Paul Wombell (River Oram Press, 1991), pp. 127–36.

3 Samir Amin, *Eurocentrism* (Zed Books, 1988).

4 Joan Rivière, 'Womanliness as masquerade' (1929) reprinted in V. Burgin, J. Donald and C. Caplan (eds), *Formations of Fantasy* (Methuen, 1986), pp. 35–44.

5 Eric Hobsbawm, 'Inventing Traditions' in E. Hobsbawm and T. Ranger (eds), *Inventing Traditions* (Cambridge University Press, 1983), pp. 1–15.

6 Alice Walker, *In Search of Our Mother's Gardens* (Women's Press, 1984).

7 Julia Kristeva, 'Women's Time' from *The Feminist Reader: Essays in Gender and The Politics of Literary Criticism*, eds C. Belsey and J. Moore (London, MacMillan, 1989), pp. 197–217.

8 Rosalind Krauss, 'The Story of the Eye', *New Literary History*, I, 2, (winter 1989), pp. 283–97.

9 Elaine Showalter, 'Piecing and Writing' in Nancy K. Miller, *The Poetics of Gender* (Columbia University Press, 1986), pp. 222–47.

10 Anna C. Chave, 'Eva Hesse: Girl Being Sculpture' in *Eva Hesse: A Retrospective* (Yale University Press, 1992), p. 108.

11 Toril Moi (ed.), *The Kristeva Reader* (Oxford, Blackwell, 1986), cited in Diana Wood Conroy, *Outside Looking in: Textiles a Marginality* (Object, Autumn, Craft Council of New South Wales, Australia, 1992), p. 29.

12 Sarat Maharaj, 'Arachne's Genre: Towards Intercultural Studies in Textiles', *Journal of Design History*, 4, 5, (Oxford, Oxford University Press, 1991), p. 94.

13 Jacques Derrida, 'The Law of Genre', (*Glyph* 7, 1980), pp. 202–32.

14 Rosalind Krauss, *The Originality of the Avant-Garde and Other Modernist Myths*, (Chicago, MIT Press, 1985), pp. 151–71.

15 Rosalind Krauss, 'Sculpture in the Expanded Field' reprinted in *Postmodern Culture*, ed. Hal Foster (London, Pluto Press, 1985), pp. 31–42.

16 Krauss, 'Sculpture in the Expanded Field', p. 41.

17 Narelle Jubelin *Double Take: Collective Memory & Current Art*, Hayward Gallery, (London 1992).

18 Zizi Raymond, 'Presence and Calculated Absence', *Tema Celeste, International Edition*, 39, (winter 1983), pp. 38–41.

19 Hélène Cixous, 'Angst', translated from the French by Jo Levy (London, John Calder, 1985), p. 19.

20 Andrea Nye, 'A Woman's Language' in *Feminist Theory and the Philosophies of Man* (London, Routledge, 1988), p. 204.

21 Judith Barry and Sandy Flitterman-Lewis, 'Textual Strategies: The Politics of Art Making', reprinted in *Visibly Female: An Anthology*, ed. Hilary Robinson (Camden Press, 1987), pp. 106–17.

22 Janet Wolff, 'Women's Knowledge and Women's Art' from *Feminine Sentences: Essays on women and culture* (Polity Press, 1990), p. 70.

23 Edwin Ardener, 'Belief in the Problem of Women' (1972) and 'The "Problem" Revisited' (1975), cited (pp. 261–3) in Elaine Showalter, 'Feminist Criticism in the Wilderness' in *The*

New Feminist Criticism: essays on women, literature and theory, ed. Elaine Showalter (Virago Press, 1986), pp. 243–69.

24 Lucy Lippard, *Strata: Nancy Graves, Eva Hesse, Michelle Stuart and Jackie Windsor*, exhibition catalogue, (Vancouver Art Gallery, Canada, 1977), pp. 19–20.

25 Mary Jacobus, *Reading Woman: Essays in Feminist Criticism* (Columbia University Press, 1986) and 'Is there a Woman in this Text?' in *New Literary History* (autumn 1982), pp. 117–42.

26 Madan Sarup, *An Introductory Guide to Poststructuralism and Postmodernism* (London, Harvester/Wheatsheaf, 1993), pp. 33–4.

27 Maharaj, 'Arachne's Genre', p. 77.

28 Sarat Maharaj, 'Textile Art – Who Are You?' in *Distant Lives/Shared Voices* ed. Sharon Marcus: introduction by Janis Jefferies, (Łódź, 1992).

29 Nancy K. Miller, 'Arachnologies: The Woman, The Text and the Critic' in *Subject to Change: Reading Feminist Writing* (Columbia University Press, 1988), pp. 77–80.

30 Sigmund Freud, 'Femininity' in *The Standard Edition of the Complete Psychological Works of Sigmund Freud* translated by James Strachey *et al.* (London, Hogarth Press, 1953–74), vol. 23, p. 132.

31 Alice A. Jardine, *Gynesis: Configurations of Woman and Modernity* (Cornell University Press, 1985), p. 25.

32 Naomi Schor, *Reading in Detail: Aesthetics and the Feminine* (London, Methuen, 1987), p. 4.

33 Bracha Lichtenberg Ettinger, 'Woman–Other–Thing: A Matrixal Touch' in *Matrixal–Borderline* [catalogue] (Museum of Modern Art [MOMA], Oxford, 1993), pp. 11–18.

34 Roland Barthes, *The Pleasure of the Text* translated by Richard Miller (Hill and Wang, 1972).

35 Jacques Derrida, *Writing and Difference* translated by Alan Bass (Chicago, University of Chicago Press, 1978) and 'Living on/Borderlines' in *Deconstruction and Criticism* (London, Routledge & Kegan Paul, 1979), pp. 75–176.

36 Schor, *Reading in Detail*, p. 97.

37 Luce Irigaray, *This Sex which is not One* translated by Catherine Porter and Carolyn Burke (Cornell University Press, 1985), p. 157.

38 Hélène Cixous, 'The Laugh of the Medusa' cited in *The New French Feminisms* eds Elaine Marks and Isabelle de Courtivron, (Harvester Press, 1981), p. 250.

39 Shoshana Felman, 'Rereading Femininity' quoted and cited in *On Deconstruction: Theory and Criticism after Structuralism* (London, Routledge & Kegan Paul, 1983), p. 42.

40 Cixous, 'The Laugh of the Medusa', p. 250.

41 Sigmund Freud, 'The Uncanny' in *The Standard Edition*, vol. 17, pp. 219–20.

42 Elizabeth Grosz, 'Lesbian Fetishism?' in *Differences* 3, 2 and cited in *Feminism and Psychoanalysis: A Critical Dictionary*, ed. Elizabeth Wright (Oxford, Blackwell, 1992), pp. 39–54.

Kinda art, sorta tapestry: tapestry as shorthand access to the definitions, languages, institutions, attitudes, hierarchies, ideologies, constructions, classifications, histories, prejudices and other bad habits of the West

I work in tapestry primarily for its materiality and its capacity to shift within traditions, to shuttle between theoretical positions, to hover around borders, to challenge hierarchies and to connect with many different resonating imperatives. The medium, belonging everywhere and nowhere, is everything and nothing. It is what you think, and it conjures what you don't know and can't remember – it has no certainty.

The process of discovering that such an undefined situation can be a positive location has been lengthy, painful and fraught with ambivalences. I gained my most helpful insights by looking outside the history of my immediate discipline and seeing the parallels with other marginalised categories of art practices and people. I extended this by investigating the ways in which notions of value have been constructed around issues of class, gender and 'race'. Then, going back to the varieties of tapestry production, I could see that, although it is an esoteric activity that defies the new technologies, its histories provide a shorthand access to institutionalised European attitudes.

A brief overview of the history of the European tapestry tradition reaffirms my discovery process. In the West the art form was at the peak of its vitality in France in the late Gothic period. At that time, production was a collaborative process executed by male weavers under the entrepreneurial direction of a dealer such as Nicholas Bataille. (Bataille, contrary to popular legend, was neither an artist nor a weaver and also dealt in wines and other goods.) Being a portable art form that could be taken into battle and from chateau to chateau, tapestries, I believe, played the role that television does now as a signifier of power.

In the late seventeenth century the *Acts of the Apostles* series of tapestries were made in Belgium from the cartoons of Raphael, and thereafter the distinction between artist and weaver widened as the work took authorship from painters with

high profiles. The greater the status of the painter, the greater the value of the tapestries which became increasingly labour-intensive and technical in order to reproduce faithfully every nuance of the master's brush. Some amazingly beautiful and virtuoso work was done, but having abandoned its own creative initiative in order to simulate another medium it had become stale.

At the end of the nineteenth century the Pre-Raphaelites, William Morris and the Arts and Crafts Movement included tapestry in their attempts to recover Gothic forms for integrating process and vision. Morris's tapestry weavers were all males, and were required to wear suits while working to demonstrate respect for the profession. In France, after the Second World War, Jean Lurçat, assisted by good dealers such as Denise Majorel, and with the backing of official French cultural policies, consciously set out to take the medium into the Modern Movement while at the same time trying to preserve the characteristics specific to tapestry. Like Morris, Lurcat attempted to close the gap between designer and weaver, and limited the number of colours, thereby restricting virtuoso reproductions. The imagery of tapestry caught up and moved closer to contemporary painting: thus it followed that the practice remained in the hands of men. Using his influence, Lurçat initiated the Lausanne Tapestry Biennial in 1962 to provide a forum for this orphaned art. By the Second Tapestry Biennial (in 1965) a group of dynamic textile artists, mainly East European and predominantly women (most significantly Magdalena Abakanowicz) submitted entries to the jury. Their work was unorthodox, sculptural, off-the-wall and very, very modernist. A battle for control followed between the French tradition of image-making and the East European and American innovators. The innovators won and Lurçat, amongst a number of anti-feminist statements, said, 'Watch out for those little girls who knit.'[1] (The misogynist and belittling tone of Lurçat's defensive remark was echoed some time later by Clement Greenberg, when he responded to criticism from the writer Rosalind Krauss with 'Spare me smart Jewish girls with their typewriters.'[2])

All this time, textiles, some with images, some without, some overtly functional and some ceremonial, ritualistic or religious continued to be made within the varied traditions of what are generally called the 'Third World countries'. Some were made by men and some were made by women.

This is the point at which my personal story intersects with the official history of art in the West — a record which excluded even so brief or selective an account of tapestry as the one I offer above, except for occasional references to the *Lady and the Unicorn* tapestries, and works designed by Burne-Jones.[3] I was born in South Africa before apartheid was legalised. I worked as a secretary and then completed a degree in African Studies and English Literature at Cape Town University, before coming to Canada in 1966. Illness and surgery, which for a time threatened to be fatal, caused me to re-examine my life and choose art making (I had been drawing and painting since childhood) as the most meaningful activity for what I thought were my few remaining years. I managed to live after all, and to complete a Bachelor of Fine Art degree in painting and printmaking during the ascendancy of abstract expressionism. I found that the issues about the human condition that had motivated me to

become an artist were not encouraged in a formalist art department strongly influenced by New York and Clement Greenberg. But as a student, I absorbed the prevailing ideology about universal excellence without questioning why it did not have application for most women or why it was exclusively dominated by white people. I taught myself tapestry (tuition was not available in any degree-granting institution in Canada) without then being aware that I was being subversive. I naively applied the principles of formalism to an outsider medium because I thought so many paintings tried to look like tapestries – a reversal of the usual subservience of tapestry. But I was dismayed to realise finally that formalist principles had currency only in a painted context if they were done by prescribed categories of people – and only in locations approved by the High Art World. (At this point I lost my naivety!)

On the other hand, in the Low Art World (Craft) I had received support, but support that was tempered by disapproval for the ineptitudes arising from my having taught myself the technical processes. So I adapted to a schizophrenic state in which, as I moved my practice from one sphere to the other, I revised and censored my language for each, because what was rewarded in one sphere was precisely what was rejected in the other. In the High Art Sphere, where tapestry was ostensibly dismissed as too well made (craft driven), invisibility was further guaranteed by lack of access to the teaching institutions, museums and critical journals that validate 'professionalism'. Conversely, in the Low Art Sphere, the rules of technical orthodoxy (Aubusson versus Gobelin, European versus nomadic, sculptural versus flat) were jealously guarded. In this sphere too, the examination of theoretical concepts (with the possible exception of an essentialising feminism) have often been resisted.

The assumptions of both spheres continue to be sustained by unquestioned acceptance of the definitions of binary opposites in which certainties of gender, location and the means of production figure prominently. Having one foot in the constructions of each of the opposing spheres was not a comfortable place for me to be. This painful dislocation was aggravated by the preconceptions of regionalism, in which we, in the Canadian prairies, are sometimes complicit, in that we internalise its notions of our inferiority in the white colonial system. Accepting our status as powerless provincials, on the margins, we often buy the whole stereotyping package, contradictions and all, without finding, or even looking for, the tools to take it apart. After doing a year of postgraduate study at Edinburgh College of Art, I was able to find those tools in 1985 when I worked for my Master of Fine Art here at the University of Saskatchewan. The title of my thesis was *Love, Labour and Tapestry: Unravelling a Victorian Legacy*. (At this point I lost my anger.)

Thereafter I could see what had in fact been quite apparent – that the diversity of people living on the Canadian Prairies can make for an actively stimulating, varied, and well-informed cultural climate. Wherever there is a good art museum, a library, a mail service to deliver journals, television, a fax machine, a Xerox copier, an airport nearby, a telephone and, with luck, an informed teaching institution, there can be exchange of ideas if that is sought. It has been sought here, and into these outsider corners have come speakers, books, journals and artists. Likewise, from the margins have gone speakers, books, journals and artists. Sadly, although the actual traffic of

ideas is a two-way process, it is not substantially different from any transaction between major and minor centres – ideas are highlighted on the way in, but often unacknowledged on the way out. Consequently, those on the margins see their work validated in the centres of power from time to time, but without reference to their authorship. These same ideas can then be returned to the periphery and read as cutting-edge material. But should some eager, ambitious, talented peripheral artists claim an innovation for themselves, their work will fail to be validated. The makers of opinion at the margins can't believe it is good, and those at the centres don't need to – and the cutting edge, having cut, will have moved on.

There are many examples of how influences relating to textiles have been recycled from margin to centre and back again. In the absence of validating institutions for art informed by textiles, the Lausanne Tapestry Biennial became virtually the only arena where reputations could be made which would allow textile artists to achieve professional recognition and with it the means of making a living. The strategy of the Biennial developed increasingly towards creating a High Craft sphere which sought to distance itself from the Low Craft sphere. For the most part any submissions which could be identified as pertaining to women's work, or figurative imagery evoking the vanquished French tradition, constituted the lower end of the Low Art sphere. The philosophy and aesthetic fostered by the Biennial, which predictably emphasised large-scale work, were promoted by much-prized catalogues and the handsome books of Mildred Constantine and Jack Lenor Larson from New York.[4] The authors were closely affiliated with a small pool of jurors who promoted an excluding professionalism that claimed international universality of intention by denying the validity of difference in identity and location. While the initial energy and innovation gave rise to the Biennial's mandate to select work that 'broke new ground', the ongoing search for new 'revolutions' privileged a certain 'look' that, with some notable exceptions, started to become predictable. The 'look' was three-dimensional and modernist, and encouraged the term 'Fibre-art' as a discipline that was separate from sculpture. However, the strategy of constructing an accepting forum for sculptural practices that were excluded from the wider jungles of the High Art World had the potential for turning into a little jungle in a cul-de-sac.

To achieve the modernist, impersonal look favoured by Lausanne and subsequent Fibre Art exhibition venues, fibre artists from major centres, (mostly Europe, America and Japan) researched remote or supposedly extinct 'ethnic' and aboriginal cultures, often through questionable or simplistic anthropological data.[5] Thus objects of worship or cultural symbols from colonised cultures were sometimes appropriated, blown up in scale and reconstituted in formal, art terms in a kind of double colonisation. But the implications of the strategies and politics of the Fibre Art movement are not at all dissimilar from those for any category of outsider identity; as Janet Wolff has pointed out, there is a limited choice for negotiating between the pitfalls of an essentialising stance that ghettoises, or of entering the wider arena disadvantaged by not being validated through the codes and conventions of the major language. One of the most noteworthy dissonances for me has been the futility of citing the revered international stars of the Biennial as signifiers of meaning and communication when

speaking in the High Art sphere – the biggest of names are simply not generally known across the disparate spheres.

To return to the subject of the circulation of ideas from centre to margin and back again, the eyes of white women artists in particular were opened by the publication in 1981 of *Old Mistresses: Women, Art and Ideology*. Rozsika Parker and Griselda Pollock, using impeccable Western methods of research, deconstructed the strategies for writing European history in which work done by women was first devalued and then often appropriated. In one example that demonstrates triple marginalising through gender, location and method of production, they cite the abstract and hard-edged painters from New York whose debt to Navajo women artists is not acknowledged even though there are ample records that they were not anonymous weavers at all.

Then in 1984 Rozsika Parker's *The Subversive Stitch: Embroidery and the Making of the Feminine*, focusing on textiles, could not be resisted by even the most conservative of Western practitioners; modernism was finally disrupted in the Low Art sphere. The empowering implications spread beyond European textile artists and affected curators, teachers, and art administrators in a much wider Western context. The postmodern influence, even though in only a few instances, started to blend the firmly-drawn lines of hierarchical distinctions. Twenty years after I had taken up art as my vocation, I began to feel the oppositional codes of the separate spheres slowly eroding as I wrote my thesis and investigated the domestication of tapestry from its previous high art status (until about the turn of the century) as a European male practice. I became able to name my situation and map my various contexts as a white woman in the northern and southern hemispheres of colonial enterprise, and thus could better understand the ambivalences and uncertainties of shifting identities within the two colliding spheres of art.

To accompany my thesis, I did my six *Virtue Series* tapestry panels in which strong, white, naked women against a seascape and a prairiescape were named, *Faith, Hope and Felicity*, and *Patience, Prudence and Constance* (Figure 55). Feeling bold about doing tapestries that would not satisfy corporate patronage (or the Lausanne Biennial), I went on to do seven panels in my *Look at it this Way* series. In these I hoped to challenge the criteria for measuring art and, amongst other strategies, I had one panel fabricated by a tapestry company in Australia, in another I simulated brush strokes according to the formalist principles of my Fine Art training, and, in another panel I painted with acrylic on the tapestry. I gave each panel two titles to address the assumptions of viewers from both the high and low spheres of art, and at the same time to acknowledge the dissonant dialogue of two of my own voices. Amongst the titles were *The first to arrive were some unwelcome memories / What did you expect?*, *Then there was Mrs. Rorschach's Dream / You are what you see* (Figure 56), *Followed by a projective taste / You see what you are*, *And from the Southern Hemisphere came a wrong sign / It ain't what you say, it's the way that you say it*, and *Finally a lesson from tapestry / It ain't what you do, it's the way that you do it*.[6] Then, in 1987, feeling even more bold, I started the *Sentences* series using found text from newspapers and advertisements dealing with aspects of tourism and exploitation (Figures 57, 58). In the tapestries, using fine silks, I have obsessively and caringly

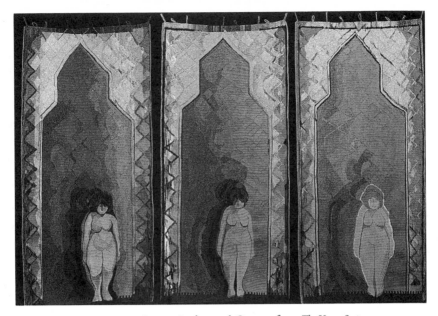

55 ANN NEWDIGATE *Patience, Prudence* and *Constance* from *The Virtue Series.*
Tapestry, 1986, 183 × 91.5 cm

woven thousands of words as monuments and a record of public events interwoven
with personal histories and also with elements of my own story as a Canadian born
in South Africa.

Thus I eventually came to value the indefinable situation of a mostly tapes-
try-based practice in the Canadian Prairies. I could then appreciate the seeming dis-
advantages of fitting nowhere as a tool for negotiating one's own voice and trying to
find a space from which to communicate in a language that does not have to be con-
stantly adjusted according to a variety of confining preconceptions. Janet Wolff's *The
Social Production of Art* and Deborah Cameron's *Feminism and Linguistic Theory* played an
important part in helping me to analyse the limiting devices of constructed defini-
tions and binary opposites. From my own experience I could understand how those
who speak a minor language often accept the pressure to be fluent in the major lan-
guage while the reverse is not demanded. Furthermore, it became clearer to me, par-
ticularly in the case of aboriginal cultures, that the colonisers have taken the liberty
of appropriating, without giving credit to their sources – a manoeuvre that was facil-
itated by conflating many varied communities into convenient invisibility. It was then
apparent to me that textile practitioners too receive no benefits from similar trans-
actions with dominant centres in which their work is inevitably assigned a lesser
value. Thereafter, I could finally forget the tired old art and craft debate and dis-
engage from the oppositional definitions and measurements that support hierarchi-
cal values.

I was helped to the insight that I could disengage from a system that is
stacked against the borders by reading around post-colonial theory, because it showed
me that as a white, middle-class woman, I might try to unlearn my privilege and

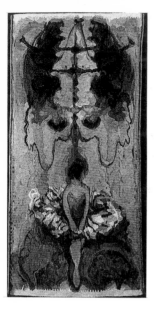

56 (*left*) ANN NEWDIGATE *Then there was Mrs Rorschach's Dream
/You are what you see*, the third piece of the *Look at it This Way*
series. Tapestry, 1987, 183 × 91.5 cm

57 (*above*) ANN NEWDIGATE *Sentences: Xhosa.* Tapestry, 1988, 137 × 160 cm

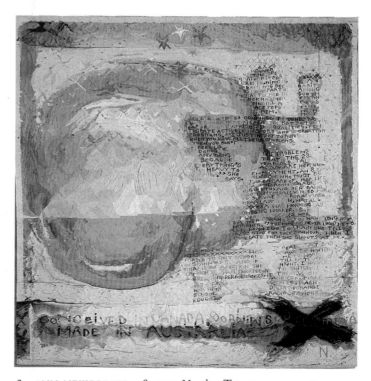

58 ANN NEWDIGATE *Sentences: Marathon.* Tapestry, 1990, 213 × 213 cm

complicities. At the same time I could move beyond the ambivalences of a privilege that is not a privilege and the margins that are not margins, and disbelieve imposed assumptions that disadvantage all women in varying degrees. Through reading and talking about ideas and theories that go beyond the visual arts (wherever one lives, however one works, and whoever one is), I believe that one can accommodate uncertainty and ambivalence as a positive situation that need not comply with the rules constructed by those who control institutions to the advantage of a few. Acknowledging and respecting the value of difference – including one's own – involves many intersecting points of incompatibility that, like slow, old tapestry, do not make for the flawless fabric of a single official history written from the perspective of a white, heterosexual, male subject position. For me, now, it does not matter whether what I do in my studio complies with a minor or a major language – whether it is kinda art or sorta textile. Whenever I feel a definition coming on, I try to remember to ask myself 'Who constructed the definition?', 'Who needs the oppositional distinctions and is going to benefit from them?', and 'Why should I comply with those codes and conventions?'

Notes

1 Thomas, Michel; Mainguy, Christine; Pommier, Sophie, *Textile Art: Embroideries, Tapestries, Fabrics, Sculptures*, 1985 (Editions d'Art Albert Skira, S.A., Geneva), p. 184. With reference to the thesis of the Canadian, Marie Frechette.

2 Krauss, Rosalind E., *The Optical Unconscious*, 1993, Cambridge Mass., The MIT Press, p. 309.

3 For example, the standard text (and accompanying slides) used for introductory Art History in North America was compiled by Horst Woldemar Janson. First published in 1962, *A History of Art: A Survey of the Major Visual Arts from the Dawn of History to the Present Day*, co-authored with Dora Jane Janson, was revised by their son, Antony F. Janson, for the third and fourth editions and now includes a slightly wider range of art practices.

4 Constantine, Mildred and Lenor Larson, Jack, *The Art Fabric: Mainstream* (no date) and *Beyond Craft: The Art Fabric* (no date), New York, Van Nostrand Reinhold.

5 Thomas, Michel, *Textile Art*, p. 14 (Preface): 'The Erika Billeter exhibition in Zurich, in 1979, also replaced this interpenetration of artistic disciplines in the retrospective light of ethnographical objects. The presence of feathered headresses of the Indians of Brazil, Australian objects made with hair, objects of religious cults forming part of the ritual and myths of non-Western societies, was a clear indication that behind this new art there lay a historical process: the rediscovery of the fundamental role of these materials in traditional societies.' (A group exhibition, 'Weich und plastisch, Soft Art'.)

6 *Look at it this Way*, 1988. Catalogue for exhibition at the Mendel Art Gallery, Saskatoon. (Essay by Dr Lynne Bell.)

Sewn constructions

One way I struggle with the problem of symbols and their signification is to look inwards to an inner landscape, to avoid using images which might be read as pliant or in any way part of the patriarchal symbolic system. Indeed, one allegory I refer to when confronted with the problem of the visual appearance of the world as proof of a natural truth is the paradigm shift in the history of astronomy.

Copernicus spent a lifetime undoing the obvious connection between the evidence of our senses and our desire to be the centre of a man-centred universe. As a result we now know that the sun is the centre of our little system, not the earth. But ask someone if s/he is hurtling through space at 1,000 miles per hour, or that the sun is still and it is the earth that is rotating, then our senses deny these facts absolutely. We feel stable in our day and night. Copernicus proved that our reading of phenomena is not to be trusted; intellectually we have to believe someone else's arithmetic, not the evidence of our own eyes. It seems to me that art has been utilised in a collusion between the representation of the world and the 'knowledge' of the Eurocentric subject. Such collusion depends on the incorruptible truth of appearances, indeed such collusion constitutes an apparently incorruptible truth. In my working practice I try to undo this collusion between representations which reveal a male consciousness in art, poetry and newspaper reports and the picture of the world that we (as women) carry around with us from our experience.

Dismayed and desolate with the ambitious young men around me at the Academy Schools in the late 1950s, I almost stopped work. There was no feminism on the horizon. I kept a small diary of paintings and constructions while promoting contemporary art, and in 1965 I was co-founder of the Ikon Gallery in Birmingham. Looking back, all my work was about the appearance of the written tick or mark. I felt at odds with most sixties and seventies ideology.

All this time I had been making sewn constructions. They were all about the appearance of writing, without using recognisable words. Recognisable words would have brought me back to individual arguments; I would have been vulnerable to criticism about the content of the text.

By 1987 I had begun to reject all notions of spatial values from art education; I wanted to avoid the symbols being mis- or reappropriated. I started a series of drawings that began from collages. The papers came from chance findings. While drawing I refuse to be concerned with whether the viewer is or is not convinced by the drawing and allow what I call current concerns to surface in the action of drawing. I fret and

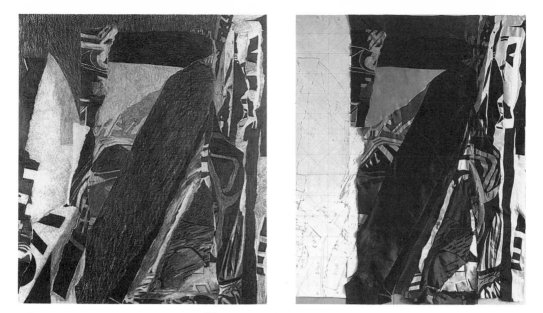

59 DINAH PRENTICE *Rubble Again.* Graphite on paper, 1991, 71 × 61 cm
60 DINAH PRENTICE *Rubble Again.* Pieced silk taffeta, hand dyed, hand pieced, 1992,
193 × 173 cm. The sewing pattern gradually replaces the cartoon pattern

tease out spaces, gaps and obscurities; I start to represent memorable spaces, only to flatten them.

Melanie Klein's object relations theory mirrors my investing current concerns, anxieties, in my pieces, objects. Indeed, Klein put her theories to the test and used discarded toys to try to prise apart the anxiety, in order to expose the source of the real anxiety as a cure. Certainly the advantage that the artist has over the theorist is that, in making an object that has not existed in the world before, I have control over signifier and signified; I can use any means to hand, literally to hand, to feed a new consciousness about what art can look like and what subjects it can be constructed to signify. I assume the authority to fill the gap between the signifiers and the signifieds that make up our symbolic universe, to give a new explanation to the power relations that fill the gap.

I always work on several pieces at once, so there will be four or five drawings in various stages of significance, that is, both in drawing and in meaning, either for future sewn pieces or just as reference. There is usually a large piece covering a whole wall in my studio in an ongoing state, that is, a full-size cartoon drawn on paper, gradually being replaced by sewn parts, and one or two smaller pieces also being sewn or quilted (Figures 59, 60).

I now aim to create new symbols that can carry my own narrative or, better still, attempt to stand for an alternative narrative. To this end I resort to free-wheeling through an uninfected sentence (an arbitrary collage) which nevertheless has to pin down the political/patriarchal conspiracy to conceal the arbitrary connection between art and its mythic representation as a natural, non-political force. I take the

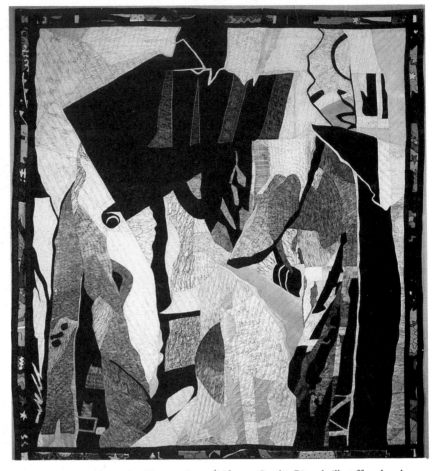

61 DINAH PRENTICE *Mountain Rescue/Helicopter Gunship.* Pieced silk taffeta, hand dyed, hand pieced and hand quilted, 1992, 190 × 175 cm

viewer across the picture plane, building forms visually and then deliberately disjointing them. I mean to allow the murderous conspiracy of power politics to steal through these symbolic disjoints or gaps and expose the anxiety that art is supposed to soothe and hide.

Both content and manner of work (not least the commitment of time and effort that must certainly speak to the least sophisticated viewer) are used to achieve this end, and the deconstruction of expectations and meanings is handed on from the material to the meaning during the drawing and sewing phase. The series *Weapons and the Deterioration of Life on Earth*[1] is dedicated to those whose hands and feet and other body parts are being blown away by modern weapons and the careless mining of rural landscapes (Figure 61).

In *Bunch of Flowers/Hand Grenade* (Figure 62) four interwoven texts have been added calligraphically, although the images are unspecific enough for the viewer to rove around each piece and invent articulations for her/himself. The lower edge has

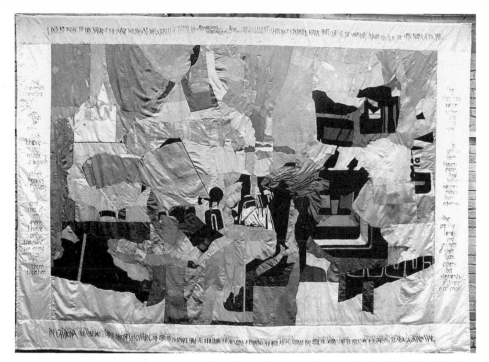

62 DINAH PRENTICE *Bunch of Flowers/Hand Grenade.* Pieced silk taffeta, hand dyed. Calligraphy, Carole Proctor, 1992, 305 × 427 cm

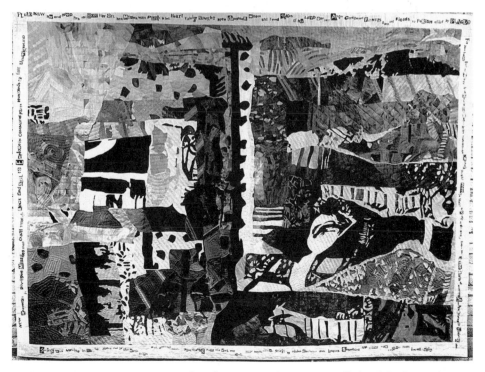

63 DINAH PRENTICE *Persephone Rising.* Pieced shantung silk, hand dyed, pieced and quilted. Quilting, Sue Martin. Calligraphy, Carole Proctor, 1992, 305 × 427 cm

a quote from an advertisement for donations to the Cambodian limb project and is spliced with a quote from an American report on the destabilisation there: 'In Cambodia over a hundred thousand innocent men, women and children no longer have all their limbs. They are victims of land-mines and other military weapons that litter the country with the intention of destabilising the area; a coward's war.' The original collage was made from bits of posters that were peeling off hot sunny walls in Spain in 1987. The text along the top edge is my own, 'I intend to raise the torn nature of the image to represent both a bunch of flowers (bourgeois sentimental posie) and the moment when tissue is disjoined, blown apart with all the secondary images that lie in the optic nerve at the time.' The right-hand side has a partial quote from a Shakespeare sonnet. 'They that have power to hurt and will do none – They surely do inherit heaven's graces and harvest nature's riches from expense. They are the lords and owners of their faces, Others but stewards of their excellence.' The text on the fourth side is from Montaigne, 'And one might therefore say that in this book I have only made up a bunch of other people's flowers, and that of my own I have only provided the string that ties them together.'

Again using texts on four sides I explore in another work an alternative reading of the myth of Persephone. A collage made in 1986 during a schools residency painted with no ulterior political motive suddenly came alive on reading a report in the *Guardian*. This stated: 'New research is developing missiles that crash through rock and soil to explode in command posts hundreds of feet underground.' The collage carried both the capacity to contain attack and the idea of the penetration of earth and woman (Figure 63).

The image of a fork-like shape striking upwards through many strata stood in my mind for Persephone rising up from the underworld in the spring. Ovid wrote: 'Pluto saw her and loved her and bore her off. Her mother, with panic in her heart, vainly sought her daughter. Where she found traces of her loved one, her anger condemned farmers' oxen and fields to perish alike by plague.' Irigaray's political call for a new trust and love amongst women, symbolised by a radical new relationship between mothers and daughters, is echoed here by Ceres' anger and her search for her daughter through the seasons. The texts written together round this quilt contrast our symbolic responsibilities towards nature with the cynical splicing of sexual meanings with the rape of both body and land. From Bacon I added 'For you have but to follow and hound out nature in her wanderings. Neither ought men to make scruple of digging of holes into mother earth or entering and penetrating or violating her.' And finally, from the beginning of *The Wind in the Willows*, a childlike plea for an imagery full of *jouissance*: 'Spring was moving in the air above and in the earth below and around him, penetrating even his dark and lowly little house with its spirit of divine discontent and longing. Something up above was calling him imperiously.'

I am exploring the effectiveness of including texts in my work as opposed to including some explanation in a catalogue. The presence of the text currently with the image affects the way in which the work is translated visually. Viewers also have a lifetime of remembered words; rich resources of intertexuality out of which we as, artist and viewer, reconstruct an internalised consciousness; a landscape.

Notes

1 These pieces were exhibited in 1993 in Derby in a newly refurbished railway shed. They read the viewer like Durrell's description of Greek mountains which, he said, silently watch the viewer watching them.

Penelope and the unravelling of history

Introduction

I began to look seriously at references to textiles in history through my interest in Penelope, and later examined other stories which reflect social and religious customs involving weaving or spinning. Associations with mythological figures shift throughout history and reflect how a society gives value and support to certain actions and codes of behaviour. As a whole, these different stories promote the values established under patriarchy. Nevertheless, (or although) individual accounts at times challenge these assumptions. It is this intersection between actual events, general assumptions and the way in which history is told and retold which I want to address, in order to explore ways in which stereotypes become established and in turn can be questioned.

Many artists who use textiles have attempted to use it as a 'neutral' medium, similar to any other in the visual arts, but material implications continue to affect the work and how it is perceived. All media are charged with their own history. It is important, therefore, to analyse the messages contained, which produce such a reading, in order to establish a critical context for discussing works on a conceptual level. The rise of the 'Fibre Art' movement during the modernist era initiated great exuberance, but also resulted in a split between textiles and its history and social place. Today, within postmodern and feminist discourses, textiles has an interesting role to play, and the consideration of its historical role is relevant. Because it is primarily women who are involved in the production of textiles, implications of this challenge reach outside the strict confines of a textile dialogue, as they reflect attitudes held by women and towards women and their activities.

I originally became a weaver because I was attracted by its materiality and its relative 'usefulness'. I remain committed to weaving for the interesting contexts it provides for women and artists today. Textiles are part of everyday life, they provide for physical needs, contribute to rituals or religious activities, and communicate about power and status, as well as political, social and cultural allegiances. Western culture, with its division into high art and craft, tends to place all textile work in a similar context.

My investigation into textiles as concept began with the following quotation from Roland Barthes:

Text means Tissue; but whereas hitherto we have always taken this tissue as a product, a ready-make veil behind which lies, more or less hidden, meaning (truth), we are now emphasizing, in this tissue, the generative idea that the text is made, is worked out in a perpetual interweaving; lost in this tissue – this texture – the subject unmakes himself, like a spider dissolving in the constructive secretions of (her) web. Were we fond of neologisms, we might define the theory of the text as an hyphology (hyphos is the tissue and the spider web).[1]

The representation of goddesses as weavers or spinners exists in many cultures. They are 'Spinners of the Thread of Life' and 'Weavers of the Tapestries of Life and Death'[2] and also 'Goddesses of Fate'.[2] Similar ideas persist in fairy tales where spinners appear as powerful and sometimes helpful, sometimes dangerous witches, and it is present today in contemporary science fiction.[4] I decided to examine specific instances where textiles played an important role in myths and tales from Western culture, particularly in early Greek myths, a period of change, during which the male pantheon became established under Zeus, in order to learn more about how value systems have become established in Western culture. In this way, Penelope became a pivotal figure for me, although not initially as a heroine. What started as a simple historical reference became gradually more significant, and I now think of Penelope as a real person, an artist, a weaver and a friend.

> Penelope: My power as a woman and weaver emerged as I worked not by consciously thinking of it . . . I simply concentrated on the task: the doing by day, the undoing by night, in never-ending rhythm. This gave me focus and discipline to continue year after year . . . the creation of beauty and the undoing of it. Both [are] equally challenging, a changing story, a changing weave, forever new, forever undone.[5]

Penelope

Penelope stalled her suitors for three years by her weaving/unweaving of a shroud, thereby avoiding choosing a new husband. Odysseus, her husband, had been gone for twenty years, ten spent in the Trojan war and another ten wandering over treacherous waters because of a curse from the gods. During this time Penelope waited and reigned in his stead. Her action or non-action has been interpreted in many different ways throughout history. In more ancient myths, her name means 'she who tears out threads',[6] connecting her with those ancient powers who controlled destiny by interwoven threads, the goddesses of Fate. Her refusal to cut the final thread or finish the work leads to the assumption, never really stated, that she controlled the life of her husband Odysseus. Her action seems less heroic than Odysseus', but it succeeded without bloodshed. Odysseus 'solved' things quickly and brutally by slaughtering all the suitors. Homer describes Penelope and her work as follows:

> Here is one of her tricks: she placed her loom,
> her big loom, out for weaving in her hall,
> and the fine warp of some vast fabric on it . . .
> so every day she wove on the great loom –
> but every night by torchlight she unwove it,
> and so for three years she deceived the Akhaians.[7]

Penelope lived at the beginning of the early Greek period, during the Bronze Age. This period is interesting because of a shifting of roles between women and men. 'The Bronze Age legends are pervaded with powerful female figures, such as Clytemnestra, Hecuba, Andromache, and Penelope.'[8] Women such as Penthesilea, Helen, Cassandra, Antigone, Electra, Medea, and Phaedra have powerful and tragic roles, although this may not accurately depict everyday life for all women.[9] But they do show women who make decisions and who use personal power to achieve their goals.

Penelope has been shown as the romantic woman waiting faithfully for her returning husband. A completely different form of marriage was practised at that period, compared with contemporary versions. Marriages then served to form allegiances between powerful families. Women were often given as rewards to the winners of competitions during this period that established our notion of the hero. Love was not the driving force behind marriages.

Similarly, Penelope became the model of the faithful Christian wife. Robert Greene's 1587 poem 'Penelope's Web' is subtitled 'wherein a Christall Myrror of faeminine perfection represents those vertues and graces, which more curiously beautifies the mynd of women . . . namely Obedience, Chastitie and Sylence'.[10] In Greene's account, Penelope tells several long and entertaining tales to the women who surround her while they all weave, illustrating these 'ideals' for women's behaviour.

Penelope is not the only weaver in the Odyssey; in fact several women challenge her and help Odysseus, and most of them are weavers who live independent lives and make their own choices, although not always as overtly as the example of Penelope shows: Io, Calypso, Circe, Helen, Arete, the Sirens and, of course, Athena. The goddess Ino gives Odysseus the veil that saves him from drowning:

> Do what I tell you,
> Shed that cloak, let the gale take your craft,
> and swim for it . . .
> Here: make my veil your sash; it is not mortal;
> you cannot, now, be drowned or suffer harm.[11]

Calypso and Circe are both weaving when Odysseus and his men arrive; both are powerful women, one a goddess, the other a nymph. They reign on their own islands and challenge or seduce travelling heroes. Both probably wove a few spells into their webs . . .

> Divine Kalipso, the mistress of the isle, was now at home . . .
> in her sweet voice, before her loom a-weaving,
> she passed her golden shuttle to and fro.[12]

Circe, who turned Odysseus' men into swine, is introduced thus:

> They heard the goddess Circe. Low she sang
> in her beguiling voice, while on her loom
> she wove ambrosial fabric sheer and bright,
> by that craft known to the goddesses of heaven.[13]

When me meet Helen in the *Iliad* she weaves a tapestry depicting the Trojan war, and it has been suggested that all the scenes that follow in the story are from her tapestry, that it is she who wove the whole story:[14]

> She [Iris] found her weaving in the women's hall
> a double violet stuff, whereon inwoven
> were many passages of arms by Trojan
> horsemen and Akhaians mailed in bronze –
> trials braved for her sake at the wargod's hand.[15]

Other women in Greek mythology weave to assert their positions. Often, because they use their power more overtly than Penelope, they are punished for it. But they do choose weaving to give voice to their ideas.

Arachne is generally remembered as the mortal woman who challenged Athena to a weaving competition and who produced the finer piece of weaving. She was punished for this and transformed into a spider. But what did Arachne weave, to deserve such treatment? Ovid, in the *Metamorphoses*, tells the story of the woman Arachne, and he describes in vivid detail her tapestry, which contained twenty-one instances of 'seductive deceptions', or rapes, committed by the Olympian gods. It is important to point out that he describes them very much as deceptive actions:[16]

> Arachne, of Maeonia, wove at first
> The story of Europa, as the bull
> Deceived her and so real was her art,
> It seemed a real bull in real water . . .
> And she wove Asterie seized
> By the assaulting eagle; and beneath the swan's
> White wings showed Leda lying by the stream.[17]

Athena weaves a tapestry that represents the symbols of her power that gave her name to the city of Athens over that of Poseidon, as well as situations where mortals had challenged gods and were punished for it.[18] When Athena sees Arachnes's work,

> Minerva [Athena] could not find a fleck or flaw –
> Even Envy can not censure perfect art –
> Enraged because Arachne had such skill
> She ripped the web, and ruined all the scenes
> That showed those wicked actions of the gods
> And with her boxwood shuttle in her hand,
> Struck the unhappy mortal on her head.[19]

'Arachnology' is a term created by Nancy Miller in response to Barthes's use of 'Hyphology'. 'By arachnology, then, I mean a critical positioning which reads *against* the weave of indifferentiation to discover the embodiment in writing of a gendered subjectivity; to recover within representation the emblem of its construction.'[20] Arachne began as a woman weaver of texts. She was transformed into a spider, an older, silent and self-generating weaver, but one which rendered the woman Arachne voiceless. The communicative power of her weaving is removed. Arachne who was first

a woman and a weaver is remembered only as a spider. Her story is often forgotten and ignored.

Philomela's story shows an act of silencing overcome through weaving. Tereus, her sister's husband, raped Philomela and afterwards cut out her tongue to silence her. So Philomela weaves her story into a coat to tell her sister of this horrible act. Such a simple 'meaningless' domestic activity easily passed the scrutiny of her jailers. Her sister understood her message and saved her, and both together avenged themselves on Tereus.

> What could Philomela hope or do? . . .
> Prevented flight and mutilated, she
> Could not communicate with anyone . . .
> Spreading the Thracian web upon the loom
> She wove in purple letters on white cloth,
> A story of the crime: and when 'twas done
> She gave it to her one attendant there
> And begged her by appropriate signs to take
> It secretly to Procne. She took the web
> She carried it to Procne, with no thought
> Of words or messages by art conveyed.[21]

If today we do not hear these stories, it is as if these acts of defiance did not exist and Philomela, Arachne and Penelope remain muted. Feminist critics, like Nancy Miller and Patricia Joplin Klindienst, have explored the idea of women using weaving as language to tell their stories, as a tool to obtain control over their own destiny. Weaving is more than a symbol for language, as Miller and Joplin argue, it is also a symbol for the gendered nature of languages and a means of resistance. For as Patricia Joplin Klindienst points out, in an article with the interesting title 'The Voice of the Shuttle is Ours', 'in the middle we recover the moment of the loom, the point of departure for the woman's story . . . revenge, or dismembering, is quick. Art, or the resistance to violence and disorder inherent in the very process of weaving, is slow.'[22] Her reading of this story argues that

> Philomela refuses her status as mute victim . . . When she transforms her suffering, captivity, and silence into the occasion of her art, the text she weaves is overburdened with a desire to tell. Her tapestry not only seeks to redress a private wrong, but should it become public, it threatens to retrieve from obscurity all that her culture defines as outside the bounds of allowable discourse, whether sexual, spiritual, or literary.[23]

How have these interpretations affected my work as an artist?

I started to dismantle men's business suits, realising that such literal 'deconstructions' of existing textiles communicated ideas effectively. Penelope in the boardroom, reincarnated (Figure 64). Initially I pulled out threads to break the existing pattern or structure. I always wondered what a pin-stripe suite would look like without any pin-stripes left. What would be its point? Who would know? For now this pin-less pin-stripe suit floats conceptually in my own and hopefully other people's heads.

Then I started to look more closely at Penelope; did she always reweave the

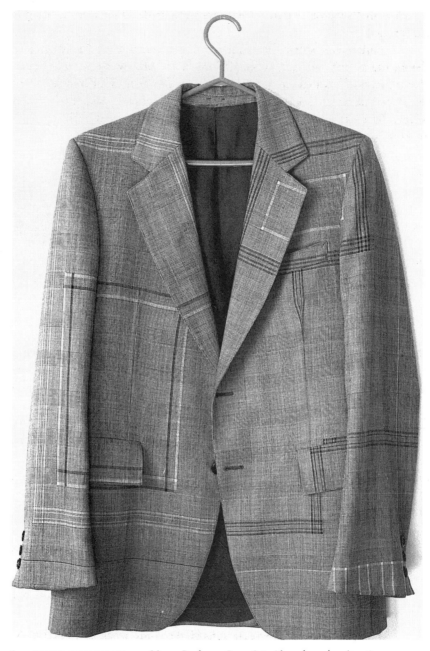

64 RUTH SCHEUING *13 Men or Penelope 1: Centre Suit.* Altered man's suit, 1989,
61 × 76 cm

same pattern or design after she had undone her work during the night? She might have worked a different piece every day, but none of the men would have noticed. They were only waiting for the finished product and were not interested in the process. Could process come to be all and the product nothing? How would her recognition of her own power affect her task? Did she ever believe that she could

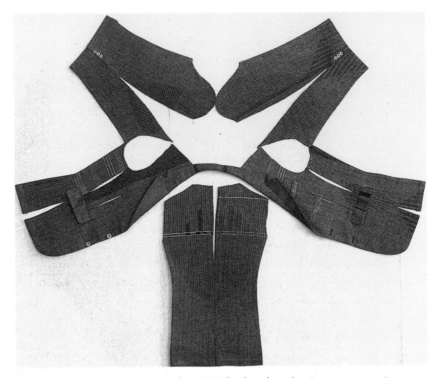

65 RUTH SCHEUING *Metamorphoses IV: Fish.* Altered man's suit, 1992, 137 × 178 cm

control Odysseus' life? Nothing in the written texts suggests this, but men wrote up the story and they did not know. Did Penelope know of the Fates? Did she know them as legendary or mythic figures, or did she believe in them?

What about the implications of Ovid's accounts of transformations in the *Metamorphoses*? As points of resolution, instead of being punished or 'saved', victims and aggressors alike are transformed into other realms of existence, into animals which often possess mythical powers. At the same time I am drawn to a more scientific interpretation of metamorphosis as a natural evolutionary step. This combination of an apparently illogical and logical act is aimed to destabilise an established reading of the suit as symbol of power and takes the initial disruption of the suit fabric one step further. By arranging the separated pieces of a suit, out of which it was initially constructed, I transform it into an elaborate decorative arrangement, charged with a new symbolic imagery (Figure 65). These new pieces pay slightly too much attention to an inordinate or obsessive amount of detail and formal arrangement, which in turn questions any final literal interpretation.

And what of Athena who has inherited her mother's knowledge and her skill as a weaver, but who acts within this male pantheon with such apparent ease?

> Pallas, after cooling down, analyzed the meaning of Arachne's defiant gesture and came to the conclusion that the mortal's act of rebellion was not directed against her but the behaviour of the gods . . . and Pallas made sure that, from that time forward, there will be mortals who will pursue Arachne's work by deconstructing the stories and texts of patriarchy.[24]

Notes

1 Roland Barthes, *The Pleasure of the Text*, (Hill and Wang, New York), 1975, p. 64.

2 Buffie Johnson and Tracy Boyd, 'The Eternal Weaver', *Heresis*, vol. 5, pp. 64–8.

3 Erich Neumann, *The Great Mother*, Bollingen Series, 47, trans. Ralph Monheim (Princeton University Press, Princeton N.J.), pp. 226–39.

4 Piers Anthony, *With a Tangled Skein*, Book Three of the Incarnations of Immortality (Ballantine Books, New York), 1985.

5 Ruth Scheuing, *Penelope*, text of a performance in collaboration with the composer Marc Patch, 6th Biennale de la Tapisserie de Montreal, 1991.

6 Paul Kretschmer, *Penelope* (Anzeiger der Akademie, 1945), p. 80.

7 Homer, *The Odyssey*, translated by Robert Fitzgerald (Anchor Books, Doubleday, New York, 1963), Book 24, lines 130–40.

8 Sarah B. Pomeroy, *Goddesses, Whores, Wives, and Slaves: Women in Classical Antiquity* (Schocken Books, New York, 1975), p. 17.

9 Pomeroy, *Goddesses*, pp. 94–119.

10 Robert Greene, 'Penelope's Web', collected works, London and Aylesbury, vol. 5, 1587.

11 Homer, *The Odyssey*, Book 5, lines 337–42.

12 Homer, *The Odyssey*, Book 5, lines 65–7.

13 Homer, *The Odyssey*, Book 10, lines 220–3.

14 Homer, *The Iliad*, translated by Pope, Book 3, lines 125–30 (footnote): 'This is a very agreeable fiction, to represent Helen weaving in a large veil, or piece of tapestry, the story of the Trojan war. One would think that Homer inherited this veil, and that his *Iliad* is only an explication of that admirable piece of art' (Dacier).

15 Homer, *The Iliad*, translated by Fitzgerald, Book 3, lines 125–30.

16 In later depictions of rape, particularly in Renaissance paintings, these stories become more of an excuse for the depiction of naked women being manhandled or bravura depictions of painted flesh.

17 Ovid, *Metamorphoses*, Book VI, lines 105–12.

18 Ovid, *Metamorphoses*, Book VI, lines 73–104.

19 Ovid, *Metamorphoses*, Book VI, lines 132–6.

20 Nancy Miller, *Arachnologies: The Woman, the Text, and the Critic*, in her *Subject to Change: Reading Feminist Writing* (Columbia University Press, New York, 1988), p. 80.

21 Ovid, *Metamorphoses*, Book VI, lines 575–87.

22 Patricia Joplin Klindienst, 'The Voice of the Shuttle is Ours', *Stanford Literature Review* 1, spring 1984, pp. 46–8.

23 Joplin, 'The Voice', p. 43.

24 Mireille Perron, *Ruth Scheuing (Re)Tracing Threads*, *Fiberarts*, vol. 20, no. 3, November 1993, p. 14.

Index